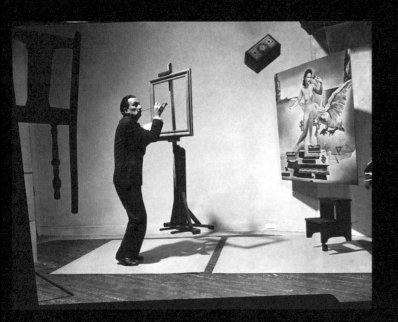
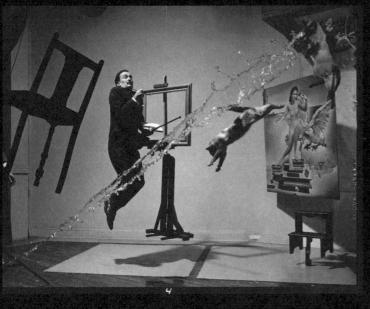
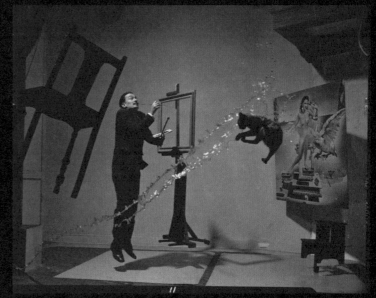
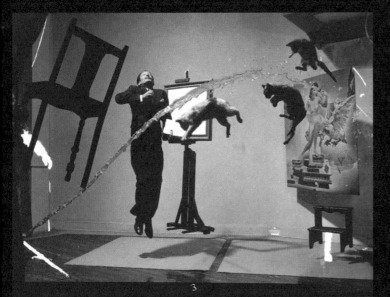
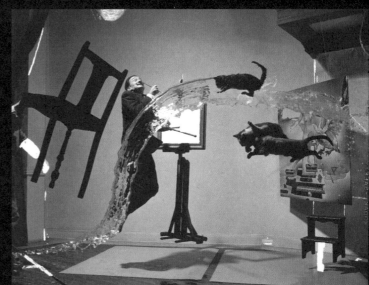

100 PHOTOGRAPHS | *the most influential images of all time*

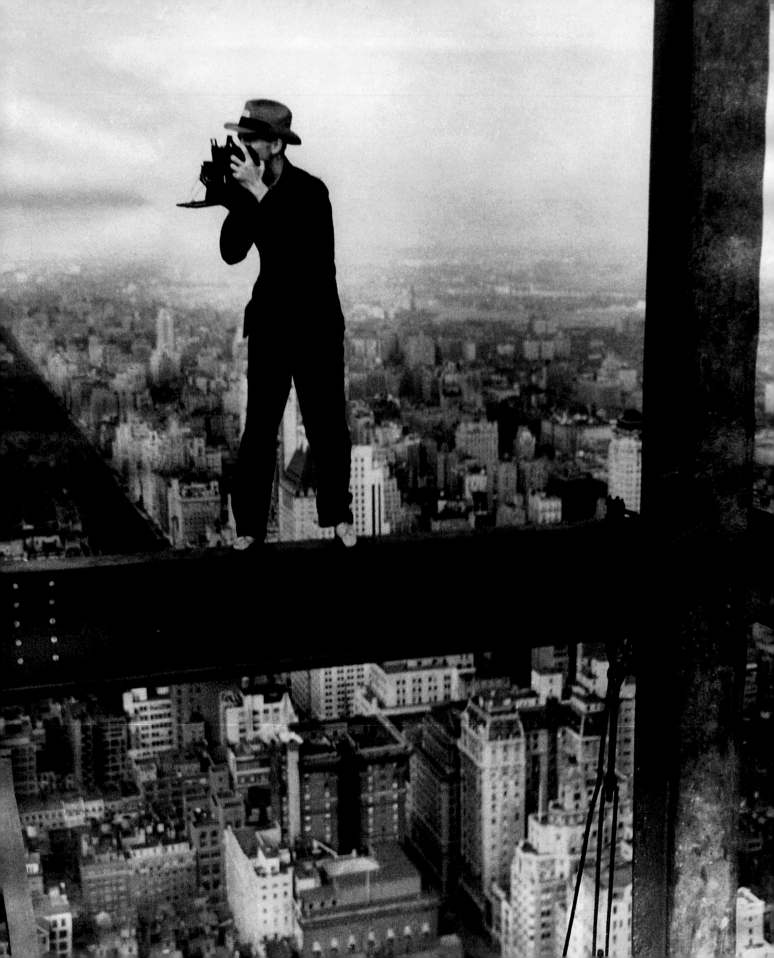

100 PHOTOGRAPHS | *the most influential images of all time*

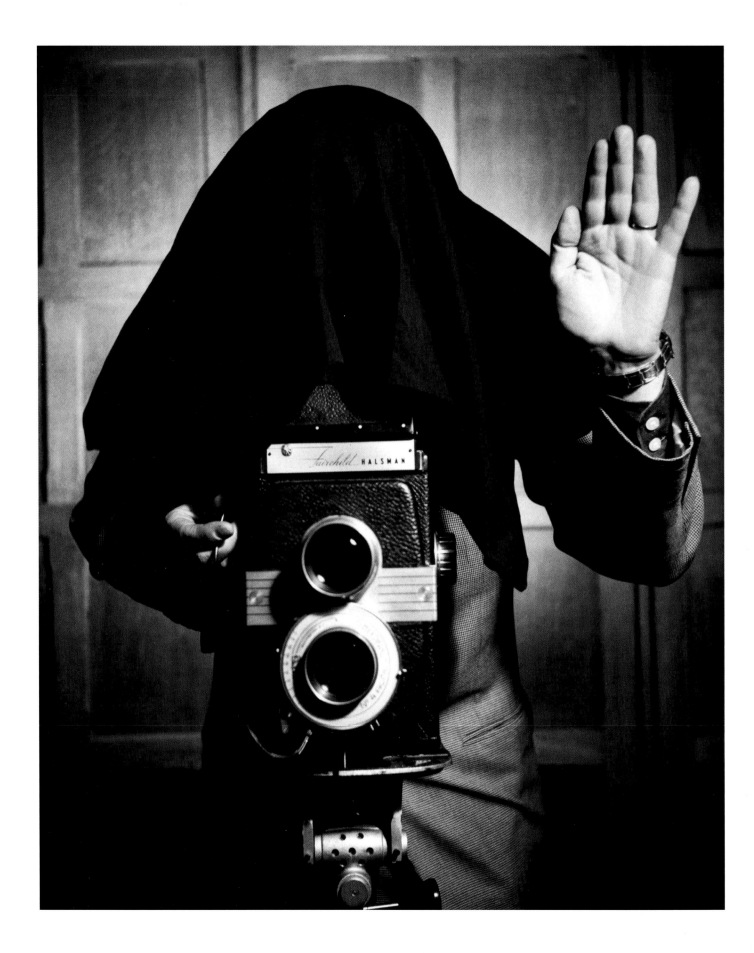

 | *table of contents*

Title page: One of the three photographers who documented the construction
of Rockefeller Center and the now-iconic *Lunch Atop a Skyscraper*
Table of contents: Philippe Halsman in his studio, circa 1950

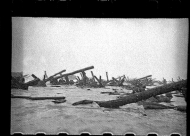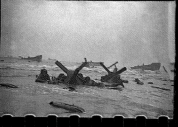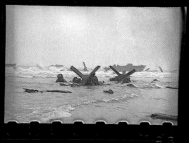

DEFINING INFLUENCE

By Ben Goldberger, Paul Moakley and Kira Pollack

We began this project with what seemed like a straightforward idea: assemble a list of the 100 most influential photographs ever taken. If a picture led to something important, it would be considered for inclusion. From that simple concept flowed countless decisions. Though photography is a much younger medium than painting—the first photo is widely considered to date from 1826—the astonishing technological advances since then mean that there are now far more pictures taken every day than there are canvases in all the world's galleries and museums. In 2014 alone, hundreds of billions of images were made.

How do you narrow a pool that large? You start by calling in the experts. We reached out to curators, historians and photo editors around the world for suggestions. Their thoughtful nominations whittled the field, and then we asked TIME reporters and editors to see if those held up to scrutiny. That meant conducting thousands of interviews with the photographers, picture subjects, their friends and family members and others, anywhere the rabbit holes led. It was an exhaustive process that unearthed some incredible stories that we are proud to tell for the first time.

Nine of Robert Capa's surviving negatives from D-Day. Most of the film showed no images after processing, and only some frames survived.

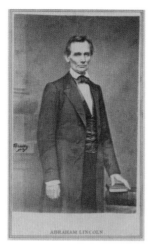

Mathew Brady's 1860 portrait
of Abraham Lincoln as seen on a
campaign *carte de visite*.

Jeff Widener's *Tank Man* photograph
on the front page of the June 6, 1989,
London *Times*.

At right: Stills from Abraham
Zapruder's film of John F. Kennedy's
assassination pictured in the
November 29, 1963, issue of LIFE.

There is no formula that makes a picture influential. Some images are on our list because they were the first of their kind, others because they shaped the way we think. And some made the cut because they directly changed the way we live. What all 100 share is that they are turning points in our human experience.

A list about influence necessarily leaves off its fair share of iconic pictures and important photographers. A survey class in great photographers would surely include Ansel Adams and Walker Evans. And yet no single one of the pictures Adams took inside Yosemite—majestic as they are—could rival in influence Carleton Watkins' work, which actually led to the creation of the park. Similarly, no one of Evans' deservedly celebrated pictures from the Depression conveyed the human toll of that dark period with the immediate force of Dorothea Lange's *Migrant Mother*.

Photography was born of a great innovation and is constantly reshaped by new ones. So it is fitting that our definition of an influential photo changes along with the ways pictures are taken and seen. There were other photographers who captured the man confronting a column of People's Liberation Army tanks during the Tiananmen Square protests in 1989. But only Jeff Widener's picture of "Tank Man" was sent out over the wire of the Associated Press. For almost seven decades, that wire was the most powerful distribution tool in photography, offering the fastest route to the largest audience. It is possible that even such an astounding image as the one Eddie Adams took of an execution in Saigon—a masterwork that distilled the futile horror of the Vietnam War into a single frame—might not have become iconic had it not been launched far and wide by the AP.

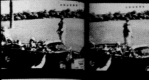
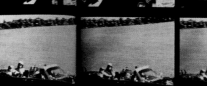
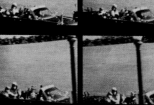

SPLIT-SECOND SEQUENCE
AS THE BULLETS STRUCK

On these and the following two pages is a remarkable and exclusive series of pictures which show, for the first time and in tragic detail, the fate which befell our President. The caravan had just passed through the downtown area of Dallas and made a sharp left turn at the corner of Elm and Houston Streets, where it headed down an incline into an underpass. First came the police motorcycle escort (*above*) and then the big Lincoln bearing the Kennedys and Texas Governor John Connally and his wife. The crowds were thin at this point, but the President and Mrs. Kennedy were smiling and waving as their car passed the brick building where the assassin lurked, and disappeared momentarily behind a highway sign.

Then came the awful moment. In these pictures, which run consecutively from left to right, it begins as the car comes out from behind the sign (*fifth picture*) The President's wave turns into a clutching movement toward his throat (*seventh picture*). Governor Connally, who glances around to see what has happened, is himself struck by a bullet (*ninth picture*) and slumps over (*tenth picture*). As the President's car approaches a lamppost (*13th picture*) Mrs. Kennedy suddenly becomes aware of what has happened and reaches over to help (*large pictures below*) while Governor Connally slumps to the floor. The President collapses on his wife's shoulder and in the last two small pictures the First Lady cradles him in her arms.

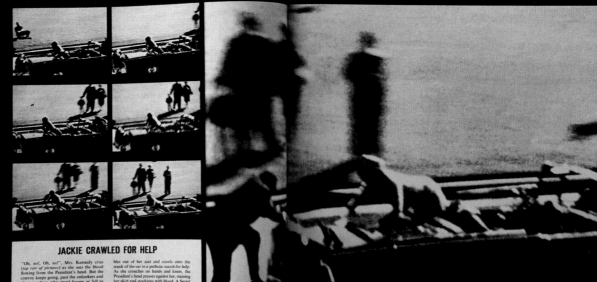

CONTINUED

JACKIE CRAWLED FOR HELP

"Oh, no!, Oh, no!", Mrs. Kennedy cries (*top row of pictures*) as she sees the blood flowing from the President's head. But the convoy keeps going, past the onlookers and photographers who stand frozen or fall to the ground as they hear the shots.

As the President lies dying, Jackie scram- bles out of her seat and crawls onto the trunk of the car in a pathetic search for help. As she crouches on hands and knees, the President's head presses against her, staining her skirt and stockings with blood. A Secret Service man leaps on the bumper to protect the First Lady and get her back into the car.

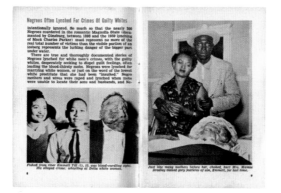

The July 23, 1964, issue of *Jet* magazine featuring David Jackson's photographs of Emmett Till.

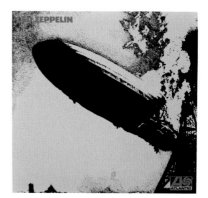

Led Zeppelin used Sam Shere's photograph of the *Hindenburg* disaster on the cover of its debut album.

In other cases, it was the appearance on the cover of a magazine or the front page of a newspaper that lent a photo its influence. The first time the world saw Abraham Zapruder's haunting images of John F. Kennedy's assassination was not as a moving picture but as a series of frame-by-frame stills published in LIFE magazine. Before televisions were in every home, the photos that ran in LIFE influenced how a lot of people understood their world. But LIFE was far from alone. In 1955, *Jet* magazine published pictures from the open-casket funeral of Emmett Till, a 14-year-old African American murdered for supposedly flirting with a white woman in Mississippi. The photo of Till's mother grieving over her son's mutilated body became a clarion call for the nascent civil rights movement.

A far lighter image reminds us that an influential picture is not necessarily a great one. Annie Leibovitz's 1991 photo of a nude, pregnant Demi Moore shattered the taboo of sexualizing pregnancy because it was on the cover of *Vanity Fair*, not because it was an important portrait. As Leibovitz herself put it, "It was a popular picture and it broke ground, but I don't think it's a good photograph per se. It's a magazine cover. If it were a great portrait, she wouldn't be covering her breasts. She wouldn't necessarily be looking at the camera."

The impact of those moments has dwindled amid yet another technological change. When Philippe Kahn rigged his cell phone to take a picture of his newborn daughter nearly 20 years ago, he could scarcely imagine that his invention would change the world. Of course, now everyone is a photographer, a publisher and a consumer. This has largely been to the good. Our connection with photography is more personal and immediate than ever—that it took several days and multiple plane flights for Robert

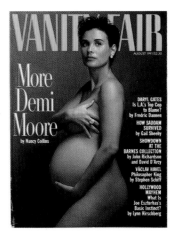

Annie Leibovitz's Demi Moore
on the cover of the August 1991
issue of *Vanity Fair*.

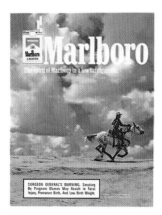

The Marlboro ad that became the
basis of Richard Prince's
controversial *Untitled (Cowboy)*.

Capa's pictures of the D-Day landings to see the light of day seems impossible when today our feeds are bursting with images from every corner of the globe. But the digital revolution has made quantifying influence a particular challenge. Likes and shares are a very real metric, but are they enough? And what of a picture that was never published in any traditional way? Unless you are in viral marketing, there is nothing to admire in the poorly framed, celebrity-packed Oscars selfie organized by Ellen DeGeneres. Yet the picture's astounding reach through social media makes it one of the most seen images of all time. Perhaps only Richard Prince, whose "rephotography" anticipated this moment of instant sharing and mutable ownership, could have seen it coming.

But not all things change. In the process of putting this list together, we noticed that one aspect of influence has largely remained constant throughout photography's more than 175 years. The photographer has to be there. The best photography is a form of bearing witness, a way of bringing a single vision to the larger world. That was as true for Alexander Gardner when he took his horse-pulled darkroom to the Battle of Antietam in 1862 as it was for David Guttenfelder when he was the first professional photographer to post directly to Instagram from inside North Korea in 2013. As James Nachtwey, who has dedicated his life to being there, put it some years ago, "You keep on going, keep on sending the pictures, because they can create an atmosphere where change is possible. I always hang on to that."

Goldberger, TIME's *nation editor; Moakley,* TIME's *deputy director of photography and visual enterprise; and Pollack,* TIME's *director of photography and visual enterprise are the editors of the 100 Photographs project.*

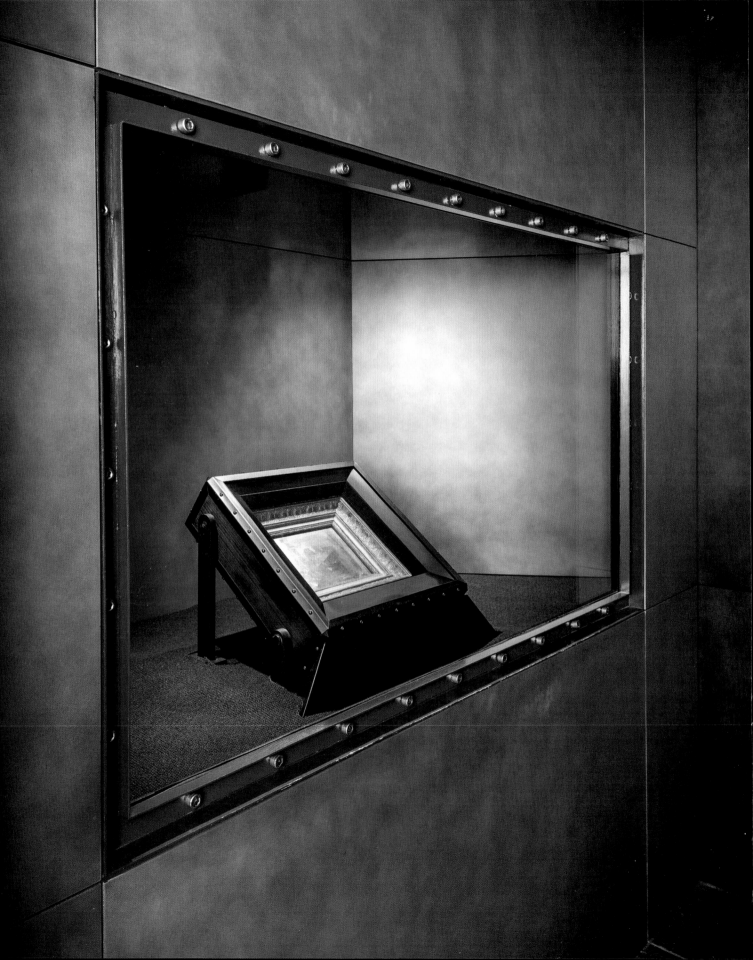

PROOF OF LIFE

Geoff Dyer

I t is quite an experience to go to the Ransom Center in Austin and see the first known photograph. Niépce's picture is housed in what looks like a bulletproof case, the kind of structure associated with delicate religious artifacts of which, it could be argued, this is a prime example. As well as seeming bulletproof, the case, unfortunately, seems very nearly lightproof. So a technology that enabled people to draw with light is preserved here in near darkness. Before your eyes adjust and until you work out the proper angle from which to view this view from a window, you can see almost nothing. Then a few shapes dimly and gradually appear in a way that echoes what, until recently, was one of the defining pleasures of the medium: the slow emergence of an image in the developing tray. Still, the truth is that as a photograph—as a record of a view from a window—you're probably better off looking at the reproduction in this book than peering at the on-site original. Which is also appropriate, since what characterizes the photograph is its inherent reproducibility.

This is worth emphasizing, since the medium's influence is bound up with the means by which

The first photograph, by Joseph Nicéphore Niépce, is sealed in an oxygen-free case at the
Harry Ransom Center in Austin. Photograph by Jeff Wilson for TIME

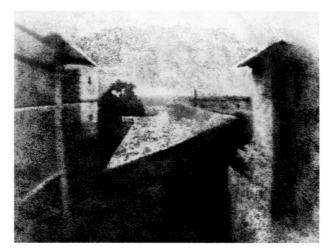

View From the Window at Le Gras, circa 1826
Joseph Nicéphore Niépce

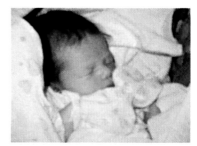

The First Cell-Phone Picture, 1997
Philippe Kahn

images are disseminated. Photography has always depended on accompanying technological advances in communications whose goals, broadly speaking, have been twofold: speed and extent of distribution. The number of people who see a given image and the time it takes for them to see it can be as important as its content in determining a picture's potential influence. Even art photographs have to appear at a timely moment if they are to acquire the mythic stature of "timeless." In the realm of news, important political announcements—which increasingly take the form of photo opportunities—will be arranged so that they fit in with certain deadlines (or, if the news is bad, so that those deadlines are deliberately missed). The history of the technologies associated with photography have involved the constant shrinking of the interval between a picture's being taken and its being seen until, at present, there is no gap at all. We can see pictorial records of events in real time, but the price paid for this is that the related technologies also enable the record to be falsified with unprecedented speed and subtlety.

This eats at the very meaning of photography. Critics with a taste for philosophy nag away at questions of what "reality" is, but most important commentators accept that photography is "a quotation" from reality (Susan Sontag, John Berger), "a certificate of presence" (Roland Barthes), that it has an indexical relationship to the world. John Szarkowski, former head of photography at the Museum of Modern Art in New York City, was more specific when he wrote of "photography's central sense of purpose and aesthetic: the precise and lucid description of significant fact."

And that, to go back to the beginning, is the religion of which the artifact at the Ransom Center is a

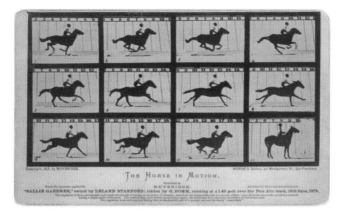

The Horse in Motion, 1878
Eadweard Muybridge

foundational document. Photography upholds the belief in verifiable reality. The late Magnum photographer Philip Jones Griffiths put it succinctly: "George Bernard Shaw said he would willingly exchange every single painting of Christ for one snapshot. That is what photography has got going for it."

Things can be proved to have happened, to have existed and therefore, by implication, to have disappeared or ceased to exist. Photographs can be manipulated, but examples of manipulation—the removal of Trotsky from Russian history—also tacitly affirm that we go to photography for proof. The mission of photography is enhanced by attempts to subvert any particular instance of it.

It is unlikely that a selection of influential photographs could ever be definitive, but consider the present choices in the light of a number of thought experiments or exercises. Consider what might, in this context, be called the negative version of the present crop of pictures. Imagine both world history and the history of photography without these instances and records: it would be like reading a book in which only material close to the edges, to the gutters and margins, had been preserved.

The other two tests are specific to what is here. First, pick a couple of photographs, study them without consulting the accompanying texts—or books or the Internet—and compose your own captions. Write out, either actually or mentally, what each picture depicts and shows. The surprising thing, I suspect, is how vague your account will be. We are used to outsourcing our knowledge and memory, of using Google to check things. But even prior to this, our visual memories being stronger than those for numbers or words, we relied on pictures to serve as metonyms of events. Our history of the world

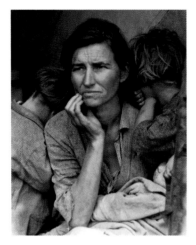

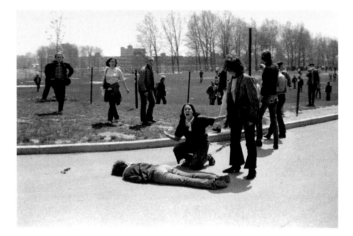

Migrant Mother, 1936
Dorothea Lange

Kent State Shootings, 1970
John Paul Filo

is not substantiated by photographs; it is photographic. If everyone knows about the Great Depression in America in the 1930s, that is partly because it was systematically documented by Walker Evans, Dorothea Lange and a veritable legion of influential photographers. By the same token, because there were almost no photographs to document it, the contemporaneous and even more catastrophic famine in Ukraine is largely a blank space in the collective memory. Relatedly, certain photographs are influential precisely because they are not seen. Ken Burns' masterly PBS series *The Roosevelts: An Intimate History* details the lengths to which Franklin D. Roosevelt's advisers went to ensure that no photographs showed how thoroughly his mobility had been impaired by polio. It was no secret that he had suffered from the disease—his ability to overcome its debilitating effects was one of his strengths—but the President had to be seen to be vigorous, and no evidence could be permitted to undermine this.

The mirror image of this exercise is to pick an event or story—the shooting at Kent State, say—and reconstruct the photo with which that story is associated, building the photograph from the caption. The results would be the reverse of those where we had struggled to conjure words from image: we can mentally summon up the photo quite easily and accurately. The process is the opposite, but the result is the same: to show how knowledge is photographic.

It would be too limiting, however, to assess the influence of photography solely within the realm of the pictorial, the documentary—or even the aesthetic. With wild prescience, D.H. Lawrence outlined what he saw as the psychic or ontological consequences of photography in a 1925 essay, "Art

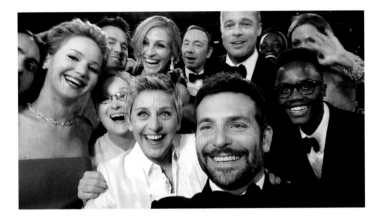

Oscars Selfie, 2014
Bradley Cooper

and Morality": "As vision developed towards the Kodak, man's idea of himself developed towards the snapshot. Primitive man simply didn't know what he was: he was always half in the dark. But we have learned to see, and each of us has a complete Kodak idea of himself."

By these terms, the selfie, and the attendant contemporary compulsion to photograph oneself doing everything, is merely the latest technological iteration of a habit of seeing and being that was, Lawrence claimed, "already old" at the time of writing.

Half a century after Lawrence, Barthes became fascinated by "the phenomenon of photography in its absolute novelty in world history." Its invention, he claimed in *Camera Lucida,* represented nothing less than "the advent of myself as other." Whether one's preference is for the ill-tempered English novelist or the suave Parisian theorist, the outcome of their investigations is similar. Photography is more than a medium, more than a means of storing knowledge, recording history or creating beauty. It has determined—permanently imprinted itself—on what it means to be human.

Dyer's books include The Ongoing Moment, *winner of an Infinity Award, for writing on photography, from the International Center of Photography.*

ICONS

One September day in 1932, in the depths of the Great Depression, the PR team for one of the world's wealthiest clans set out to fan excitement for the family's latest project: Rockefeller Center, some 6 million square feet of skyscraper space built on 22 acres in the heart of Manhattan. The team took a lot of photos that day, but only one became iconic. It showed 11 men sitting casually on a girder 800 feet above the pavement. They chat, scan newspapers, cadge a light, all while dangling their feet in an ocean of thin air. *Lunch Atop a Skyscraper* suggests the peril that yawned in 1932, when America, and the world, dangled over an abyss. And it contains the crazy confidence of a nation that knew the gravest danger was fear itself.

Iconic photographs lodge first in the viscera, then move to the brain to unpack their meanings. Nat Fein's forlorn image of Babe Ruth's last appearance in Yankee Stadium, his luster eclipsed by time and cancer, contains all there is to know about the paths of glory. When James VanDerZee's picture of black New Yorkers in furs was discovered in 1969, it reanimated the Harlem Renaissance in a way no shelf of books could do. The catastrophe of the AIDS epidemic can be felt in a glimpse of Therese Frare's picture of David Kirby on his deathbed.

A photograph is, in a sense, the fossil version of light, a kind of time machine bringing a moment of the past forward while ferrying the present into the past. Iconic photographs, like those of the fossils of Olduvai Gorge, record more than a jawbone or a footprint. They suggest a world.

ABRAHAM LINCOLN | *Mathew Brady, 1860*

'I had great trouble in making a natural picture.' –MATHEW BRADY

Abraham Lincoln was a little-known one-term Illinois Congressman with national aspirations when he arrived in New York City in February 1860 to speak at the Cooper Union. The speech had to be perfect, but Lincoln also knew the importance of image. Before taking to the podium, he stopped at the Broadway photography studio of Mathew B. Brady. The portraitist, who had photographed everyone from Edgar Allan Poe to James Fenimore Cooper and would chronicle the coming Civil War, knew a thing or two about presentation. He set the gangly rail splitter in a statesmanlike pose, tightened his shirt collar to hide his long neck and retouched the image to improve his looks. In a click of a shutter, Brady dispelled talk of what Lincoln said were "rumors of my long ungainly figure ... making me into a man of human aspect and dignified bearing." By capturing Lincoln's youthful features before the ravages of the Civil War would etch his face with the strains of the Oval Office, Brady presented him as a calm contender in the fractious antebellum era. Lincoln's subsequent talk before a largely Republican audience of 1,500 was a resounding success, and Brady's picture soon appeared in publications like *Harper's Weekly* and on *cartes de visite* and election posters and buttons, making it the most powerful early instance of a photo used as campaign propaganda. As the portrait spread, it propelled Lincoln from the edge of greatness to the White House, where he preserved the Union and ended slavery. As Lincoln later admitted, "Brady and the Cooper Union speech made me President of the United States."

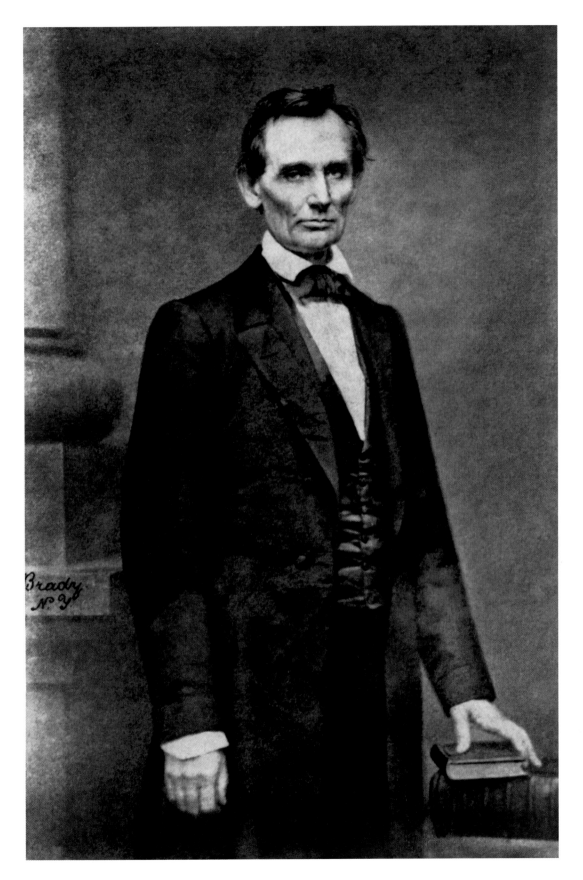

LUNCH ATOP A SKYSCRAPER | *Unknown, 1932*

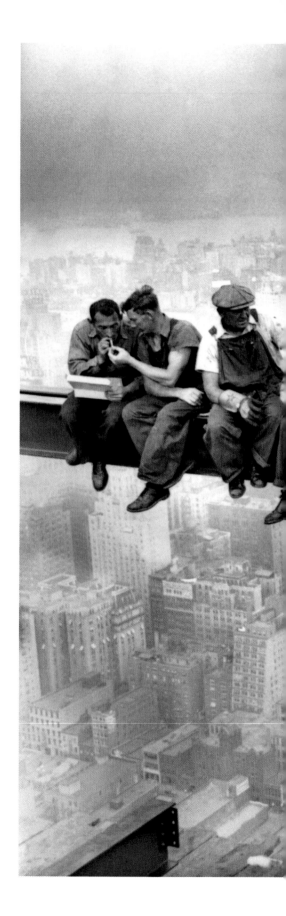

'If you see this picture once, you never forget it.'
–CHRISTINE ROUSSEL, ROCKEFELLER CENTER HISTORIAN

It's the most perilous yet playful lunch break ever captured: 11 men casually eating, chatting and sneaking a smoke as if they weren't 840 feet above Manhattan with nothing but a thin beam keeping them aloft. That comfort is real; the men are among the construction workers who helped build Rockefeller Center. But the picture, taken on the 69th floor of the flagship RCA Building (now the GE Building), was staged as part of a promotional campaign for the massive skyscraper complex. While the photographer and the identities of most of the subjects remain a mystery—the photographers Charles C. Ebbets, Thomas Kelley and William Leftwich were all present that day, and it's not known which one took it—there isn't an ironworker in New York City who doesn't see the picture as a badge of their bold tribe. In that way they are not alone. By thumbing its nose at both danger and the Depression, *Lunch Atop a Skyscraper* came to symbolize American resilience and ambition at a time when both were desperately needed. It has since become an iconic emblem of the city in which it was taken, affirming the romantic belief that New York is a place unafraid to tackle projects that would cow less brazen cities. And like all symbols in a city built on hustle, *Lunch Atop a Skyscraper* has spawned its own economy. It is the Corbis photo agency's most reproduced image. And good luck walking through Times Square without someone hawking it on a mug, magnet or T-shirt.

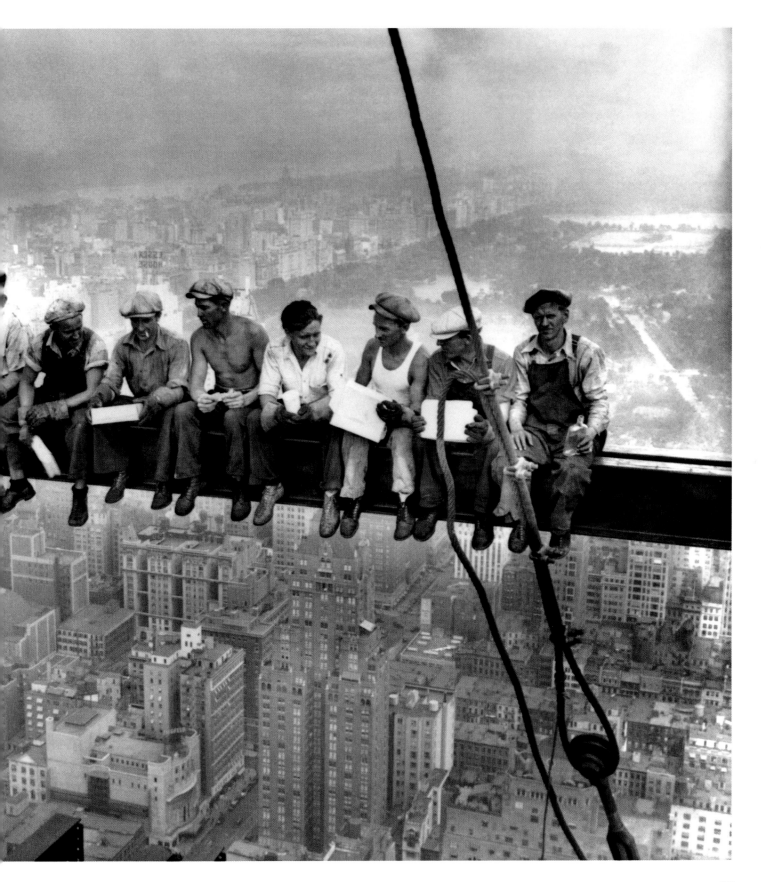

COUPLE IN RACCOON COATS | *James VanDerZee, 1932*

'I always wanted people to look good, to look the way they wanted to look.' –JAMES VANDERZEE

To many white Americans in the 1930s, black people were little more than domestics or sharecroppers. They were ignored, invisible, forgotten. But that was not what James VanDerZee saw when he gazed through his camera lens. Seeking to counter the degrading and widely disseminated caricatures of African Americans in popular culture, VanDerZee not only photographed Harlem weddings, funerals, clubs and families but also chronicled the likes of black nationalist Marcus Garvey, dancer Bill "Bojangles" Robinson and the poet Countee Cullen—the leaders, artists, writers, movers and strivers of the Harlem Renaissance. In his Guarantee Photo Studio and along the neighborhood's streets, VanDerZee crafted portraits that were meticulously staged to celebrate the images his subjects wanted to project. And nowhere is this pride more evident than in his glowing picture of a handsome couple sporting raccoon coats beside a Cadillac roadster. The swish backdrop—props curated by VanDerZee—challenged popular perceptions about race, class and success and became an aspirational model for generations of African Americans yearning for a full piece of the American Dream.

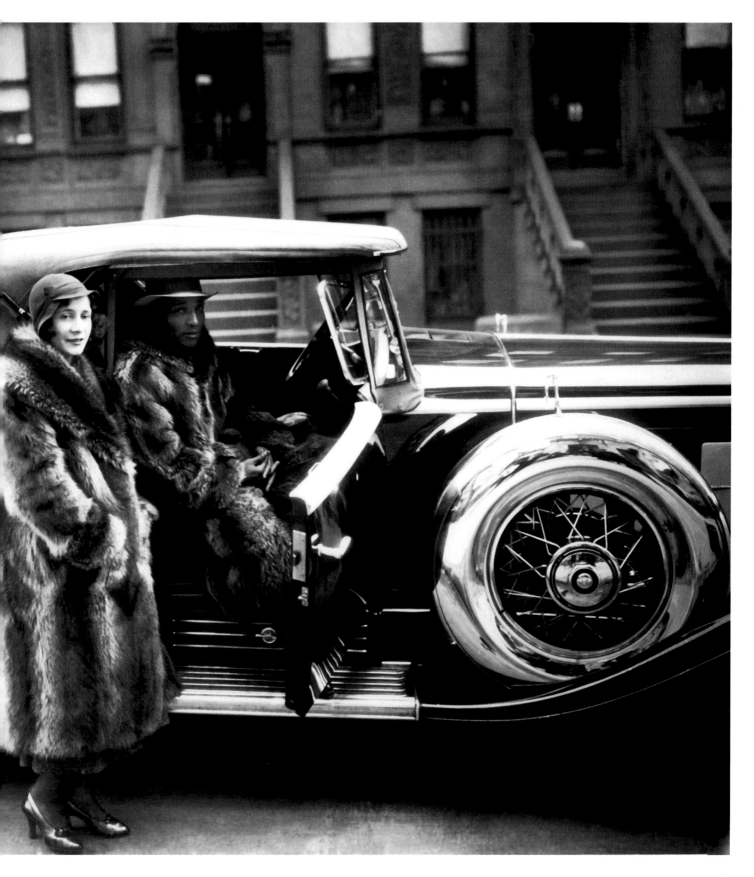

MIGRANT MOTHER | *Dorothea Lange, 1936*

The picture that did more than any other to humanize the cost of the Great Depression almost didn't happen. Driving past the crude "Pea-Pickers Camp" sign in Nipomo, north of Los Angeles, Dorothea Lange kept going for 20 miles. But something nagged at the photographer from the government's Resettlement Administration, and she finally turned around. At the camp, the Hoboken, N.J.–born Lange spotted Frances Owens Thompson and knew she was in the right place. "I saw and approached the hungry and desperate mother in the sparse lean-to tent, as if drawn by a magnet," Lange later wrote. The farm's crop had frozen, and there was no work for the homeless pickers, so the 32-year-old Thompson sold the tires from her car to buy food, which was supplemented with birds killed by the children. Lange, who believed that one could understand others through close study, tightly framed the children and the mother, whose eyes, worn from worry and resignation, look past the camera. Lange took six photos with her 4x5 Graflex camera, later writing, "I knew I had recorded the essence of my assignment." Afterward Lange informed the authorities of the plight of those at the encampment, and they sent 20,000 pounds of food. Of the 160,000 images taken by Lange and other photographers for the Resettlement Administration, *Migrant Mother* has become the most iconic picture of the Depression. Through an intimate portrait of the toll being exacted across the land, Lange gave a face to a suffering nation.

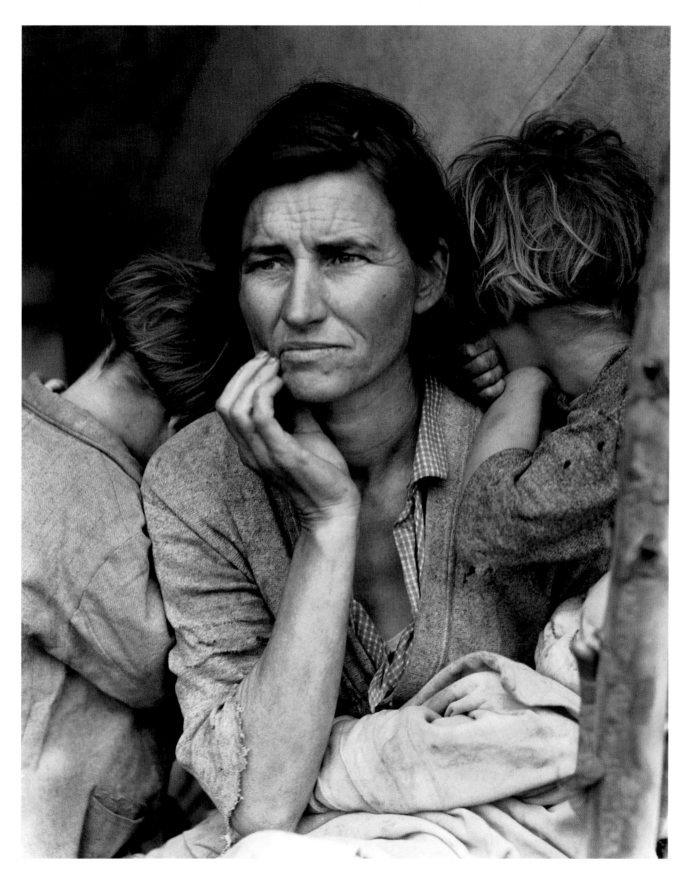

FORT PECK DAM | *Margaret Bourke-White, 1936*

'To see, and to show, is the mission now undertaken by LIFE.' –HENRY R. LUCE

It was to quickly become the most influential news and photography magazine of its time, and LIFE's November 1936 debut issue proudly announced that it would cover stories of enormous scope and complexity in a uniquely visual way. What better person, thought publisher Henry Luce, than his FORTUNE magazine photographer Margaret Bourke-White to shoot LIFE's premier story, on the construction of Montana's Fort Peck Dam? There, on the cover with the castle-like structure and a photo essay inside, Bourke-White used pictures to give a human feel to an article on the world's largest earth-filled dam. She did this by focusing not only on the technical challenges of the massive New Deal project in the Missouri River Basin but also on the Wild West vibe in "the whole ramshackle town," a place "stuffed to the seams with construction men, engineers, welders, quack doctors, barmaids, fancy ladies." Bourke-White's cover became the defining image of the magazine that helped define a style of photojournalism and set the tone for the other great LIFE photographers who followed her. As her colleague Carl Mydans, the great war photojournalist, put it, Bourke-White's influence "was incalculable."

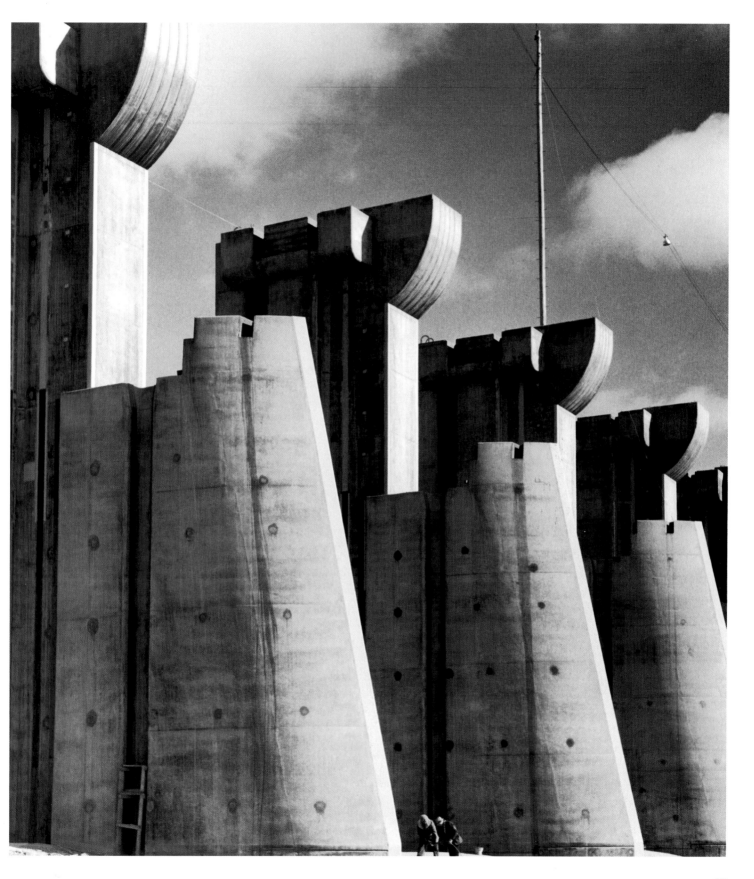

WINSTON CHURCHILL | *Yousuf Karsh, 1941*

'The strength and power of Churchill's face stiffened the resolution of the English people.' –PETER POLLACK, HISTORIAN

Britain stood alone in 1941. By then Poland, France and large parts of Europe had fallen to the Nazi forces, and it was only the tiny nation's pilots, soldiers and sailors, along with those of the Commonwealth, who kept the darkness at bay. Winston Churchill was determined that the light of England would continue to shine. In December 1941, soon after the Japanese attacked Pearl Harbor and America was pulled into the war, Churchill visited Parliament in Ottawa to thank Canada and the Allies for their help. Churchill wasn't aware that Yousuf Karsh had been tasked to take his portrait afterward, and when he came out and saw the Turkish-born Canadian photographer, he demanded to know, "Why was I not told?" Churchill then lit a cigar, puffed at it and said to the photographer, "You may take one." As Karsh prepared, Churchill refused to put down the cigar. So once Karsh made sure all was ready, he walked over to the Prime Minister and said, "Forgive me, sir," and plucked the cigar out of Churchill's mouth. "By the time I got back to my camera, he looked so belligerent, he could have devoured me. It was at that instant that I took the photograph." Ever the diplomat, Churchill then smiled and said, "You may take another one" and shook Karsh's hand, telling him, "You can even make a roaring lion stand still to be photographed."

The result of Karsh's lion taming is one of the most widely reproduced images in history and a watershed in the art of political portraiture. It was Karsh's picture of the bulldoggish Churchill—published first in the American daily *PM* and eventually on the cover of LIFE—that gave modern photographers permission to make honest, even critical portrayals of our leaders.

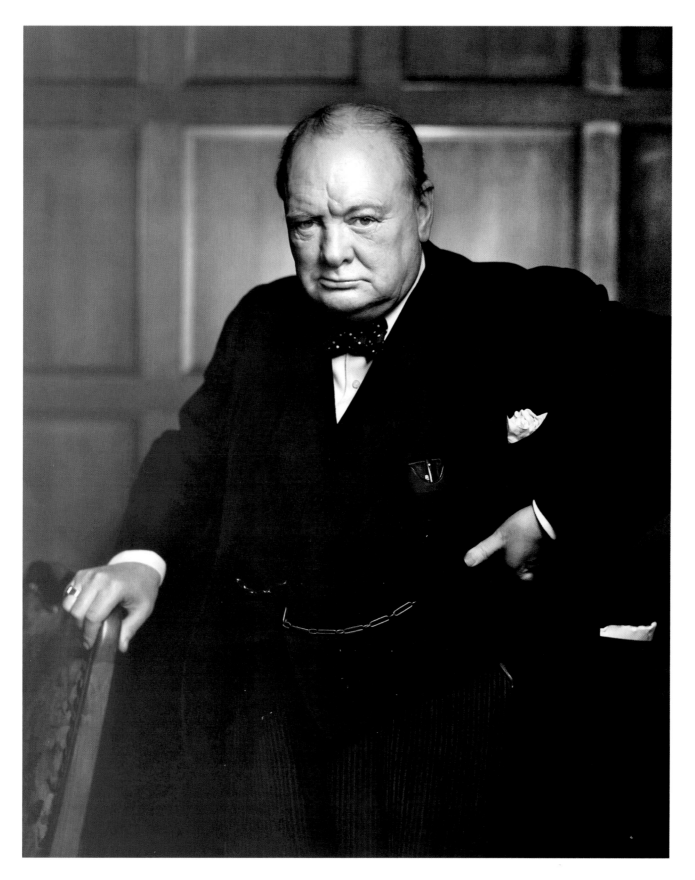

AMERICAN GOTHIC | *Gordon Parks, 1942*

'I didn't care about what anybody else felt. That's what I felt about America and Ella Watson's position inside America.' –GORDON PARKS

As the 15th child of black Kansas sharecroppers, Gordon Parks knew poverty. But he didn't experience virulent racism until he arrived in Washington in 1942 for a fellowship at the Farm Security Administration (FSA). Parks, who would go on to became the first African-American photographer at LIFE, was stunned. "White restaurants made me enter through the back door. White theaters wouldn't even let me in the door," he recalled. Refusing to be cowed, Parks searched out older African Americans to document how they dealt with such daily indignities and came across Ella Watson, who worked in the FSA's building. She told him of her life of struggle, of a father murdered by a lynch mob, of a husband shot to death. He photographed Watson as she went about her day, culminating in his *American Gothic*, a clear parody of Grant Wood's iconic 1930 oil painting. It served as an indictment of the treatment of African Americans by accentuating the inequality in "the land of the free" and came to symbolize life in pre-civil-rights America. "What the camera had to do was expose the evils of racism," Parks later observed, "by showing the people who suffered most under it."

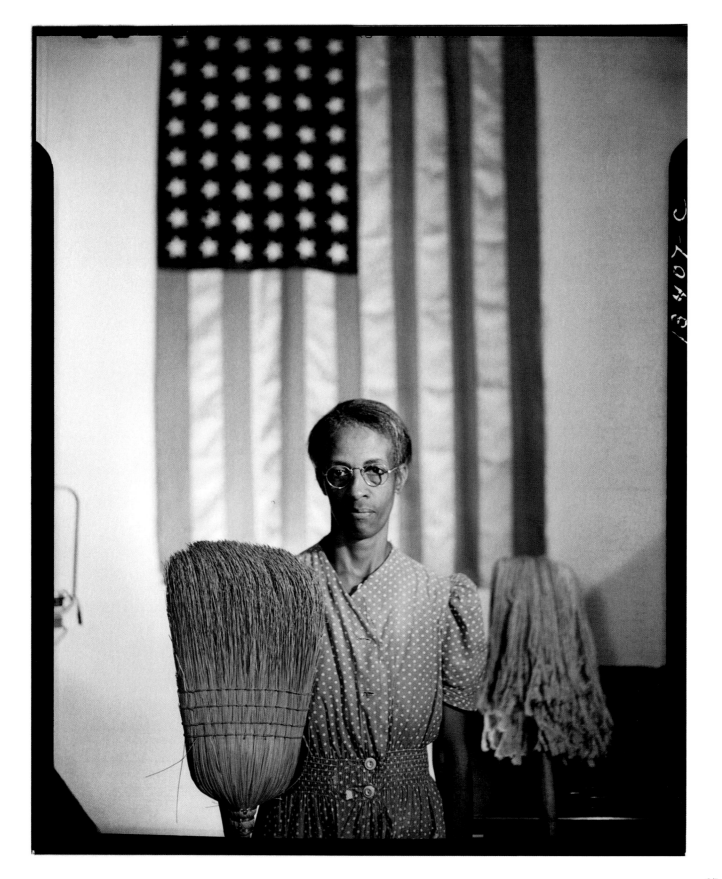

BETTY GRABLE | *Frank Powolny, 1943*

Helen of Troy, the mythic Greek demigod who sparked the Trojan War and "launch'd a thousand ships," had nothing on Betty Grable of St. Louis. For that platinum blond, blue-eyed Hollywood starlet had a set of gams that inspired American soldiers, sailors, airmen and Marines to set forth to save civilization from the Axis powers. And unlike Helen, Betty represented the flesh-and-blood "girl back home," patiently keeping the fires burning. Frank Powolny brought Betty to the troops by accident. A photographer for 20th Century Fox, he was taking publicity pictures of the actress for the 1943 film *Sweet Rosie O'Grady* when she agreed to a "back shot." The studio turned the coy pose into one of the earliest pinups, and soon troops were requesting 50,000 copies every month. The men took Betty wherever they went, tacking her poster to barrack walls, painting her on bomber fuselages and fastening 2-by-3 prints of her next to their hearts. Before Marilyn Monroe, Betty's smile and legs—said to be insured for a million bucks with Lloyd's of London—rallied countless homesick young men in the fight of their lives (including a young Hugh Hefner, who cited her as an inspiration for *Playboy*). "I've got to be an enlisted man's girl," said Grable, who signed hundreds of her pinups each month during the war. "Just like this has got to be an enlisted man's war."

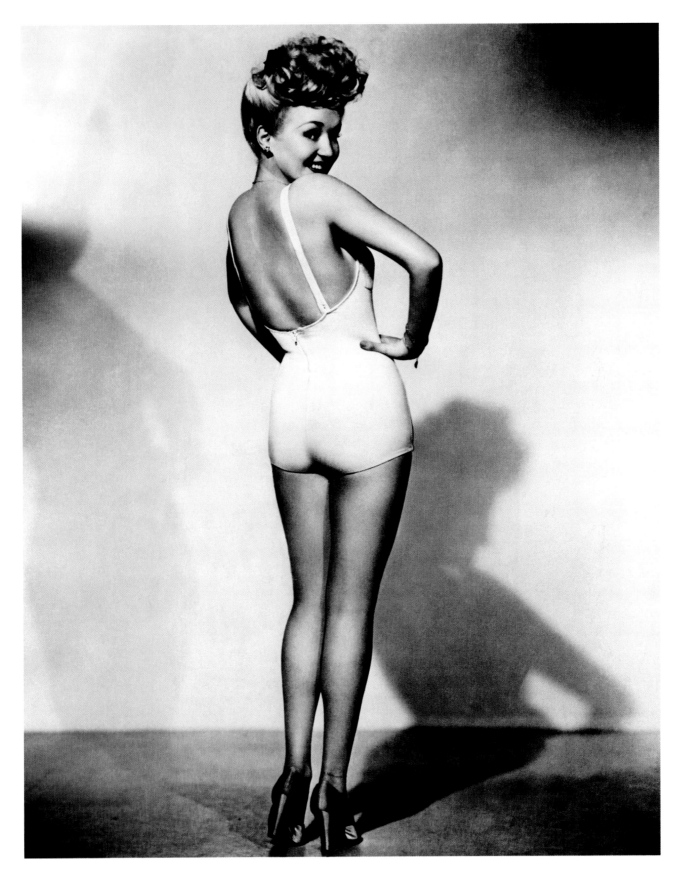

FLAG RAISING ON IWO JIMA
Joe Rosenthal, 1945

'The picture delivered the message that Americans wanted to hear.' –HAL BUELL, AP PHOTO EDITOR

It is but a speck of an island 760 miles south of Tokyo, a volcanic pile that blocked the Allies' march toward Japan. The Americans needed Iwo Jima as an air base, but the Japanese had dug in. U.S. troops landed on February 19, 1945, beginning a month of fighting that claimed the lives of 6,800 Americans and 21,000 Japanese. On the fifth day of battle, the Marines captured Mount Suribachi. An American flag was quickly raised, but a commander called for a bigger one, in part to inspire his men and demoralize his opponents. Associated Press photographer Joe Rosenthal lugged his bulky Speed Graphic camera to the top, and as five Marines and a Navy corpsman prepared to hoist the Stars and Stripes, Rosenthal stepped back to get a better frame—and almost missed the shot. "The sky was overcast," he later wrote of what has become one of the most recognizable images of war. "The wind just whipped the flag out over the heads of the group, and at their feet the disrupted terrain and the broken stalks of the shrubbery exemplified the turbulence of war." Two days later Rosenthal's photo was splashed on front pages across the U.S., where it was quickly embraced as a symbol of unity in the long-fought war. The picture, which earned Rosenthal a Pulitzer Prize, so resonated that it was made into a postage stamp and cast as a 100-ton bronze memorial.

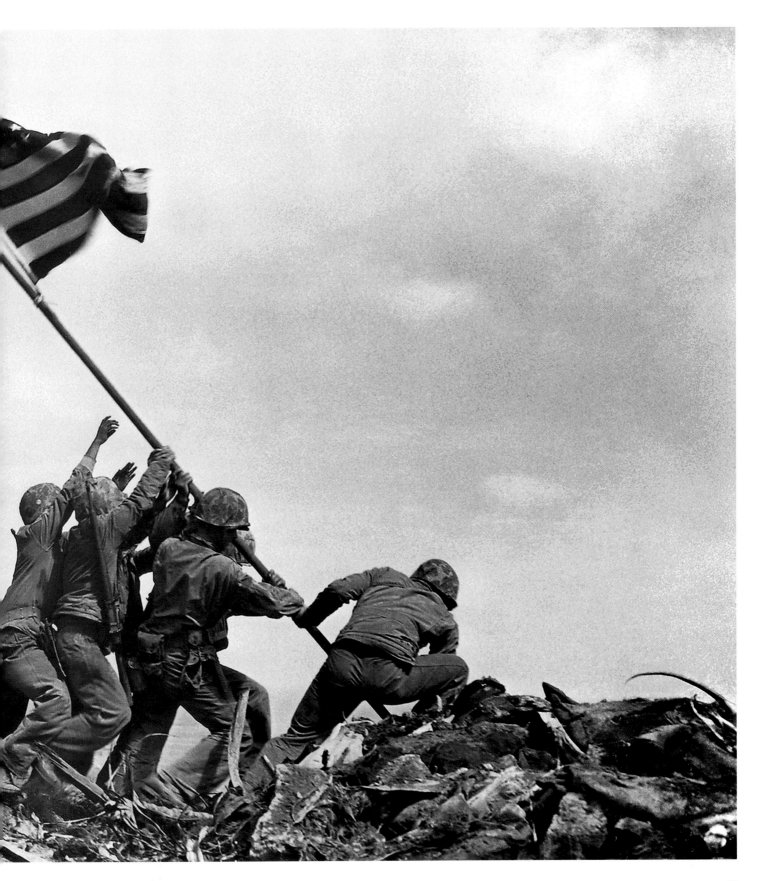

RAISING A FLAG
OVER THE REICHSTAG
Yevgeny Khaldei, 1945

'**Then I found my spot, and I told
the soldier, "Alyosha, climb up there."** '
–YEVGENY KHALDEI

"This is what I was waiting for for 1,400 days," the
Ukrainian-born Yevgeny Khaldei said as he gazed at
the ruins of Berlin on May 2, 1945. After four years
of fighting and photographing across Eastern Europe,
the Red Army soldier arrived in the heart of the Nazis'
homeland armed with his Leica III rangefinder and a
massive Soviet flag that his uncle, a tailor, had fash-
ioned for him from three red tablecloths. Adolf Hitler
had committed suicide two days before, yet the war
still raged as Khaldei made his way to the Reichstag.
There he told three soldiers to join him, and they clam-
bered up broken stairs onto the parliament building's
blood-soaked parapet. Gazing through his camera,
Khaldei knew he had the shot he had hoped for: "I was
euphoric." In printing, Khaldei dramatized the image
by intensifying the smoke and darkening the sky—
even scratching out part of the negative—to craft a
romanticized scene that was part reality, part artifice
and all patriotism. Published in the Russian magazine
Ogonek, the image became an instant propaganda icon.
And no wonder. The flag jutting from the heart of the
enemy exalted the nobility of communism, proclaimed
the Soviets the new overlords and hinted that by low-
ering the curtain of war, Premier Joseph Stalin would
soon hoist a cold new iron one across the land.

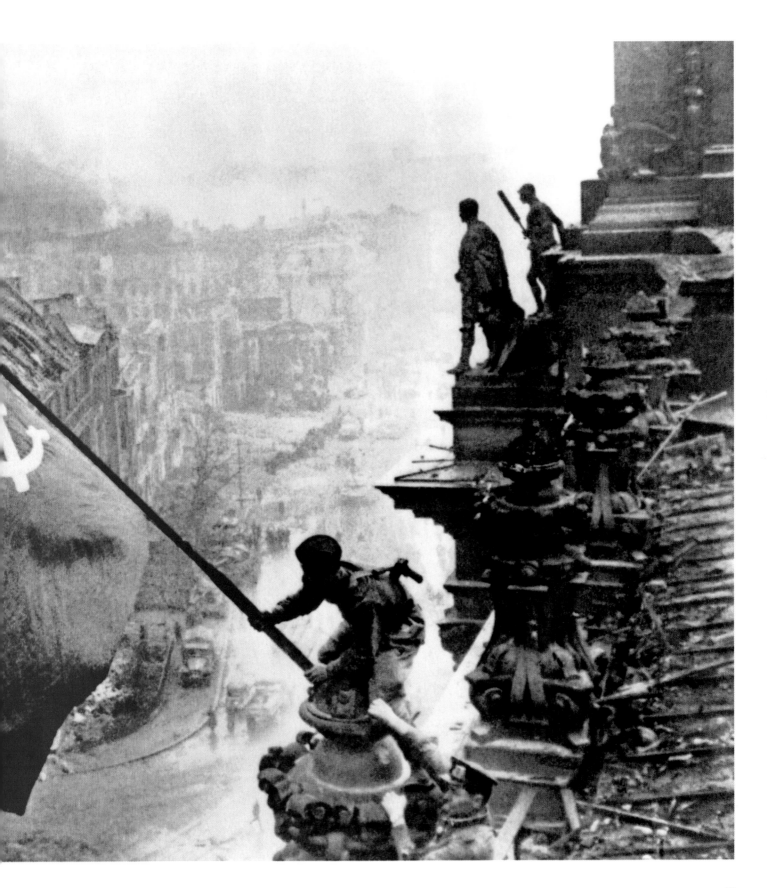

V-J DAY IN TIMES SQUARE | *Alfred Eisenstaedt, 1945*

'Then suddenly, in a flash, I saw something white being grabbed. I turned around and clicked the moment the sailor kissed the nurse.' –ALFRED EISENSTAEDT

At its best, photography captures fleeting snippets that crystallize the hope, anguish, wonder and joy of life. Alfred Eisenstaedt, one of the first four photographers hired by LIFE magazine, made it his mission "to find and catch the storytelling moment." He didn't have to go far for it when World War II ended on August 14, 1945. Taking in the mood on the streets of New York City, Eisenstaedt soon found himself in the joyous tumult of Times Square. As he searched for subjects, a sailor in front of him grabbed hold of a nurse, tilted her back and kissed her. Eisenstaedt's photograph of that passionate swoop distilled the relief and promise of that momentous day in a single moment of unbridled joy (although some argue today that it should be seen as a case of sexual assault). His beautiful image has become the most famous and frequently reproduced picture of the 20th century, and it forms the basis of our collective memory of that transformative moment in world history. "People tell me that when I'm in heaven," Eisenstaedt said, "they will remember this picture."

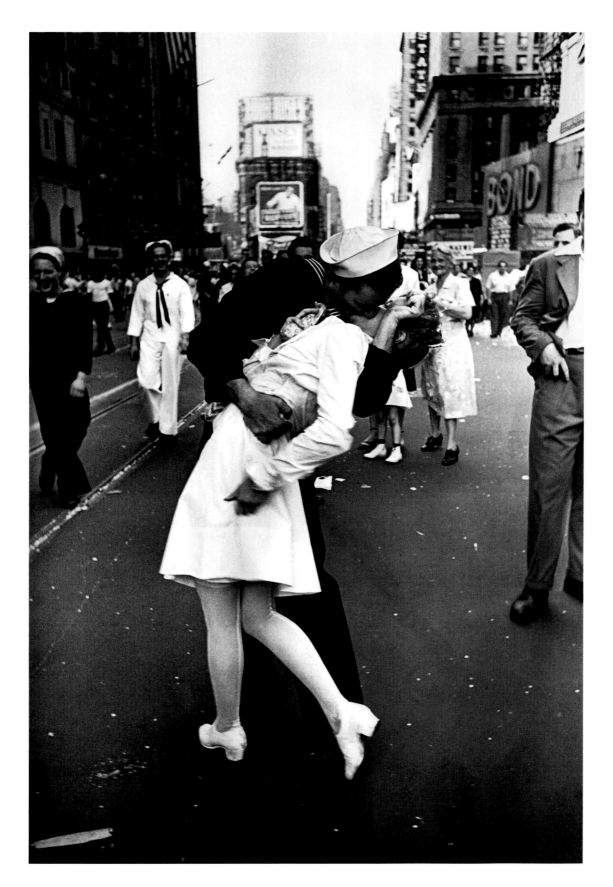

GANDHI AND THE SPINNING WHEEL
Margaret Bourke-White, 1946

'**Nonviolence was Gandhi's creed, and
the spinning wheel was the perfect weapon.**'
–MARGARET BOURKE-WHITE

When the British held Mohandas Gandhi prisoner at Yeravda prison in Pune, India, from 1932 to 1933, the nationalist leader made his own thread with a *charkha*, a portable spinning wheel. The practice evolved from a source of personal comfort during captivity into a touchstone of the campaign for independence, with Gandhi encouraging his countrymen to make their own homespun cloth instead of buying British goods. By the time Margaret Bourke-White came to Gandhi's compound for a LIFE article on India's leaders, spinning was so bound up with Gandhi's identity that his secretary, Pyarelal Nayyar, told Bourke-White that she had to learn the craft before photographing the leader. Bourke-White's picture of Gandhi reading the news alongside his *charkha* never appeared in the article for which it was taken, but less than two years later LIFE featured the photo prominently in a tribute published after Gandhi's assassination. It soon became an indelible image, the slain civil-disobedience crusader with his most potent symbol, and helped solidify the perception of Gandhi outside the subcontinent as a saintly man of peace.

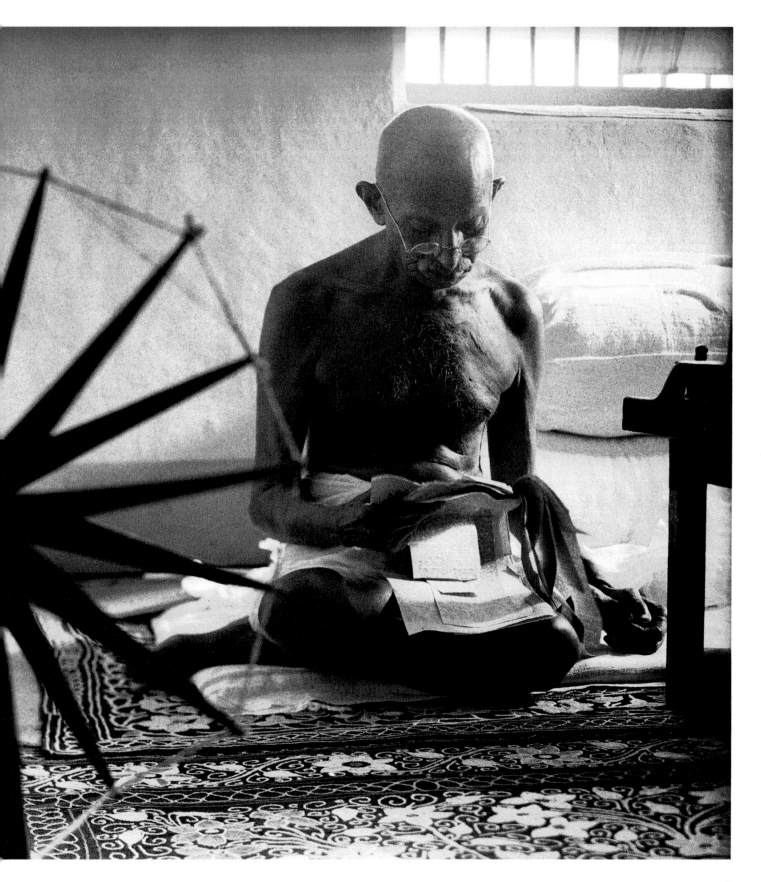

THE BABE BOWS OUT | *Nat Fein, 1948*

'If I didn't know that the Babe's uniform was being retired, it would have never occurred to me to go in the back of him.' –NAT FEIN

He was the greatest ballplayer of them all, the towering Sultan of Swat. But by 1948, Babe Ruth had been out of the game for more than a decade and was struggling with terminal cancer. So when the beloved Bambino stood before a massive crowd on June 13 to help celebrate the silver anniversary of Yankee Stadium—known to all in attendance as the House That Ruth Built—and to retire his No. 3, it was clear this was a final public goodbye.

Nat Fein of the New York *Herald Tribune* was one of dozens of photographers staked out along the first-base line. But as the sound of "Auld Lang Syne" filled the stadium, Fein "got a feeling" and walked behind Ruth, where he saw the proud ballplayer leaning on a bat, his thin legs hinting at the toll the disease had wreaked on his body. From that spot, Fein captured the almost mythic role that athletes play in our lives—even at their weakest, they loom large. Two months later Ruth was dead, and Fein went on to win a Pulitzer Prize for his picture. It was the first one awarded to a sports photographer, giving critical legitimacy to a form other than hard-news reportage.

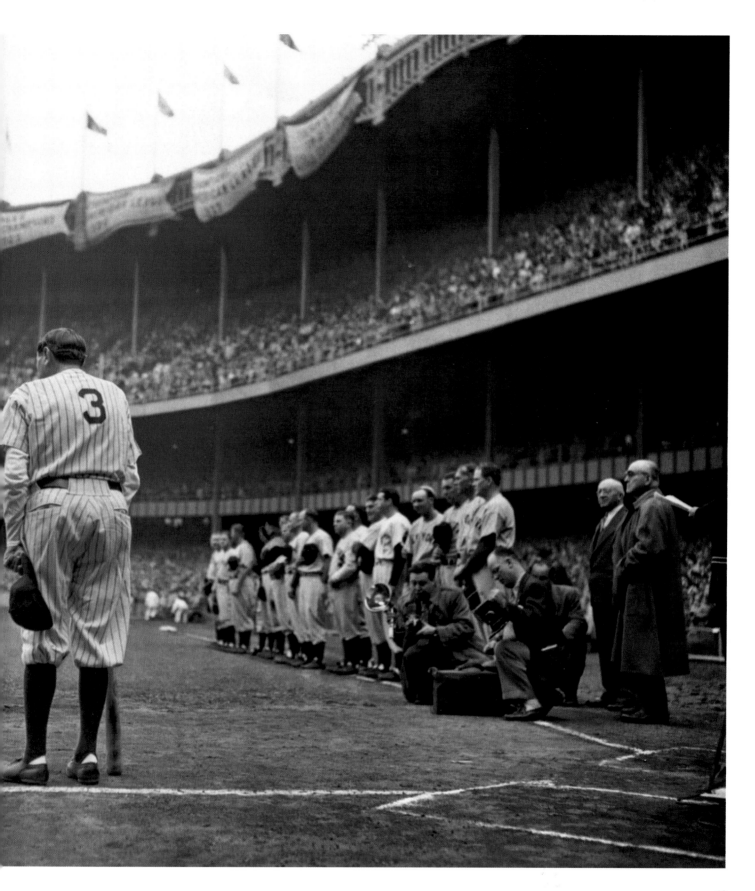

COUNTRY DOCTOR | *W. Eugene Smith, 1948*

'I spent four weeks living with him. I made very few
pictures at first. I mainly tried to learn what made the doctor tick.'
–W. EUGENE SMITH

Although lauded for his war photography, W. Eugene Smith left his most enduring
mark with a series of midcentury photo essays for LIFE magazine. The Wichita, Kans.–
born photographer spent weeks immersing himself in his subjects' lives, from a South
Carolina nurse-midwife to the residents of a Spanish village. His aim was to see the
world from the perspective of his subjects—and to compel viewers to do the same. "I do
not seek to possess my subject but rather to give myself to it," he said of his approach.
Nowhere was this clearer than in his landmark photo essay "Country Doctor." Smith
spent 23 days with Dr. Ernest Ceriani in and around Kremmling, Colo., trailing the
hardy physician through the ranching community of 2,000 souls beneath the Rocky
Mountains. He watched him tend to infants, deliver injections in the backseats of cars,
develop his own x-rays, treat a man with a heart attack and then phone a priest to give
last rites. By digging so deeply into his assignment, Smith created a singular, starkly
intimate glimpse into the life of a remarkable man. It became not only the most influ-
ential photo essay in history but the aspirational template for the form.

CAMELOT | *Hy Peskin, 1953*

'He became emblematic of a new breed of celebrity politician, as notable for his good looks, infectious smile, charm and wit as for his thoughtful pronouncements.' –ROBERT DALLEK, HISTORIAN

Before they could become American royalty, America needed to meet John Fitzgerald Kennedy and Jacqueline Lee Bouvier. That introduction came when Hy Peskin photographed the handsome politician on the make and his radiant fiancée over a summer weekend in 1953. Peskin, a renowned sports photographer, headed to Hyannis Port, Mass., at the invitation of family patriarch Joseph Kennedy. The ambassador, eager for his son to take the stage as a national figure, thought a feature in the pages of LIFE would foster a fascination with John, his pretty girlfriend and one of America's wealthiest families. That it did. Peskin put together a somewhat contrived "behind the scenes" series titled "Senator Kennedy Goes A-Courting." While Jackie bristled at the intrusion—John's mother Rose even told her how to pose—she went along with the staging, and readers got to observe Jackie mussing the hair of "the handsomest young member of the U.S. Senate," playing football and softball with her future in-laws, and sailing aboard John's boat, *Victura*. "They just shoved me into that boat long enough to take the picture," she later confided to a friend.

It was pitch-perfect brand making, with Kennedy on the cover of the world's most widely read photo magazine, cast as a self-assured playboy prepared to say goodbye to bachelorhood. A few months later LIFE would cover the couple's wedding, and by then America was captivated. In the staid age of Dwight David Eisenhower and Richard Milhous Nixon, Peskin unveiled the face of Camelot, one that changed America's perception of politics and politicians, and set John and Jackie off on becoming the most recognizable couple on the planet.

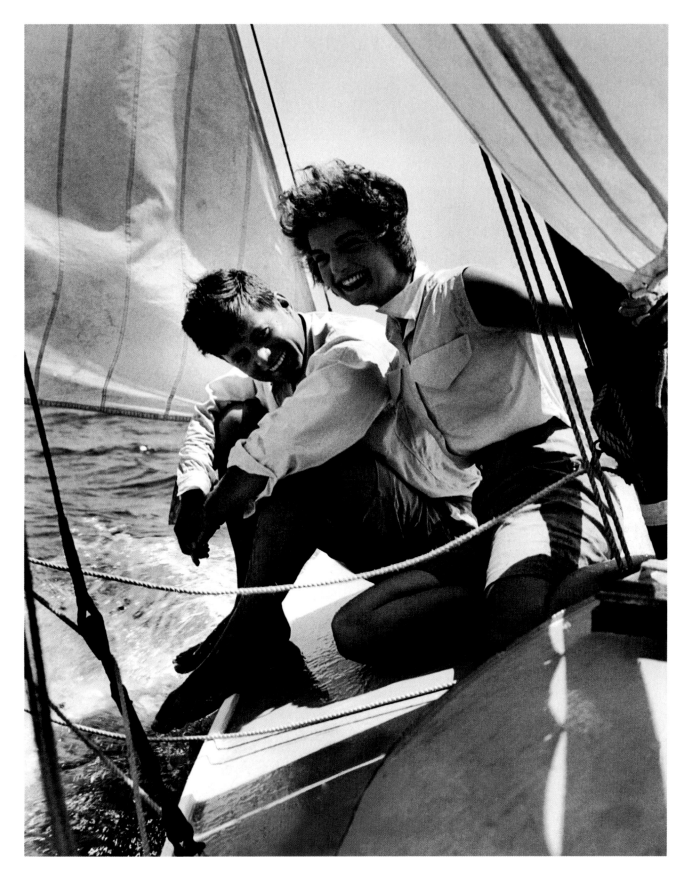

DOVIMA WITH ELEPHANTS | *Richard Avedon, Cirque d'Hiver, Paris, August 1955*

**'I saw the elephants under an enormous skylight and in a second I knew
that I then had to find the right dress, and I knew that there was potential here
for a kind of dream image.'** –RICHARD AVEDON

When Richard Avedon photographed Dovima at a Paris circus in 1955 for *Harper's Bazaar*, both were already prominent in their fields. She was one of the world's most famous models, and he was one of the most famous fashion photographers. It makes sense, then, that *Dovima With Elephants* is one of the most famous fashion photographs of all time. But its enduring influence lies as much in what it captures as in the two people who made it. Dovima was one of the last great models of the sophisticated mold, when haute couture was a relatively cloistered and elite world. After the 1950s, models began to gravitate toward girl-next-door looks instead of the old generation's unattainable beauty, helping turn high fashion into entertainment. *Dovima With Elephants* distills that shift by juxtaposing the spectacle and strength of the elephants with Dovima's beauty—and the delicacy of her gown, which was the first Dior dress designed by Yves Saint Laurent. The picture also brings movement to a medium that was previously typified by stillness. Models had long been mannequins, meant to stand still while the clothes got all the attention. Avedon saw what was wrong with that equation: clothes didn't just make the man; the man also made the clothes. And by moving models out of the studio and placing them against exciting backdrops, he helped blur the line between commercial fashion photography and art. In that way, *Dovima With Elephants* captures a turning point in our broader culture: the last old-style model, setting fashion off on its new path.

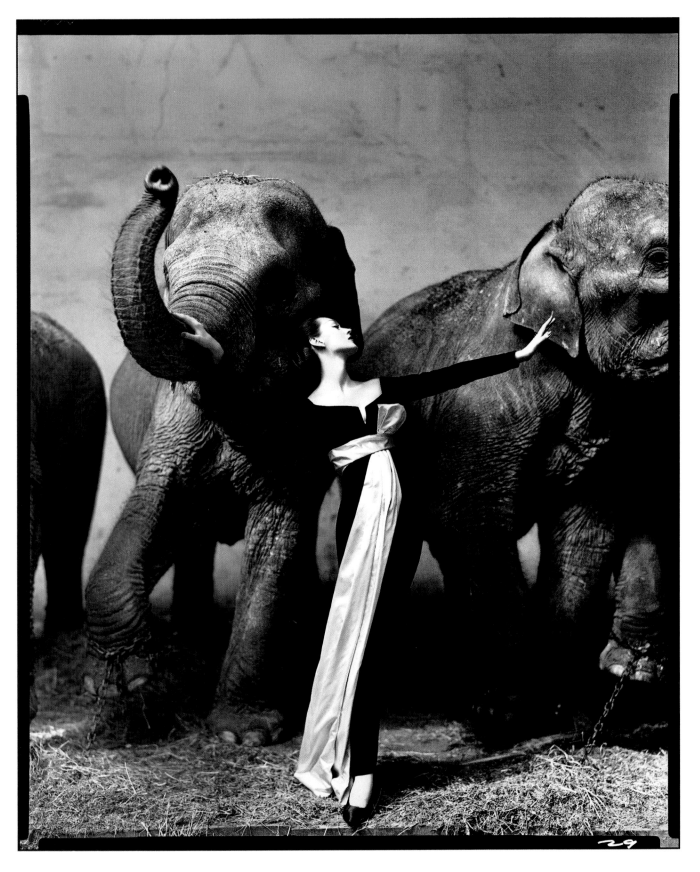

GUERRILLERO HEROICO | *Alberto Korda, 1960*

'It seems that there is not one socially conscious young person in the world who does not believe that this man, Che, represents what they'd like to become.' –ALBERTO KORDA

The day before Alberto Korda took his iconic photograph of Cuban revolutionary Che Guevara, a ship had exploded in Havana Harbor, killing the crew and dozens of dockworkers. Covering the funeral for the newspaper *Revolución*, Korda focused on Fidel Castro, who in a fiery oration accused the U.S. of causing the explosion. The two frames he shot of Castro's young ally were a seeming afterthought, and they went unpublished by the newspaper. But after Guevara was killed leading a guerrilla movement in Bolivia nearly seven years later, the Cuban regime embraced him as a martyr for the movement, and Korda's image of the beret-clad revolutionary soon became its most enduring symbol. In short order, *Guerrillero Heroico* was appropriated by artists, causes and admen around the world, appearing on everything from protest art to underwear to soft drinks. It has become the cultural shorthand for rebellion and one of the most recognizable and reproduced images of all time, with its influence long since transcending its steely-eyed subject.

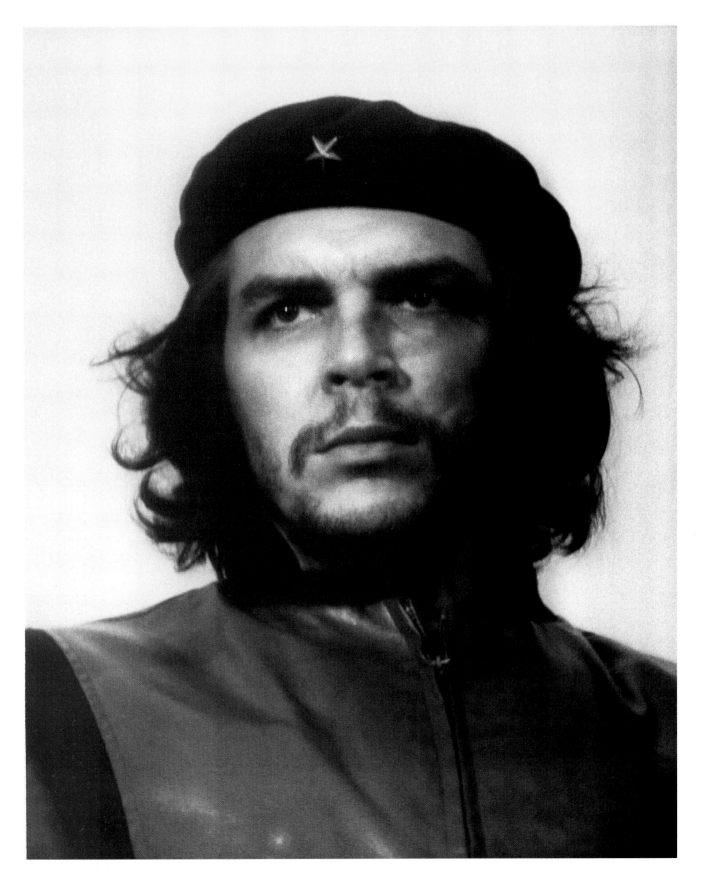

CASE STUDY HOUSE NO. 22, LOS ANGELES | *Julius Shulman, 1960*

'This was the time when we were building rockets to go to the moon and we were planning on colonizing Mars, and this sort of popular zeitgeist is caught perfectly in that picture.' –TOM FORD, DESIGNER

For decades, the California Dream meant the chance to own a stucco home on a sliver of paradise. The point was the yard with the palm trees, not the contour of the walls. Julius Shulman helped change all that. In May 1960, the Brooklyn-born photographer headed to architect Pierre Koenig's Stahl House, a glass-enclosed Hollywood Hills home with a breathtaking view of Los Angeles—one of 36 Case Study Houses that were part of an architectural experiment extolling the virtues of modernist theory and industrial materials. Shulman photographed most of the houses in the project, helping demystify modernism by highlighting its graceful simplicity and humanizing its angular edges. But none of his other pictures was more influential than the one he took of Case Study House No. 22. To show the essence of this air-breaking cantilevered building, Shulman set two glamorous women in cocktail dresses inside the house, where they appear to be floating above a mythic, twinkling city. The photo, which he called "one of my masterpieces," is the most successful real estate image ever taken. It perfected the art of aspirational staging, turning a house into the embodiment of the Good Life, of stardusted Hollywood, of California as the Promised Land. And, thanks to Shulman, that dream now includes a glass box in the sky.

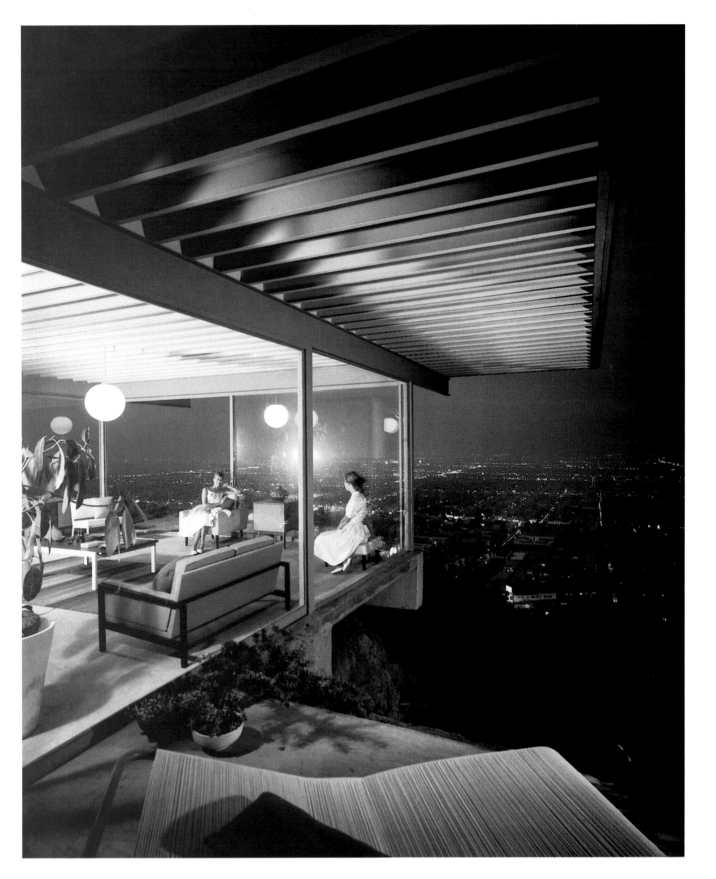

NUIT DE NOËL (HAPPY CLUB) | *Malick Sidibé, 1963*

**'Youth is about childlike games. Those moments which
tell you there is no suffering.'** –MALICK SIDIBÉ

Malian photographer Malick Sidibé's life followed the trajectory of his nation. He started out herding his family's goats, then trained in jewelry making, painting and photography. As French colonial rule ended in 1960, he captured the subtle and profound changes reshaping his nation. Nicknamed the Eye of Bamako, Sidibé took thousands of photos that became a real-time chronicle of the euphoric zeitgeist gripping the capital, a document of a fleeting moment. "Everyone had to have the latest Paris style," he observed of young people wearing flashy clothes, straddling Vespas and nuzzling in public as they embraced a world without shackles. On Christmas Eve in 1963, Sidibé happened on a young couple at a club, lost in each other's eyes. What Sidibé called his "talent to observe" allowed him to capture their quiet intimacy, heads brushing as they grace an empty dance floor. "We were entering a new era, and people wanted to dance," Sidibé said. "Music freed us. Suddenly, young men could get close to young women, hold them in their hands. Before, it was not allowed. And everyone wanted to be photographed dancing up close."

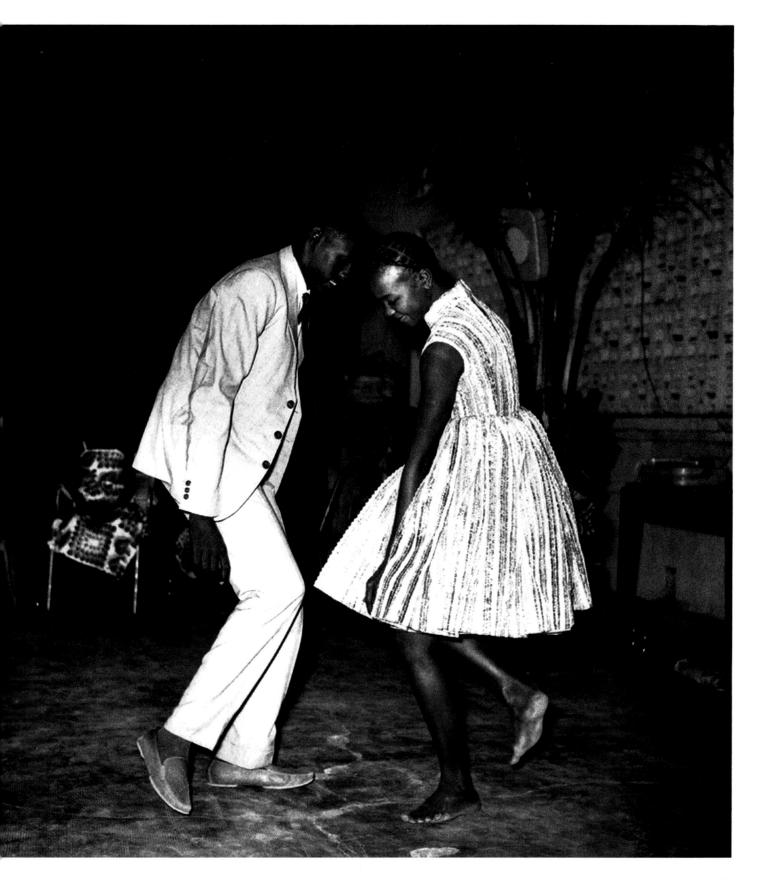

THE PILLOW FIGHT | *Harry Benson, 1964*

'The Beatles will never have a pillow fight again, and I couldn't repeat that picture again.' –HARRY BENSON

Harry Benson didn't want to meet the Beatles. The Glasgow-born photographer had plans to cover a news story in Africa when he was assigned to photograph the musicians in Paris. "I took myself for a serious journalist and I didn't want to cover a rock 'n' roll story," he scoffed. But once he met the boys from Liverpool and heard them play, Benson had no desire to leave. "I thought, 'God, I'm on the right story.' " The Beatles were on the cusp of greatness, and Benson was in the middle of it. His pillow-fight photo, taken in the swanky George V Hotel the night the band found out "I Want to Hold Your Hand" hit No. 1 in the U.S., freezes John, Paul, George and Ringo in an exuberant cascade of boyish talent—and perhaps their last moment of unbridled innocence. It captures the sheer joy, happiness and optimism that would be embraced as Beatlemania and that helped lift America's morale just 11 weeks after John F. Kennedy's assassination. The following month, Benson accompanied the Fab Four as they flew to New York City to appear on *The Ed Sullivan Show,* kick-starting the British Invasion. The trip led to decades of collaboration with the group and, as Benson later recalled, "I was so close to not being there."

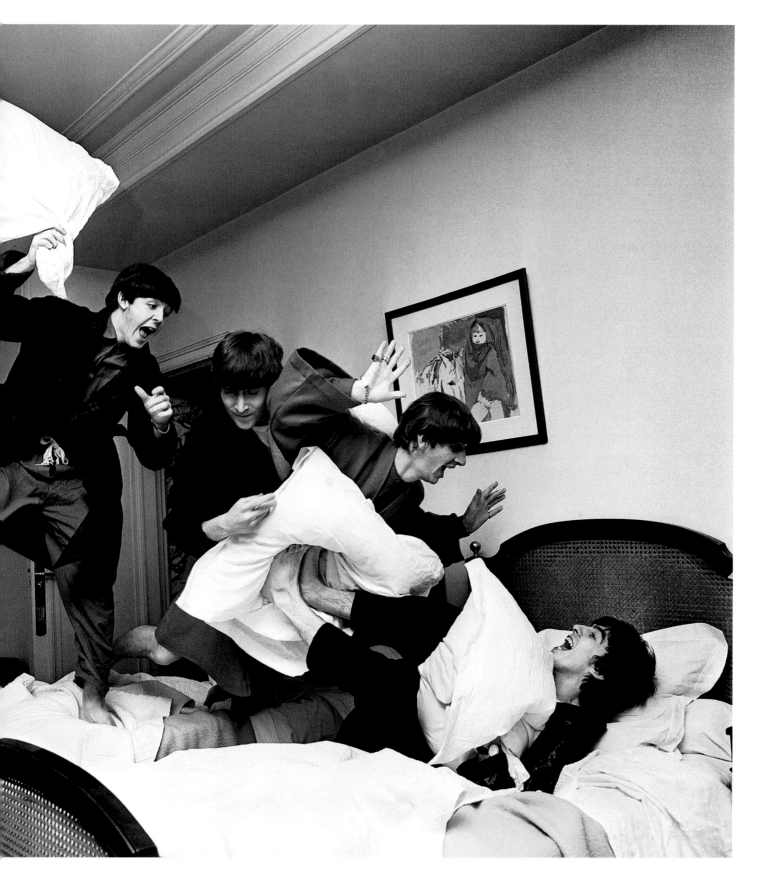

MUHAMMAD ALI VS. SONNY LISTON | *Neil Leifer, 1965*

'As Ali got older, people wanted to remember him at his absolute best. People wanted to remember him that way.' –NEIL LEIFER

So much of great photography is being in the right spot at the right moment. That was what it was like for SPORTS ILLUSTRATED photographer Neil Leifer when he shot perhaps the greatest sports photo of the century. "I was obviously in the right seat, but what matters is I didn't miss," he later said. Leifer had taken that ringside spot in Lewiston, Maine, on May 25, 1965, as 23-year-old heavyweight boxing champion Muhammad Ali squared off against 34-year-old Sonny Liston, the man he'd snatched the title from the previous year. One minute and 44 seconds into the first round, Ali's right fist connected with Liston's chin and Liston went down. Leifer snapped the photo of the champ towering over his vanquished opponent and taunting him, "Get up and fight, sucker!" Powerful overhead lights and thick clouds of cigar smoke had turned the ring into the perfect studio, and Leifer took full advantage. His perfectly composed image captures Ali radiating the strength and poetic brashness that made him the nation's most beloved and reviled athlete, at a moment when sports, politics and popular culture were being squarely battered in the tumult of the '60s.

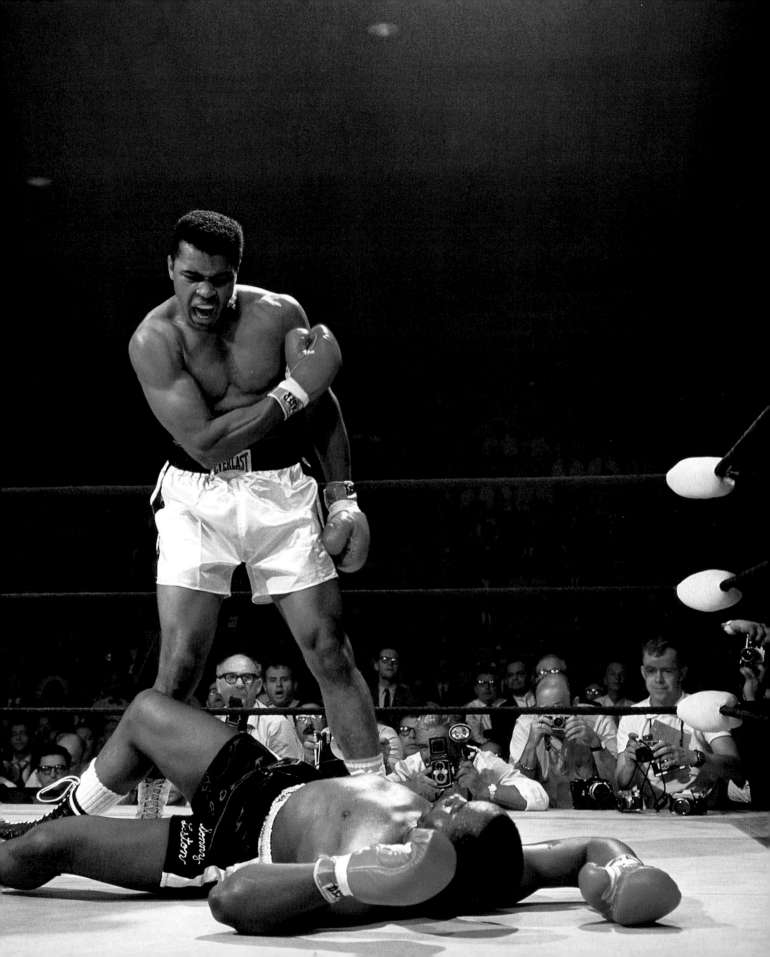

CHAIRMAN MAO SWIMS IN THE YANGTZE | *Unknown, 1966*

'The guerrilla must move amongst the people as a fish swims in the sea.' –CHAIRMAN MAO ZEDONG

After decades leading the Chinese Communist Party and then his nation, Mao Zedong began to worry about how he would be remembered. The 72-year-old Chairman feared too that his legacy would be undermined by the stirrings of a counterrevolution. And so in July 1966, with an eye toward securing his grip on power, Mao took a dip in the Yangtze River to show the world that he was still in robust health. It was a propaganda coup. The image of that swim, one of the few widely circulated photos of the leader, did just what Mao hoped. Back in Beijing, Mao launched his Great Proletarian Cultural Revolution, rallying the masses to purge his rivals. His grip on power was tighter than ever. Mao enlisted the nation's young people and implored these rabid Red Guards to "dare to be violent." Insanity quickly descended on the land of 750 million, as troops clutching the Chairman's Little Red Book smashed relics and temples and punished perceived traitors. When the Cultural Revolution finally petered out a decade later, more than a million people had perished.

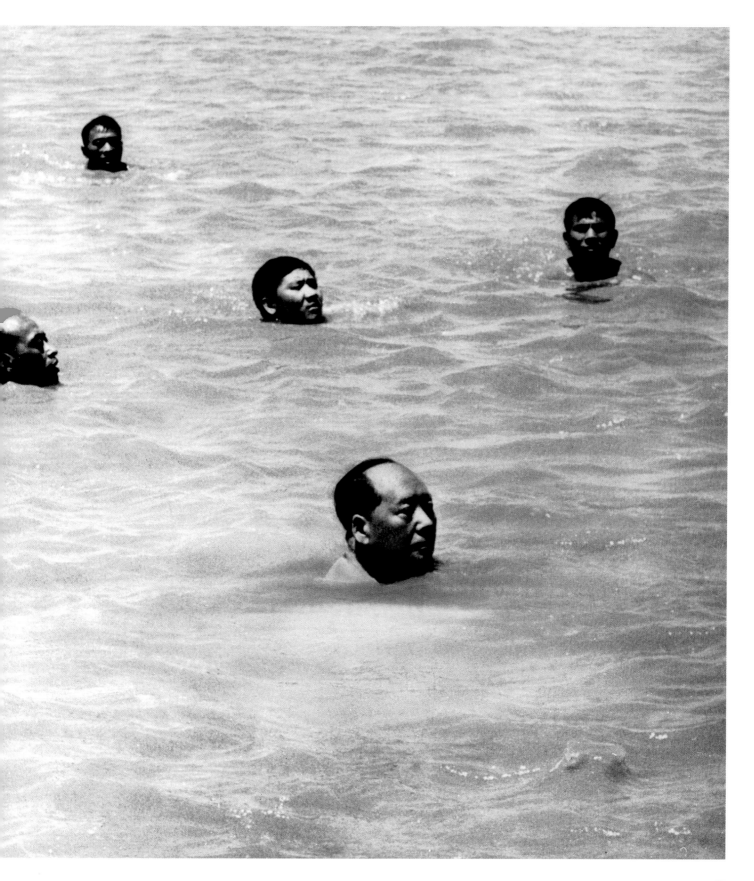

BLACK POWER SALUTE | *John Dominis, 1968*

'We were trying to wake the country up and wake the world up too.' –JOHN CARLOS

The Olympics are intended to be a celebration of global unity. But when the American sprinters Tommie Smith and John Carlos ascended the medal stand at the 1968 Games in Mexico City, they were determined to shatter the illusion that all was right in the world. Just before "The Star-Spangled Banner" began to play, Smith, the gold medalist, and Carlos, the bronze winner, bowed their heads and raised black-gloved fists in the air. Their message could not have been clearer: Before we salute America, America must treat blacks as equal. "We knew that what we were going to do was far greater than any athletic feat," Carlos later said. John Dominis, a quick-fingered LIFE photographer known for capturing unexpected moments, shot a close-up that revealed another layer: Smith in black socks, his running shoes off, in a gesture meant to symbolize black poverty. Published in LIFE, Dominis' image turned the somber protest into an iconic emblem of the turbulent 1960s.

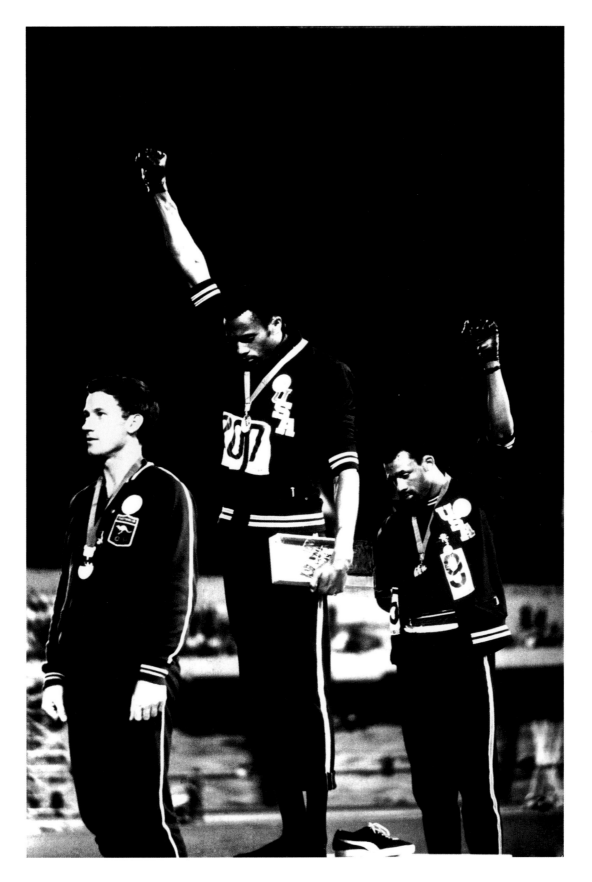

ALBINO BOY, BIAFRA | *Don McCullin, 1969*

'This is one of the most obscene photographs I've ever taken.' –DON MCCULLIN

Few remember Biafra, the tiny western African nation that split off from southern Nigeria in 1967 and was retaken less than three years later. Much of the world learned of the enormity of that brief struggle through images of the mass starvation and disease that took the lives of possibly millions. None proved as powerful as British war photographer Don McCullin's picture of a 9-year-old albino child. "To be a starving Biafran orphan was to be in a most pitiable situation, but to be a starving albino Biafran was to be in a position beyond description," McCullin wrote. "Dying of starvation, he was still among his peers an object of ostracism, ridicule and insult." This photo profoundly influenced public opinion, pressured governments to take action, and led to massive airlifts of food, medicine and weapons. McCullin hoped that such stark images would be able to "break the hearts and spirits of secure people." While public attention eventually shifted, McCullin's work left a lasting legacy: he and other witnesses of the conflict inspired the launch of Doctors Without Borders, which delivers emergency medical support to those suffering from war, epidemics and disasters.

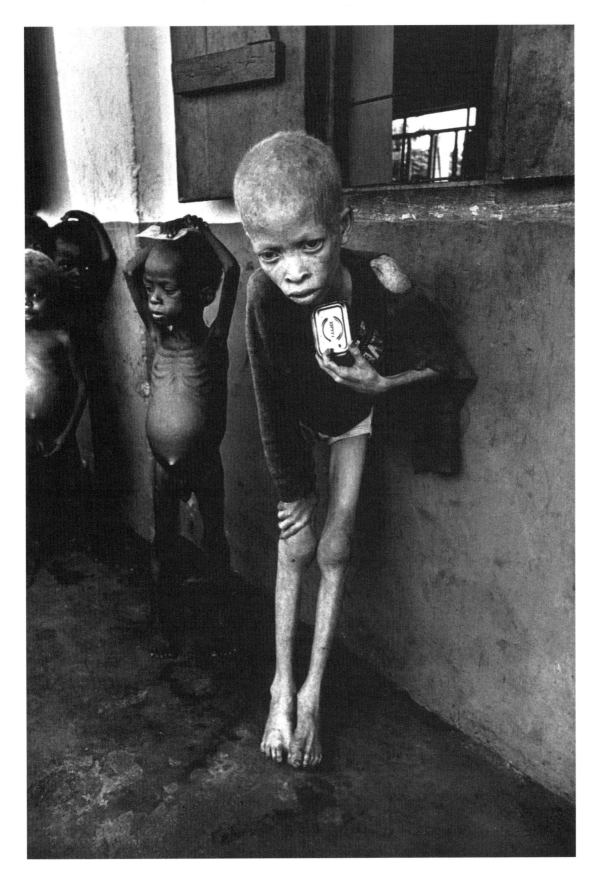

WINDBLOWN JACKIE | *Ron Galella, 1971*

'On the corner, I did a brilliant thing. I took a taxi because you have to hide to get the off-guard picture.' –RON GALELLA

People simply could not get enough of Jacqueline Kennedy Onassis, the beautiful young widow of the slain President who married a fabulously wealthy Greek shipping tycoon. She was a public figure with a tightly guarded private life, which made her a prime target for the photographers who followed wherever she went. And none was as devoted to capturing the former First Lady as Ron Galella. One of the original freewheeling celebrity shooters, Galella created the model for today's paparazzi with a follow-and-ambush style that ensnared everyone from Michael Jackson and Sophia Loren to Marlon Brando, who so resented Galella's attention that he knocked out five of the photographer's teeth. But Galella's favorite subject was Jackie O., whom he shot to the point of obsession. It was Galella's relentless fixation that led him to hop in a taxi and trail Onassis after he spotted her on New York City's Upper East Side in October 1971. The driver honked his horn, and Galella clicked his shutter just as Onassis turned to look in his direction. "I don't think she knew it was me," he recalled. "That's why she smiled a little." The picture, which Galella proudly called "my Mona Lisa," exudes the unguarded spontaneity that marks a great celebrity photo. "It was the iconic photograph of the American celebrity aristocracy, and it created a genre," says the writer Michael Gross. The image also tested the blurry line between newsgathering and a public figure's personal rights. Jackie, who resented the constant attention, twice dragged Galella to court and eventually got him banned from photographing her family. No shortage of others followed in his wake.

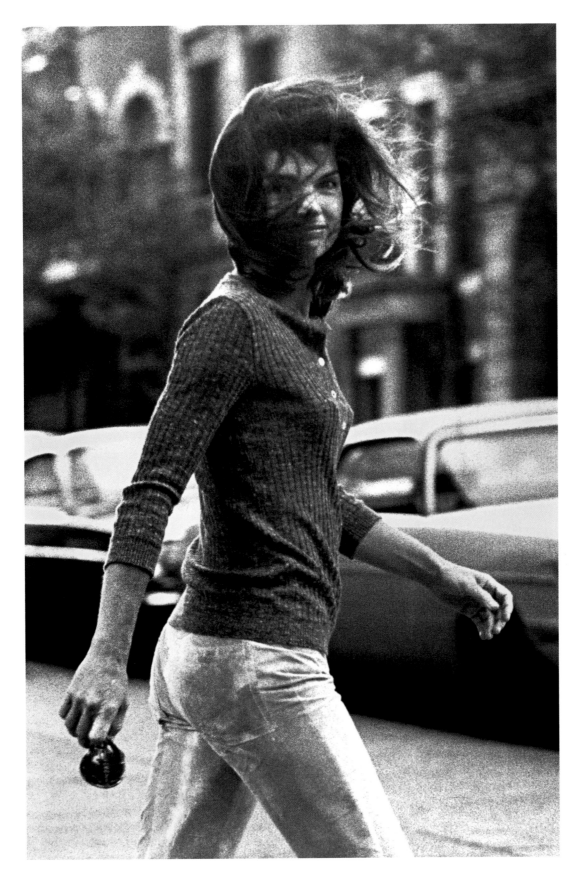

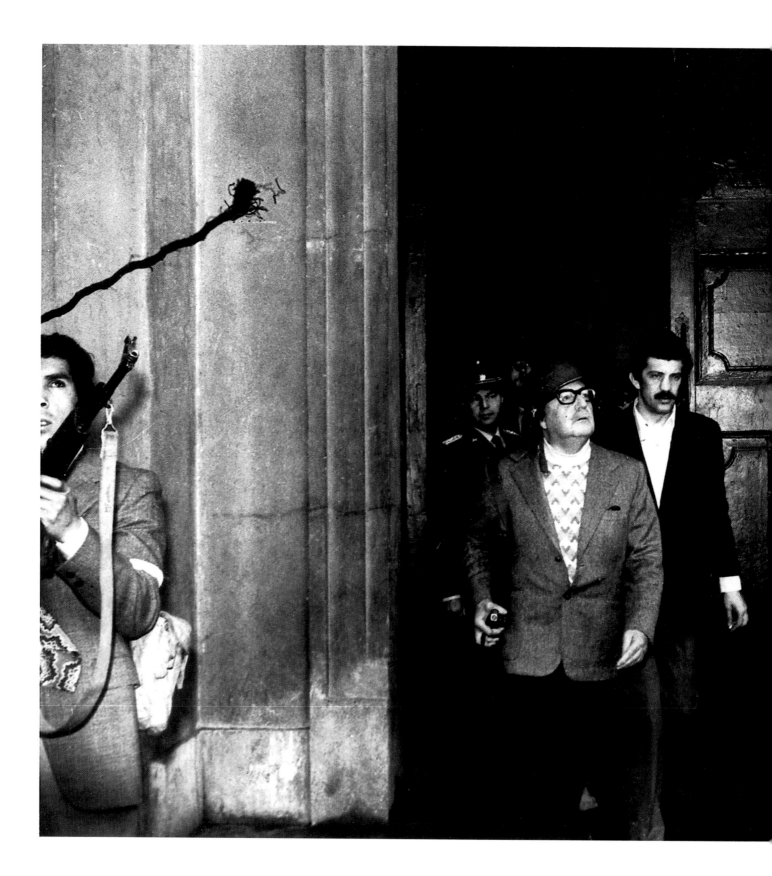

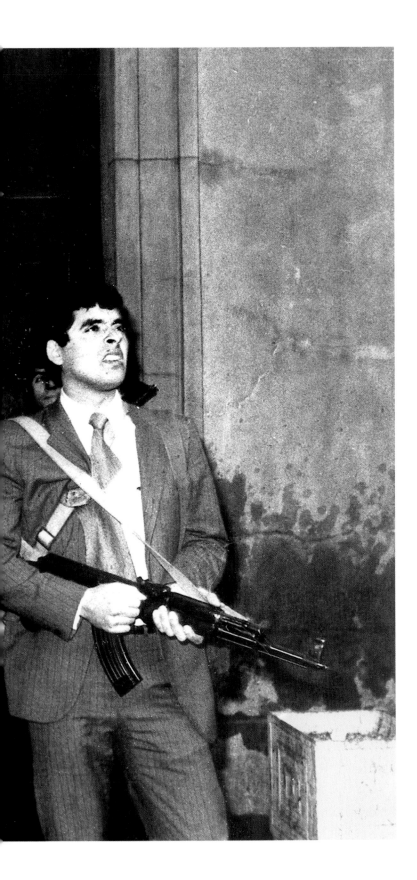

ALLENDE'S LAST STAND
Luis Orlando Lagos, 1973

'With my life I will pay for defending the
principles dear to our nation.'
–SALVADOR ALLENDE

Salvador Allende was the first democratically elected
Marxist head of state, and he assumed the presidency of
Chile in 1970 with a mandate to transform the country.
He nationalized U.S.-owned companies, turned estates
into cooperatives, froze prices, increased wages and
churned out money to bankroll the changes. But the
economy faltered, inflation soared, and unrest grew. In
late August 1973, Allende appointed Augusto Pinochet
as commander of the army. Eighteen days later, the
conservative general orchestrated a coup. Allende re-
fused to leave. Armed with an AK-47 and protected
only by loyal guards at his side, he broadcast his final
address on the radio, the sound of gunfire audible in
the background. As Santiago's presidential palace was
bombarded, Luis Orlando Lagos, Allende's official pho-
tographer, captured one of his final moments. Not long
after, Allende committed suicide—though for decades
many believed he was killed by the advancing troops.
Fearing for his own life, Lagos fled. During Pinochet's
nearly 17-year rule, 40,000 Chileans were interrogat-
ed, tortured, killed or disappeared. Lagos' picture ap-
peared anonymously. It won the 1973 World Press Pho-
to of the Year award and became revered as an image
that immortalized Allende as a hero who gladly chose
death over dishonor. It was only after Lagos' death in
2007 that people learned the photographer's identity.

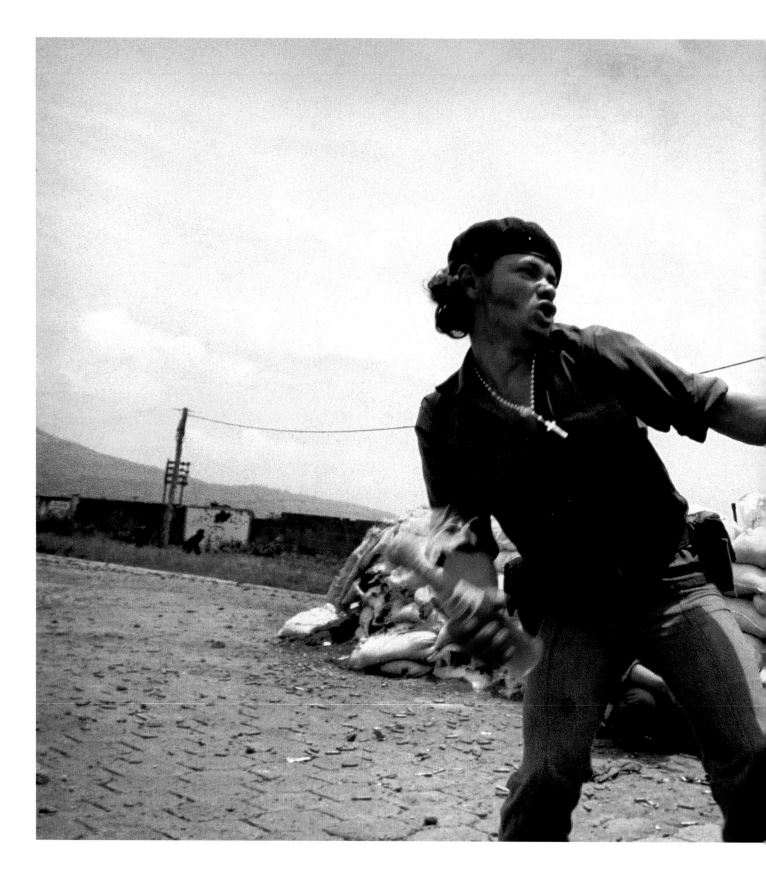

MOLOTOV MAN | *Susan Meiselas, 1979*

'*Molotov Man* kept appearing and
reappearing, used by different players for
different purposes.' –SUSAN MEISELAS

Susan Meiselas traveled to Nicaragua in the late 1970s
as a young photographer with an anthropologist's
eye, keen to make sense of the struggle between the
long-standing Somoza dictatorship and the socialist
Sandinistas fighting to overthrow it. For six weeks she
roamed the country, documenting a nation of grind-
ing poverty, stunning natural beauty and wrenching
inequality. Meiselas' work was sympathetic to the
Sandinista cause, and she gained the trust of the rev-
olutionaries as they slowly prevailed in the fight. On
the day before President Anastasio Somoza Debayle
fled, Meiselas photographed Pablo de Jesus "Bareta"
Araúz lobbing a Molotov cocktail at one of the last
national guard fortresses. After the Sandinistas took
power, the image became the defining symbol of the
revolution—a reviled dictator toppled by a ragtag
army of denim-clad fighters wielding makeshift weap-
ons. Eagerly disseminated by the Sandinistas, *Molotov
Man* soon became ubiquitous throughout Nicaragua,
appearing on matchbooks, T-shirts, billboards and
brochures. It later became a flash point in the debate
over artistic appropriation when the painter Joy Gar-
nett used it as the basis of her 2003 painting *Molotov.*

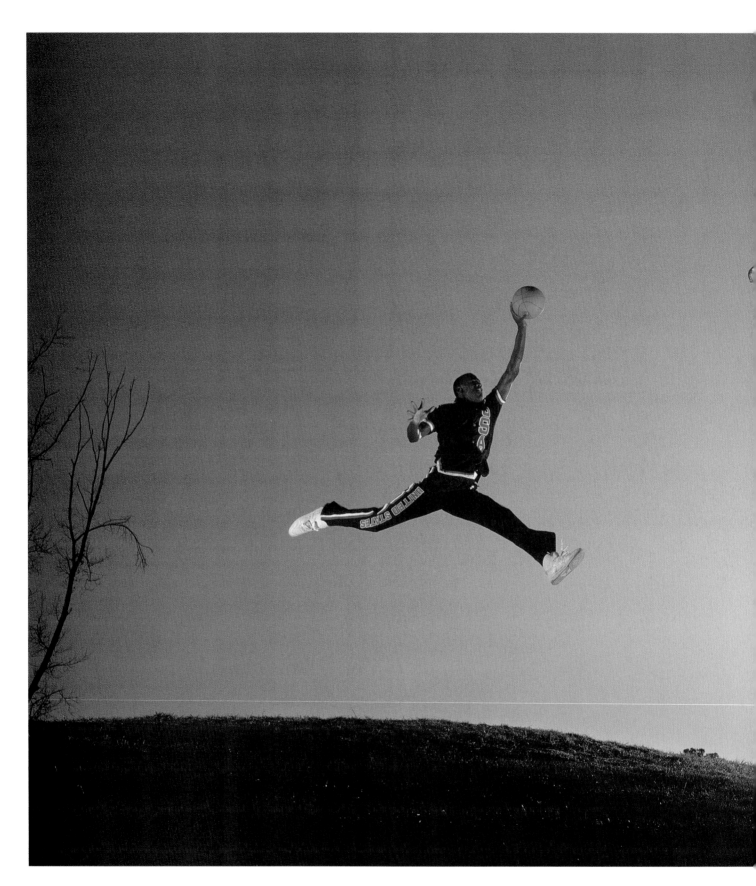

MICHAEL JORDAN
Co Rentmeester, 1984

'It's gotta be the shoes.' –NIKE COMMERCIAL, 1989

It may be the most famous silhouette ever photographed. Shooting Michael Jordan for LIFE in 1984, Jacobus "Co" Rentmeester captured the basketball star soaring through the air for a dunk, legs split like a ballet dancer's and left arm stretched to the stars. A beautiful image, but one unlikely to have endured had Nike not devised a logo for its young star that bore a striking resemblance to the photo. Seeking design inspiration for its first Air Jordan sneakers, Nike paid Rentmeester $150 for temporary use of his slides from the LIFE shoot. Soon, "Jumpman" was etched onto shoes, clothing and bedroom walls around the world, eventually becoming one of the most popular commercial icons of all time. With Jumpman, Nike created the concept of athletes as valuable commercial properties unto themselves. The Air Jordan brand, which today features other superstar pitchmen, earned $3.2 billion in 2014. Rentmeester, meanwhile, has sued Nike for copyright infringement. No matter the outcome, it's clear his image captures the ascendance of sports celebrity into a multibillion-dollar business, and it's still taking off.

THE FACE OF AIDS | *Therese Frare, 1990*

'I didn't know that it was going to be the photo that changed how people looked at AIDS.' –THERESE FRARE

David Kirby died surrounded by his family. But Therese Frare's photograph of the 32-year-old man on his deathbed did more than just capture the heartbreaking moment. It humanized AIDS, the disease that killed Kirby, at a time when it was ravaging victims largely out of public view. Frare's photograph, published in LIFE in 1990, showed how the widely misunderstood disease devastated more than just its victims. It would be another year before the red ribbon became a symbol of compassion and resilience, and three years before President Bill Clinton created a White House Office of National AIDS Policy. In 1992 the clothing company Benetton used a colorized version of Frare's photograph in a series of provocative ads. Many magazines refused to run it, and a range of groups called for a boycott. But Kirby's family consented to its use, believing that the ad helped raise critical awareness about AIDS at a moment when the disease was still uncontrolled and sufferers were lobbying the federal government to speed the development of new drugs. "We just felt it was time that people saw the truth about AIDS," Kirby's mother Kay said. Thanks to Frare's image, they did.

DEMI MOORE | *Annie Leibovitz, 1991*

'I don't think it's a good photograph per se. It's a magazine cover. If it were a great portrait, she wouldn't be covering her breasts.' –ANNIE LEIBOVITZ

The Hollywood star Demi Moore was seven months pregnant with her second child when she graced the cover of *Vanity Fair* in nothing but her birthday suit. Such a display was not unusual for Moore, who had the birth of her first child recorded with three video cameras. But it was unprecedented for a mainstream media outlet. Portraitist Annie Leibovitz made an image that celebrated pregnancy as much as it titillated, showing how maternity could be not only empowering but also sexy. The magazine's editor, Tina Brown, deemed Moore's act a brave declaration, "a new young movie star willing to say, 'I look beautiful pregnant,' and not ashamed of it." The photo was the first mass-media picture to sexualize pregnancy, and many found it too shocking for the newsstand. Some grocery chains refused to stock the issue, while others covered it up like pornography. It was not, of course. But it was a provocative magazine cover, and it did what only the best covers can: change the culture. Once pregnancy was a relatively private affair, even for public figures. After Leibovitz's picture, celebrity births, naked maternity shots and paparazzi snaps of baby bumps have become industries unto themselves.

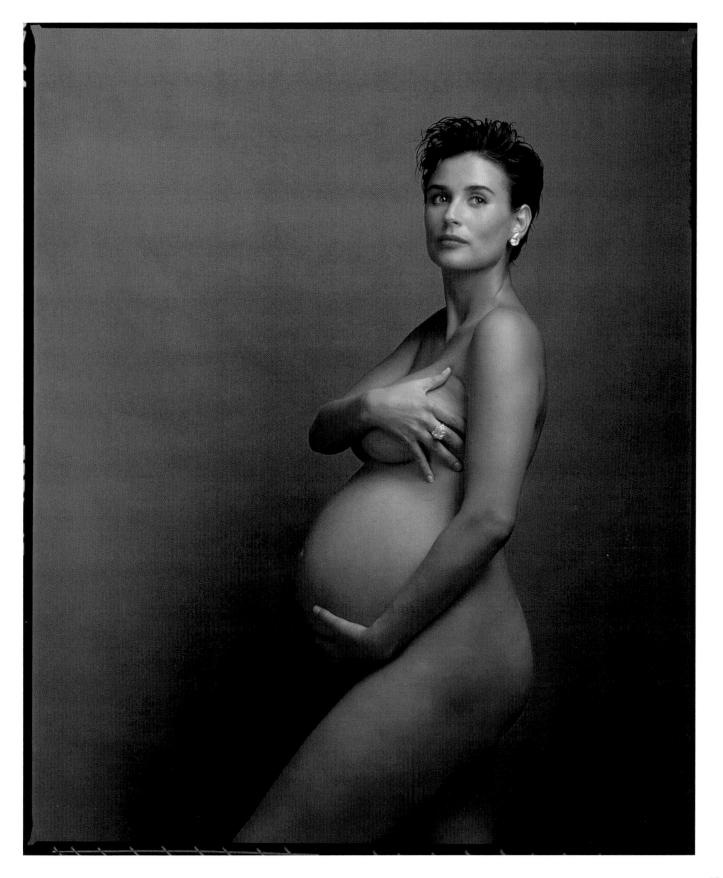

EVIDENCE

Knowledge is power, said Sir Francis Bacon—and photography greatly expanded access to that power. Before photography, humans bore witness only with their own eyes, and what were the chances that any person would be in the right place at the right time? All other accounts were secondhand at best; then, as now, the credibility of retellings was questionable.

Seeing is believing. But that's not the end of it. Believing often leads to caring, and caring can grow into action. Civil rights leaders understood this in the years after World War II. If only white Americans could see the disfigured body of the lynched teenager Emmett Till, or watch as snarling police dogs attacked peaceful demonstrators.

A photograph is not a manifesto, nor is it an agenda. But it can stir up the ground in which movements take root. The gradual shift in public opinion against America's war in Vietnam, for example, cannot be separated from the photographs that documented the chaos and brutality. Or it might be said that Barack Obama's road to the White House was paved with photographs from Abu Ghraib prison, for Obama—alone among the major candidates—had opposed the Iraq War.

This is why tyrants fear and manipulate photographs. Some images are doctored, others are suppressed. In China, many college students have reportedly never seen the 1989 image of a lone man confronting a column of tanks in Tiananmen Square. The picture is too dangerous to the powers that be. It might move others to stand up.

CATHEDRAL ROCK, YOSEMITE | *Carleton Watkins, 1861*

'A perfection of art which compares with the finest
European work.' –OLIVER WENDELL HOLMES, 1862

Decades before Ansel Adams ever saw Yosemite's jagged peaks, Carleton Watkins
packed his mammoth plate camera, tripods and a makeshift tent darkroom on mules
and ventured into the remote California valley. At the journey's end, Watkins had 130
negatives that offered the first printed images of Yosemite's towering masses, glacial
geology and jaw-dropping expanse. The images, including Watkins' intimate view of
Cathedral Rock, floored the growing nation's power brokers. John Conness, a U.S.
Senator from California, owned a set of the prints and became an evangelist for the
work. On June 30, 1864, President Abraham Lincoln signed into law the Yosemite
Grant Act, laying the foundation for the National Park System, which now protects
some 84 million acres of land.

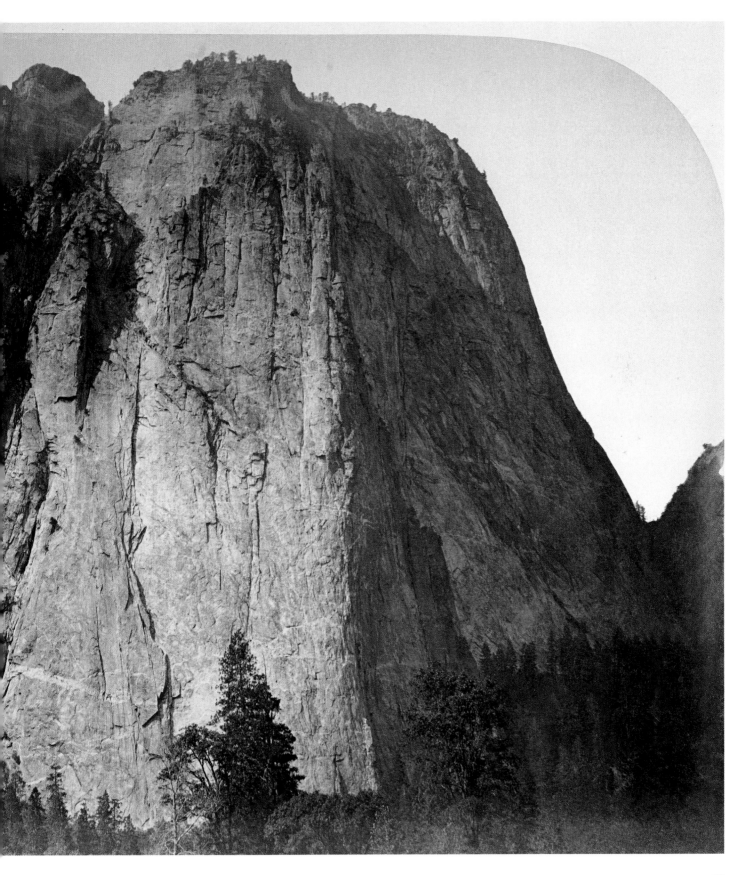

THE DEAD OF ANTIETAM
Alexander Gardner, 1862

'Mr. Brady has done something to bring home to us the terrible reality and earnestness of war. If he has not brought bodies and laid them in our dooryards and along the streets, he has done something very like it.' –NEW YORK *TIMES*

It was at Antietam, the blood-churning battle in Sharpsburg, Md., where more Americans died in a single day than ever had before, that one Union soldier recalled how "the piles of dead ... were frightful." The Scottish-born photographer Alexander Gardner arrived there two days after the September 17, 1862, slaughter. He set up his stereo wet-plate camera and started taking dozens of images of the body-strewn countryside, documenting fallen soldiers, burial crews and trench graves. Gardner worked for Mathew Brady, and when he returned to New York City his employer arranged an exhibition of the work. Visitors were greeted with a plain sign reading "The Dead of Antietam." But what they saw was anything but simple. Genteel society came upon what are believed to be the first recorded images of war casualties. Gardner's photographs are so sharp that people could make out faces. The death was unfiltered, and a war that had seemed remote suddenly became harrowingly immediate. Gardner helped make Americans realize the significance of the fratricide that by 1865 would take more than 600,000 lives. For in the hallowed fields fell not faceless strangers but sons, brothers, fathers, cousins and friends. And Gardner's images of Antietam created a lasting legacy by establishing a painfully potent visual precedent for the way all wars have since been covered.

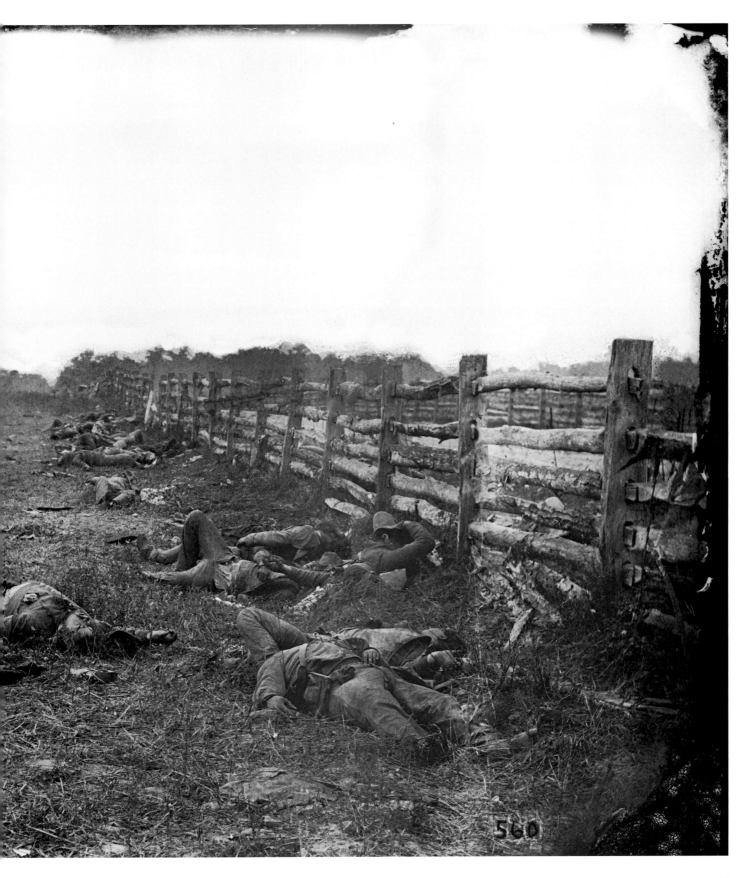

560

THE VANISHING RACE | *Edward S. Curtis, 1904*

'The passing of every old man or woman means the passing of some tradition, some knowledge of sacred rites possessed by no other.' –EDWARD S. CURTIS

Native Americans were the great casualty of the U.S.'s grand westward advance. As settlers tamed the seemingly boundless stretches of the young nation, they evicted Indians from their ancestral lands, shoving them into impoverished reservations and forcing them to assimilate. Fearing the imminent disappearance of America's first inhabitants, Edward S. Curtis sought to document the assorted tribes, to show them as a noble people—"the old time Indian, his dress, his ceremonies, his life and manners." Over more than two decades, Curtis turned these pictures and observations into *The North American Indian,* a 20-volume chronicle of 80 tribes. No single image embodied the project better than *The Vanishing Race,* his picture of Navajo riding off into the dusty distance. To Curtis the photo epitomized the plight of the Indians, who were "passing into the darkness of an unknown future." Alas, Curtis' encyclopedic work did more than convey the theme—it cemented a stereotype. Railroad companies soon lured tourists west with trips to glimpse the last of a dying people, and Indians came to be seen as a relic out of time, not an integral part of modern American society. It's a perception that persists to this day.

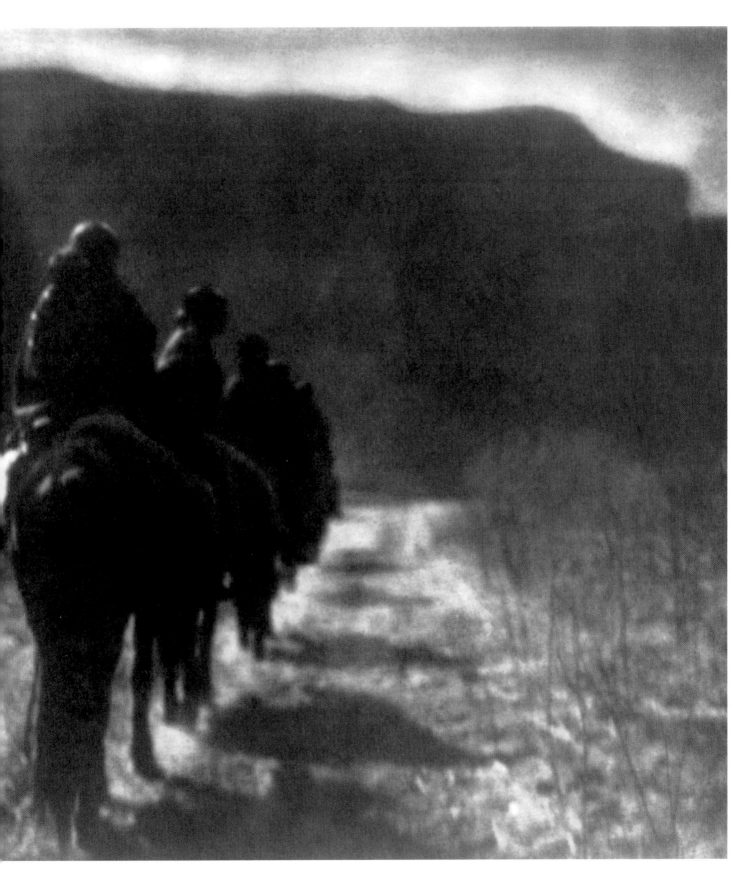

'If all my photographs were lost and I'd be represented by just one,
The Steerage, I'd be satisfied.' –ALFRED STIEGLITZ

As a leader of the Photo-Secession movement, Alfred Stieglitz searched for beauty through the craftsman-like creation of photographs, held pioneering exhibitions of his contemporaries, published their works and sought to have the still nascent art form taken as seriously as painting. But as modernism seeped into the cultural ferment in the early 20th century, Stieglitz became mesmerized by the growing cacophony of society, of rising skyscrapers and soaring airplanes, and strove to create what he termed "straight photography," offering truthful takes on the real world. In 1907 he was sailing to Europe, 4x5 Speed Graflex in tow, when he set off from the first-class deck and came upon the huddled masses in the ship's steerage. There, the shawled and swathed were crammed together on the compact lower deck, the skewed geometry of the ship emphasizing their claustrophobic accommodations and visually segregating them from those on the upper deck. "A round straw hat; the funnel leaning left, the stairway leaning right; the white drawbridge, its railings made of chain," Stieglitz later wrote. "I stood spellbound for a while. I saw shapes related to one another—a picture of shapes, and underlying it, a new vision that held me." Despite its momentary impact, Stieglitz's photo, with its clear, unapologetic take on life, lay unnoticed for four years. But when he published it on the cover of his magazine *Camera Work, The Steerage* presented a radical way of thinking about photography, not as a momentary mimic of painting but a wholly formed and unique type of art. Appearing at the time of a seismic revolution in the arts, with the emergence of such seminal figures as the composer Igor Stravinsky and the architect Walter Gropius, this, one of the first "modernist" pictures, helped photography to be seen on a par with these other innovative forms of art. None other than the painter Pablo Picasso admired *The Steerage*'s cubistic sense and wrote that both he and Stieglitz were "working in the same spirit."

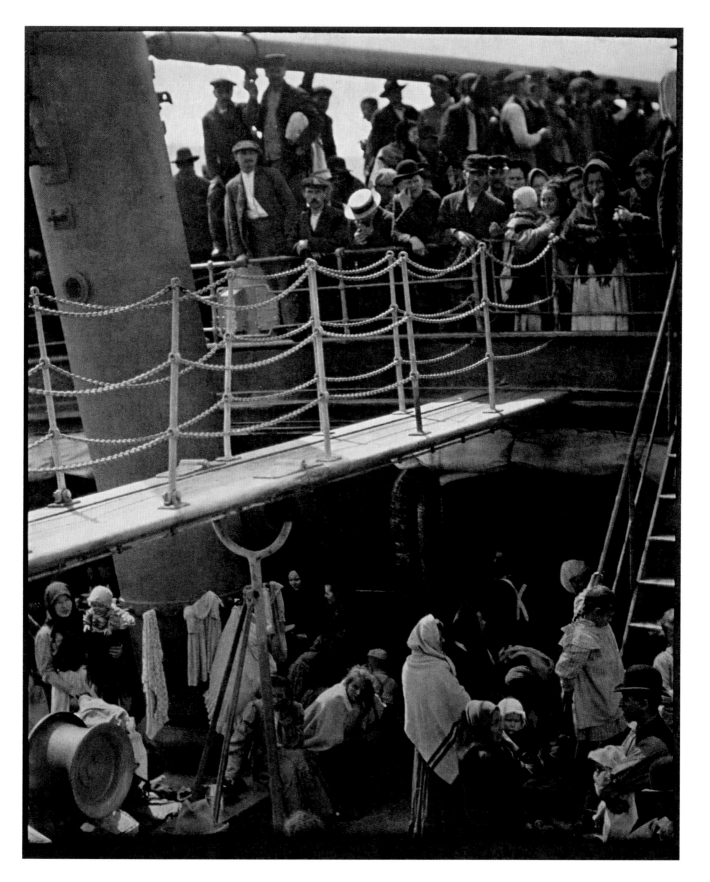

GIRL WORKER IN CAROLINA COTTON MILL
Lewis Hine, 1908

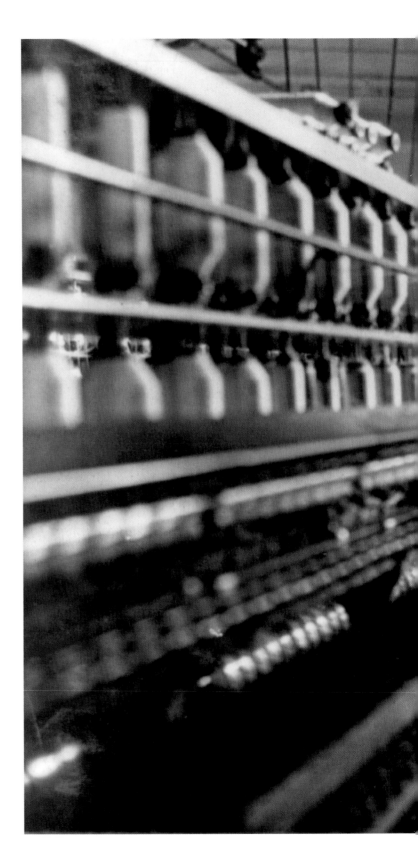

'Photography can light up darkness and expose ignorance.' –LEWIS HINE

Working as an investigative photographer for the National Child Labor Committee, Lewis Hine believed that images of child labor would force citizens to demand change. The muckraker conned his way into mills and factories from Massachusetts to South Carolina by posing as a Bible seller, insurance agent or industrial photographer in order to tell the plight of nearly 2 million children. Carting around a large-format camera and jotting down information in a hidden notebook, Hine recorded children laboring in meat-packing houses, coal mines and canneries, and in November 1908 he came upon Sadie Pfeifer, who embodied the world he exposed. A 48-inch-tall wisp of a girl, she was "one of the many small children at work" manning a gargantuan cotton-spinning machine in Lancaster, S.C. Since Hine often had to lie to get his shots, he made "double-sure that my photo data was 100% pure—no retouching or fakery of any kind." His images of children as young as 8 dwarfed by the cogs of a cold, mechanized universe squarely set the horrors of child labor before the public, leading to regulatory legislation and cutting the number of child laborers nearly in half from 1910 to 1920.

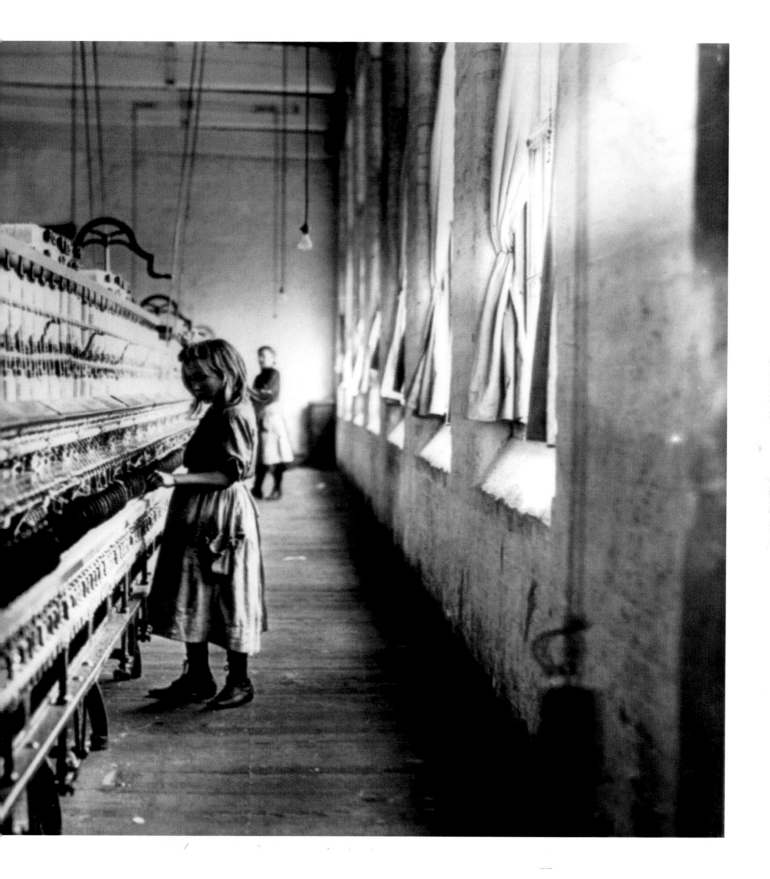

ROMANOV EXECUTION | *Unknown, 1919*

'It was a visual indictment of the nation
in ignorance of its history.' –IRINA CHMYREVA, HISTORIAN

For seven decades, the July 1918 deaths of Czar Nicholas II, Czarina Alexandra and their four daughters and son at Ipatiev House in Yekaterinburg spawned theories about the demise of the Russian royal family. The Bolsheviks clearly killed the family as they ushered in a communist era that had little room for nobility or dissent. Yet the family's remains were lost. The house in the Ural Mountains became a Museum of the Revolution and, to the annoyance of the Soviet leadership, also attracted pro-Romanov worshippers, causing Soviet leader Boris Yeltsin to order its destruction in 1977. But the demolition could not bury history. For just over a decade before, Harvard University received a gift of documents from the investigation into the deaths. Among the papers from coroner Nikolay Sokolov's probe was this image of the room where the deaths took place, with the bloodstained wallpaper ripped by bullets, the shattered wall and the plaster-covered floor all seemingly intact from the day of the massacre. Suddenly there was visual proof of the regicide that marked the start of the Soviet Union. It would be decades still before the nation owned up to the deaths. In August 2000—nine years after the Soviet Union fell—the Russian Orthodox Church canonized the Romanovs, proclaiming that these victims of Bolshevism were "passion bearers" for their "humbleness, patience and meekness" during their imprisonment. Churches have since been built for each of the family members, and in 2003 the gold-domed Church on Blood in Honour of All Saints Resplendent in the Russian Land rose on the site of Ipatiev House, a fitting worship space for the flocking pilgrims. Five years later, the Russian Supreme Court rehabilitated the family and ruled their execution an act of "unfounded repression."

HITLER AT A NAZI PARTY RALLY

Heinrich Hoffmann, 1934

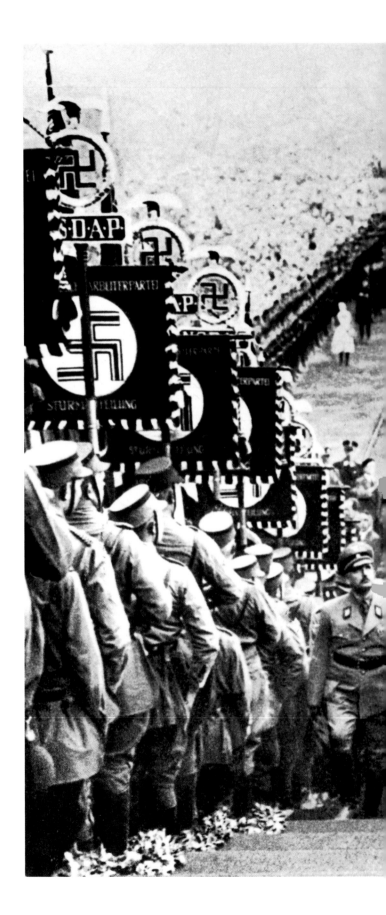

'Would you like to come with me?
You'll certainly get some very interesting
photographs!' –HITLER TO HOFFMANN

Spectacle was like oxygen for the Nazis, and Heinrich Hoffmann was instrumental in staging Hitler's growing pageant of power. Hoffmann, who joined the party in 1920 and became Hitler's personal photographer and confidant, was charged with choreographing the regime's propaganda carnivals and selling them to a wounded German public. Nowhere did Hoffmann do it better than on September 30, 1934, in his rigidly symmetrical photo at the Bückeberg Harvest Festival, where the Mephistophelian Führer swaggers at the center of a grand Wagnerian fantasy of adoring and heiling troops. By capturing this and so many other extravaganzas, Hoffmann—who took more than 2 million photos of his boss—fed the regime's vast propaganda machine and spread its demonic dream. Such images were all-pervasive in Hitler's Reich, which shrewdly used Hoffman's photos, the stark graphics on Nazi banners and the films of Leni Riefenstahl to make Aryanism seem worthy of godlike worship. Humiliated by World War I, punishing reparations and the Great Depression, a nation eager to reclaim its sense of self was rallied by Hitler's visage and his seemingly invincible men aching to right wrongs. Hoffmann's expertly rendered propaganda is a testament to photography's power to move nations and plunge a world into war.

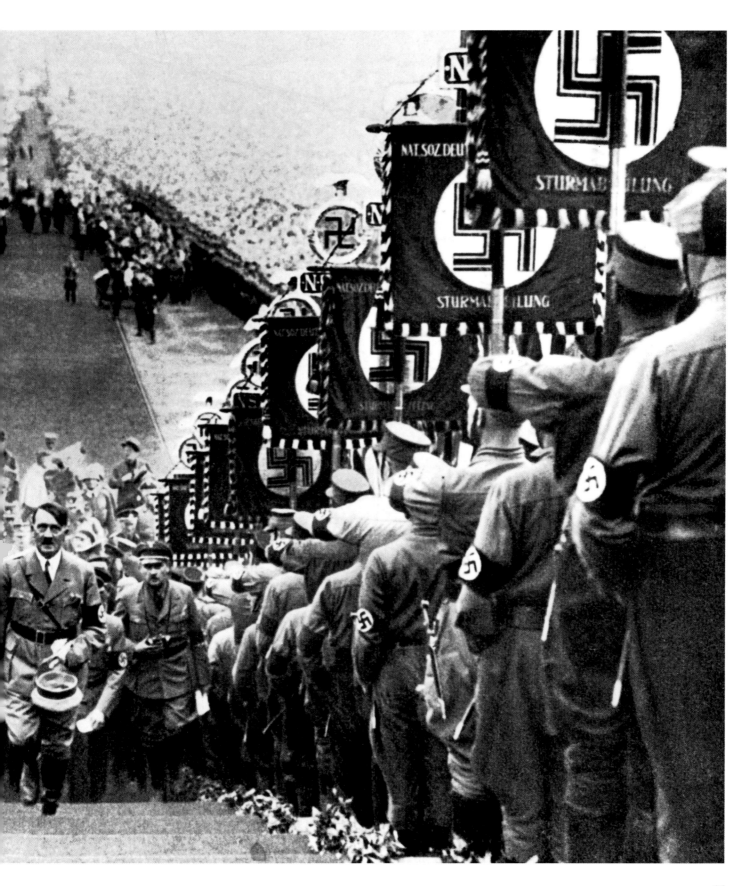

THE HINDENBURG DISASTER | *Sam Shere, 1937*

'I literally 'shot' from the hip—it was over so fast, there was nothing else to do.' –SAM SHERE

Zeppelins were majestic skyliners, luxurious behemoths that signified wealth and power. The arrival of these ships was news, which is why Sam Shere of the International News Photos service was waiting in the rain at the Lakehurst, N.J., Naval Air Station on May 6, 1937, for the 804-foot-long LZ 129 *Hindenburg* to drift in from Frankfurt. Suddenly, as the assembled media watched, the grand ship's flammable hydrogen caught fire, causing it to spectacularly burst into bright yellow flames and kill 36 people. Shere was one of nearly two dozen still and newsreel photographers who scrambled to document the fast-moving tragedy. But it is his image, with its stark immediacy and horrible grandeur, that has endured as the most famous—owing to its publication on front pages around the world and in LIFE and, more than three decades later, its use on the cover of the first Led Zeppelin album. The crash helped bring the age of the airships to a close, and Shere's powerful photograph of one of the world's most formative early air disasters persists as a cautionary reminder of how human fallibility can lead to death and destruction. Almost as famous as Shere's photo is the anguished voice of Chicago radio announcer Herbert Morrison, who cried as he watched people tumbling through the air, "It is bursting into flames … This is terrible. This is one of the worst catastrophes in the world … Oh, the humanity!"

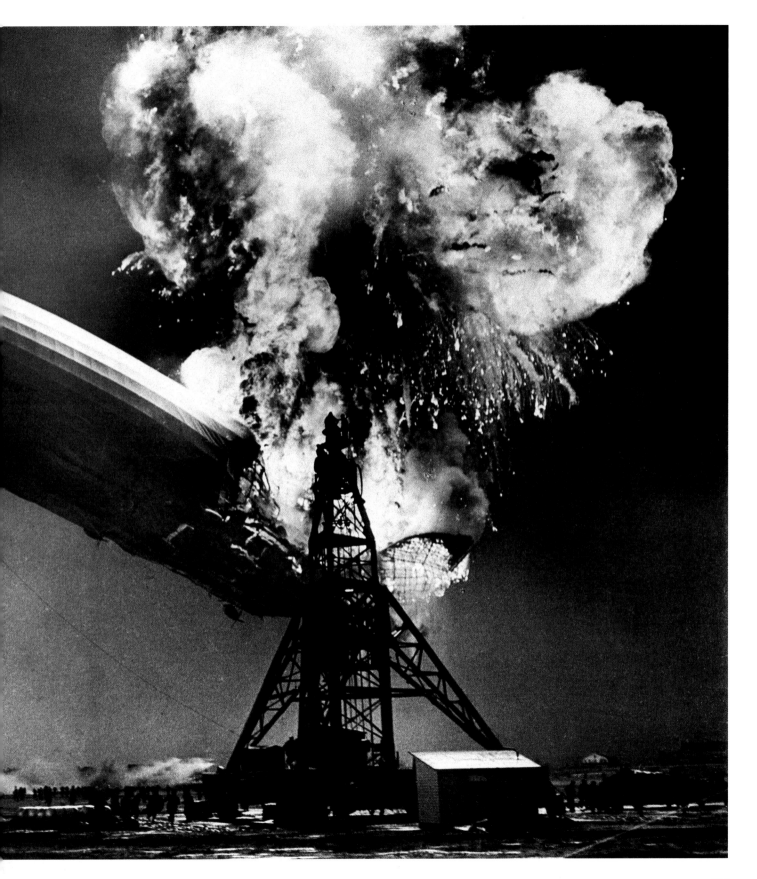

BLOODY SATURDAY | *H.S. Wong, 1937*

'It was a horrible sight. People were still trying to get up. Dead and injured lay strewn across the tracks and platform. Limbs lay all over the place. Only my work helped me forget what I was seeing.' –H.S. WONG

The same imperialistic desires festering in Europe in the 1930s had already swept into Asia. Yet many Americans remained wary of wading into a conflict in what seemed a far-off, alien land. But that opinion began to change as Japan's army of the Rising Sun rolled toward Shanghai in the summer of 1937. Fighting started there in August, and the unrelenting shelling and bombing caused mass panic and death in the streets. But the rest of the world didn't put a face to the victims until they saw the aftermath of an August 28 attack by Japanese bombers. When H.S. Wong, a photographer for Hearst Metrotone News nicknamed Newsreel, arrived at the destroyed South Station, he recalled carnage so fresh "that my shoes were soaked with blood." In the midst of the devastation, Wong saw a wailing Chinese baby whose mother lay dead on nearby tracks. He said he quickly shot his remaining film and then ran to carry the baby to safety, but not before the boy's father raced over and ferried him away. Wong's image of the wounded, helpless infant was sent to New York and featured in Hearst newsreels, newspapers and LIFE magazine—the widest audience a picture could then have. Viewed by more than 136 million people, it struck a personal chord that transcended ethnicity and geography. To many, the infant's pain represented the plight of China and the bloodlust of Japan, and the photo dubbed *Bloody Saturday* was transformed into one of the most powerful news pictures of all time. Its dissemination reveals the potent force of an image to sway official and public opinion. Wong's picture led the U.S., Britain and France to formally protest the attack and helped shift Western sentiment in favor of wading into what would become the world's second great war.

GRIEF | *Dmitri Baltermants, 1942*

'War is, above all, grief.' –DMITRI BALTERMANTS

The Polish-born Dmitri Baltermants had planned to be a math teacher but instead fell in love with photography. Just as World War II broke out, he got a call from his bosses at the Soviet government paper *Izvestia*: "Our troops are crossing the border tomorrow. Get ready to shoot the annexation of western Ukraine!" At the time the Soviet Union considered Nazi Germany its ally. But after Adolf Hitler turned on his comrades and invaded the Soviet Union, Baltermants' mission changed too. Covering what then became known as the Great Patriotic War, he captured grim images of body-littered roads along with those of troops enjoying quiet moments. In January 1942 he was in the newly liberated city of Kerch, Crimea, where two months earlier Nazi death squads had rounded up the town's 7,000 Jews. "They drove out whole families—women, the elderly, children," Baltermants recalled years later. "They drove all of them to an antitank ditch and shot them." There Baltermants came upon a bleak, corpse-choked field, the outstretched limbs of old and young alike frozen in the last moment of pleading. Some of the gathered townspeople wailed, their arms wide. Others hunched in paroxysms of grief. Baltermants, who witnessed more than his share of death, recorded what he saw. Yet these images of mass Nazi murders on Soviet soil were too graphic for his nation's leaders, wary of displaying the suffering of their people. Like many of Baltermants' photos, this one was censored, being shown only decades later as liberalism seeped into Russian society in the 1960s. When it finally emerged, Baltermants' picture allowed generations of Russians to form a collective memory of their great war. "You do your work the best you can," he somberly observed, "and someday it will surface."

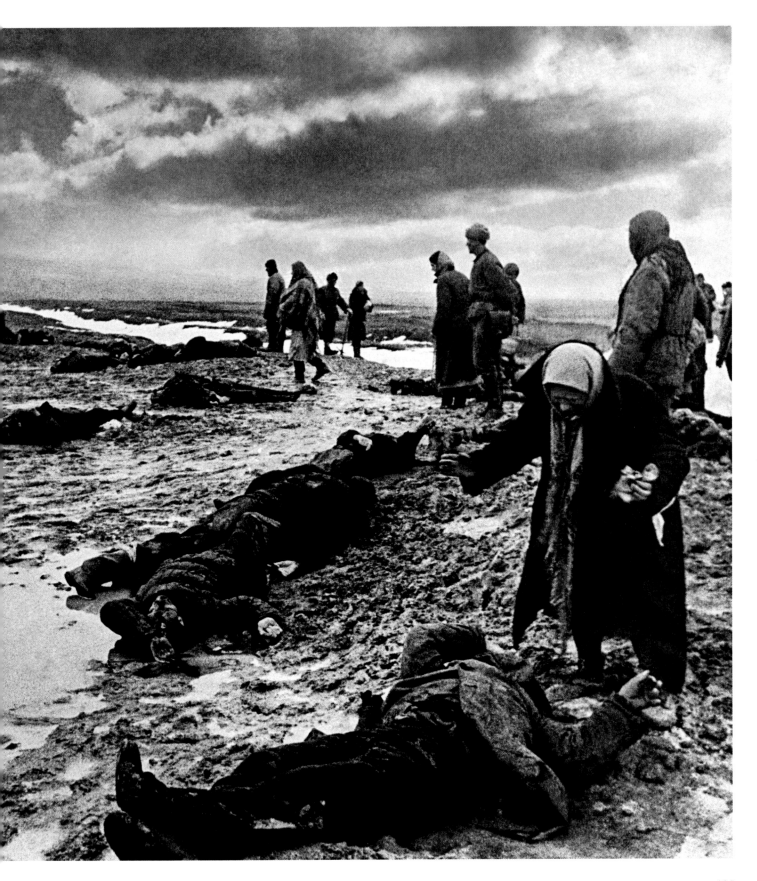

JEWISH BOY
SURRENDERS IN WARSAW
Unknown, 1943

'I hold a report written with Teutonic devotion to detail, illustrated with photographs to authenticate its almost incredible text.' –ROBERT JACKSON, CHIEF U.S. PROSECUTOR AT THE NUREMBURG TRIALS

The terrified young boy with his hands raised at the center of this image was one of nearly half a million Jews packed into the Warsaw ghetto, a neighborhood transformed by the Nazis into a walled compound of grinding starvation and death. Beginning in July 1942, the German occupiers started shipping some 5,000 Warsaw inhabitants a day to concentration camps. As news of exterminations seeped back, the ghetto's residents formed a resistance group. "We saw ourselves as a Jewish underground whose fate was a tragic one," wrote its young leader Mordecai Anielewicz. "For our hour had come without any sign of hope or rescue." That hour arrived on April 19, 1943, when Nazi troops came to take the rest of the Jews away. The sparsely armed partisans fought back but were eventually subdued by German tanks and flamethrowers. When the revolt ended on May 16, the 56,000 survivors faced summary execution or deportation to concentration and slave-labor camps. SS Major General Jürgen Stroop took such pride in his work clearing out the ghetto that he created the Stroop Report, a leather-bound victory album whose 75 pages include a laundry list of boastful spoils, reports of daily killings and dozens of heart-wrenching photos like that of the boy raising his hands. This collection proved his undoing, for besides giving a face to those who died, the pictures reveal the power of photography as a documentary tool. At the subsequent Nuremburg war-crimes trials, the volume became key evidence against Stroop and resulted in his hanging near the ghetto in 1951. The Holocaust produced scores of searing images. But none had the evidentiary impact of the boy's surrender. The child, whose identity has never been confirmed, has come to represent the face of the 6 million defenseless Jews killed by the Nazis.

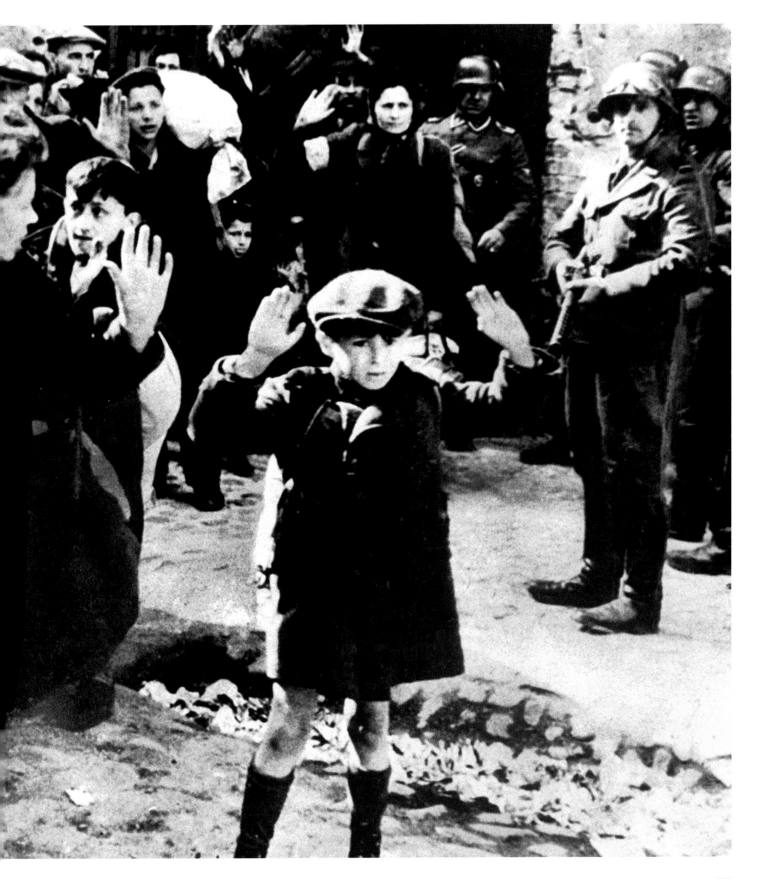

'I couldn't see what I was snapping but could almost smell the smugness.' –WEEGEE

Arthur Fellig had a sharp eye for the unfairness of life. An Austrian immigrant who grew up on the gritty streets of New York City's Lower East Side, Fellig became known as Weegee—a phonetic take on Ouija—for his preternatural ability to get the right photo. Often these were film-noirish images of crime, tragedy and the denizens of nocturnal New York. In 1943, Weegee turned his Speed Graphic camera's blinding flash on the social and economic inequalities that lingered after the Great Depression. Not averse to orchestrating a shot, he dispatched his assistant, Louie Liotta, to a Bowery dive in search of an inebriated woman. He found a willing subject and took her to the Metropolitan Opera House for its Diamond Jubilee celebration. Then Liotta set her up near the entrance while Weegee watched for the arrival of Mrs. George Washington Kavanaugh and Lady Decies, two wealthy women who regularly graced society columns. When the tiara- and fur-bedecked socialites arrived for the opera, Weegee gave Liotta the signal to spring the drunk woman. "It was like an explosion," Liotta recalled. "I thought I went blind from the three or four flash exposures." With that flash, Weegee captured the stark juxtaposition of fabulous wealth and dire poverty, in a gotcha style that anticipated the commercial appeal of paparazzi decades later. The photo appeared in LIFE under the headline "The Fashionable People," and the piece let readers know how the women's "entry was viewed with distaste by a spectator." That *The Critic* was later revealed to have been staged did little to dampen its influence.

D-DAY | *Robert Capa, 1944*

'It never occurred to me until later that in order to take that picture, Capa had to get ahead of that soldier and turn his back on the action.'
–JOHN MORRIS, CAPA'S EDITOR AT *LIFE*

It was the invasion to save civilization, and LIFE's Robert Capa was there, the only still photographer to wade with the 34,250 troops onto Omaha Beach during the D-Day landing. His photographs—infused with jarring movement from the center of that brutal assault—gave the public an American soldier's view of the dangers of war. The soldier in this case was Private First Class Huston Riley, who after the Nazis shelled his landing craft jumped into water so deep that he had to walk along the bottom until he could hold his breath no more. When he activated his Navy M-26 belt life preservers and floated to the surface, Riley became a target for the guns and artillery shells mowing down his comrades. Struck several times, the 22-year-old soldier took about half an hour to reach the Normandy shore. Capa took this photo of him in the surf and then with the assistance of a sergeant helped Riley, who later recalled thinking, "What the hell is this guy doing here? I can't believe it. Here's a cameraman on the shore." Capa spent an hour and a half under fire as men around him died. A courier then transported his four rolls of film to LIFE's London offices, and the magazine's general manager stopped the presses to get them into the June 19 issue. Most of the film, though, showed no images after processing, and only some frames survived. The remaining images have a grainy, blurry look that gives them the frenetic feel of action, a quality that has come to define our collective memory of that epic clash.

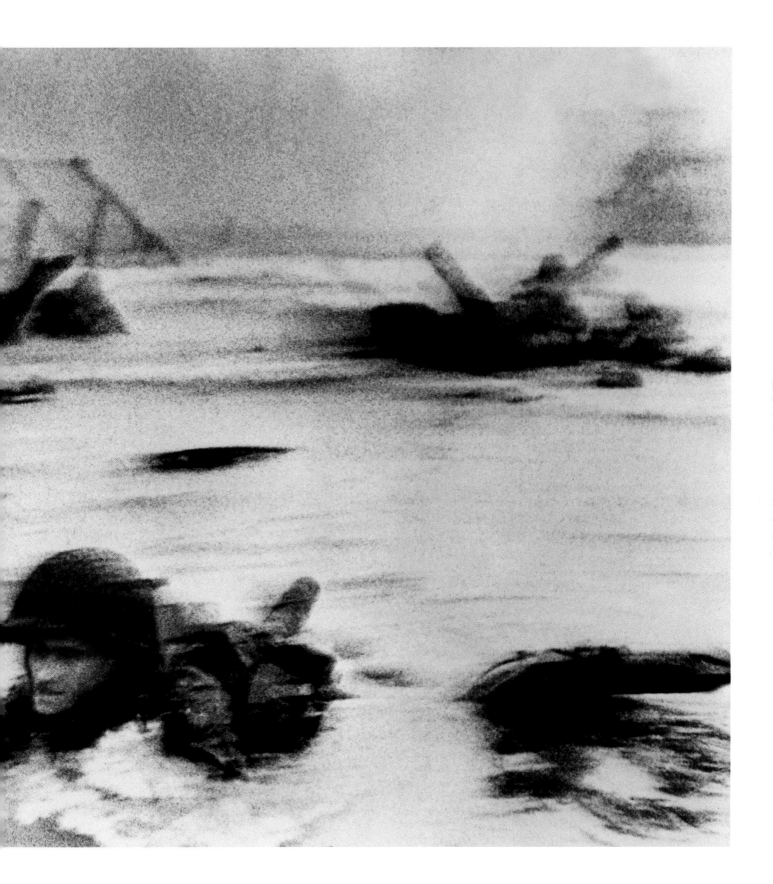

MUSHROOM CLOUD OVER NAGASAKI | *Lieutenant Charles Levy, 1945*

'Observers in the tail of our ship saw a giant ball of fire rise as though from the bowels of the earth.' –WILLIAM L. LAURENCE, EYEWITNESS

Three days after an atomic bomb nicknamed Little Boy obliterated Hiroshima, Japan, U.S. forces dropped an even more powerful weapon dubbed Fat Man on Nagasaki. The explosion shot up a 45,000-foot-high column of radioactive dust and debris. "We saw this big plume climbing up, up into the sky," recalled Lieutenant Charles Levy, the bombardier, who was knocked over by the blow from the 20-kiloton weapon. "It was purple, red, white, all colors—something like boiling coffee. It looked alive." The officer then shot 16 photographs of the new weapon's awful power as it yanked the life out of some 80,000 people in the city on the Urakami River. Six days later, the two bombs forced Emperor Hirohito to announce Japan's unconditional surrender in World War II. Officials censored photos of the bomb's devastation, but Levy's image—the only one to show the full scale of the mushroom cloud from the air—was circulated widely. The effect shaped American opinion in favor of the nuclear bomb, leading the nation to celebrate the atomic age and proving, yet again, that history is written by the victors.

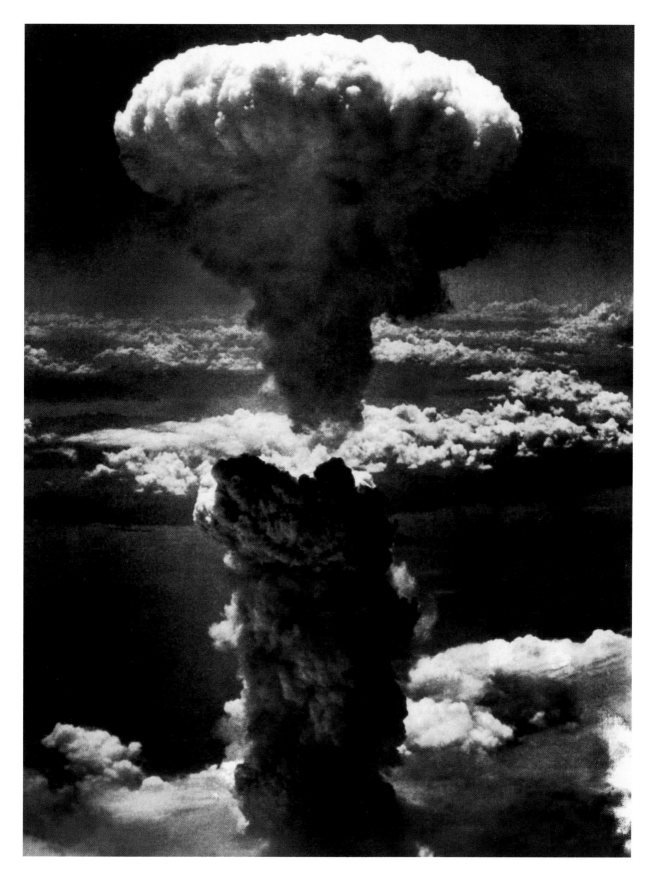

EMMETT TILL | *David Jackson, 1955*

In August 1955, Emmett Till, a black teenager from Chicago, was visiting relatives in Mississippi when he stopped at Bryant's Grocery and Meat Market. There he encountered Carolyn Bryant, a white woman. Whether Till really flirted with Bryant or whistled at her isn't known. But what happened four days later is. Bryant's husband Roy and his half brother, J.W. Milam, seized the 14-year-old from his great-uncle's house. The pair then beat Till, shot him, and strung barbed wire and a 75-pound metal fan around his neck and dumped the lifeless body in the Tallahatchie River. A white jury quickly acquitted the men, with one juror saying it had taken so long only because they had to break to drink some pop. When Till's mother Mamie came to identify her son, she told the funeral director, "Let the people see what I've seen." She brought him home to Chicago and insisted on an open casket. Tens of thousands filed past Till's remains, but it was the publication of the searing funeral image in *Jet*, with a stoic Mamie gazing at her murdered child's ravaged body, that forced the world to reckon with the brutality of American racism. For almost a century, African Americans were lynched with regularity and impunity. Now, thanks to a mother's determination to expose the barbarousness of the crime, the public could no longer pretend to ignore what they couldn't see.

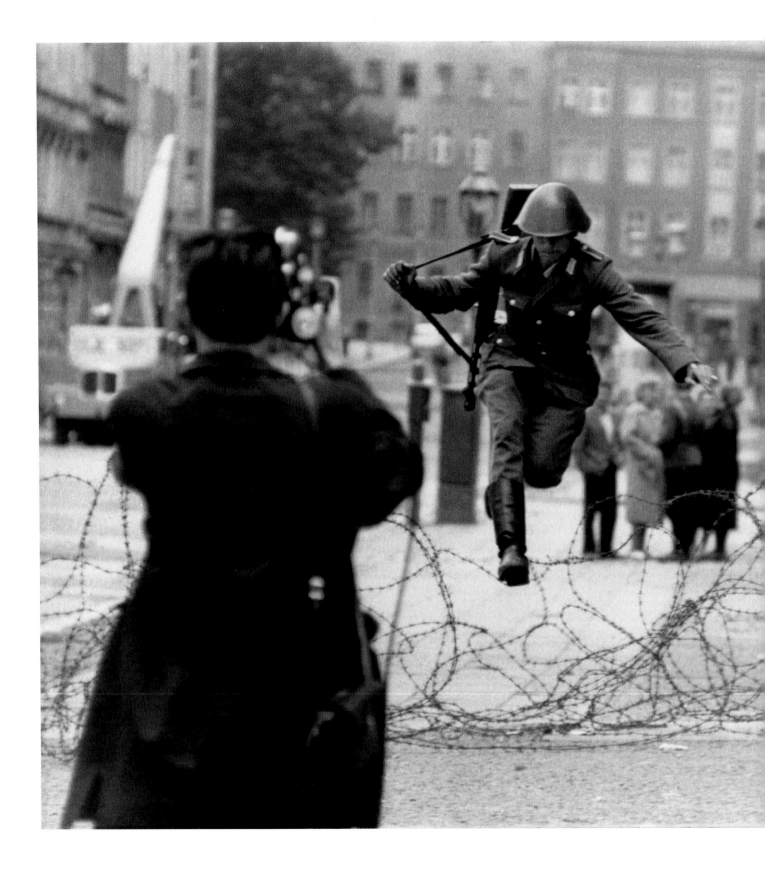

LEAP INTO FREEDOM
Peter Leibing, 1961

'I stood there for two hours,
looking toward **West Berlin** and looking
back at **East Berlin**. Then I jumped.'
–HANS CONRAD SCHUMANN

Following World War II, the conquering Allied governments carved Berlin into four occupation zones. Yet each part was not equal, and from 1949 to 1961 some 2.5 million East Germans fled the Soviet section in search of freedom. To stop the flow, East German leader Walter Ulbricht had a barbed-wire-and-cinder-block barrier thrown up in early August 1961. A few days later, Associated Press photographer Peter Leibing was tipped off that a defection might happen. He and other cameramen gathered and watched as a West Berlin crowd enticed 19-year-old border guard Hans Conrad Schumann, yelling to him, "Come on over!" Schumann, who later said he did not want to "live enclosed," suddenly ran for the barricade. As he cleared the sharp wires he dropped his rifle and was whisked away. Sent out across the AP wire, Leibing's photo ran on front pages across the world. It made Schumann, reportedly the first known East German soldier to flee, into a poster child for those yearning to be free, while lending urgency to East Germany's push for a more permanent Berlin Wall. Schumann was sadly haunted by the weight of it all. While he quietly lived in the West, he could not grapple with his unintended stature as a symbol of freedom, and he committed suicide in 1998.

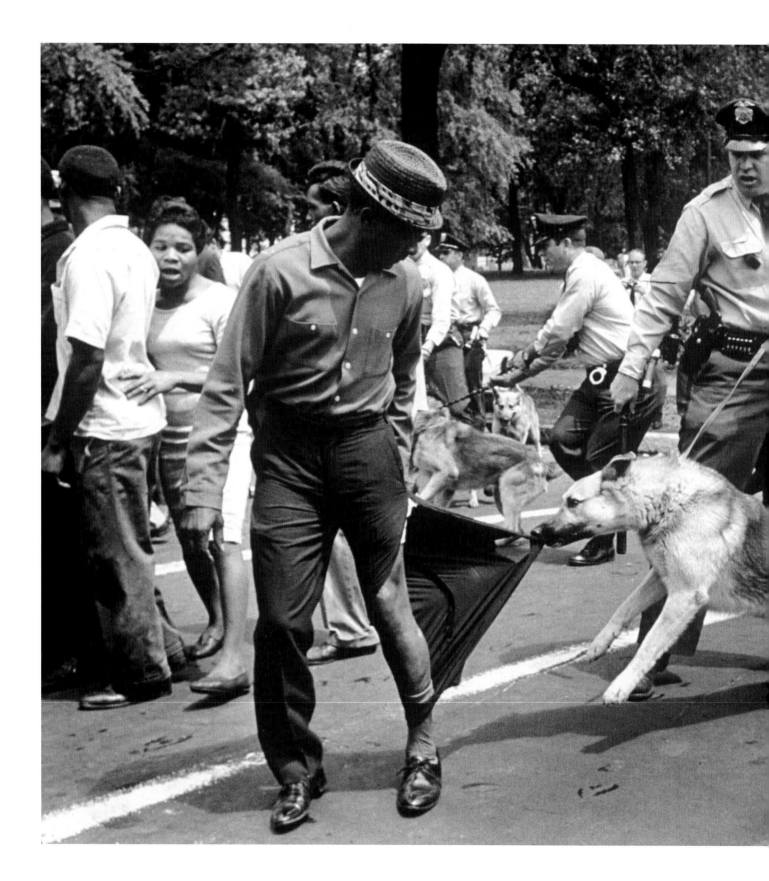

BIRMINGHAM, ALABAMA
Charles Moore, 1963

'The photographs of Bull Connor's police dogs lunging at the marchers in Birmingham did as much as anything to transform the national mood.' –ARTHUR SCHLESINGER JR., HISTORIAN

Sometimes the most effective mirror is a photograph. In the summer of 1963, Birmingham was boiling over as black residents and their allies in the civil rights movement repeatedly clashed with a white power structure intent on maintaining segregation—and willing to do whatever that took. A photographer for the Montgomery *Advertiser* and LIFE, Charles Moore was a native Alabaman and son of a Baptist preacher appalled by the violence inflicted on African Americans in the name of law and order. Though he photographed many other seminal moments of the movement, it was Moore's image of a police dog tearing into a black protester's pants that captured the routine, even casual, brutality of segregation. When the picture was published in LIFE, it quickly became apparent to the rest of the world what Moore had long known: ending segregation was not about eroding culture but about restoring humanity. Hesitant politicians soon took up the cause and passed the Civil Rights Act of 1964 nearly a year later.

THE BURNING MONK
Malcolm Browne, 1963

'I just kept shooting and shooting and shooting and that protected me from the horror of the thing.' –MALCOLM BROWNE

In June 1963, most Americans couldn't find Vietnam on a map. But there was no forgetting that war-torn Southeast Asian nation after Associated Press photographer Malcolm Browne captured the image of Thich Quang Duc immolating himself on a Saigon street. Browne had been given a heads-up that something was going to happen to protest the treatment of Buddhists by the regime of President Ngo Dinh Diem. Once there he watched as two monks doused the seated elderly man with gasoline. "I realized at that moment exactly what was happening, and began to take pictures a few seconds apart," he wrote soon after. His Pulitzer Prize–winning photo of the seemingly serene monk sitting lotus style as he is enveloped in flames became the first iconic image to emerge from a quagmire that would soon pull in America. Quang Duc's act of martyrdom became a sign of the volatility of his nation, and President Kennedy later commented, "No news picture in history has generated so much emotion around the world as that one." Browne's photo forced people to question the U.S.'s association with Diem's government, and soon resulted in the Administration's decision not to interfere with a coup that November.

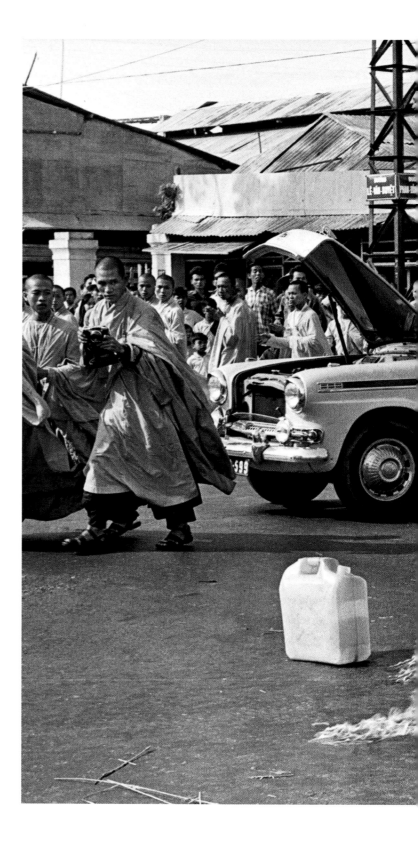

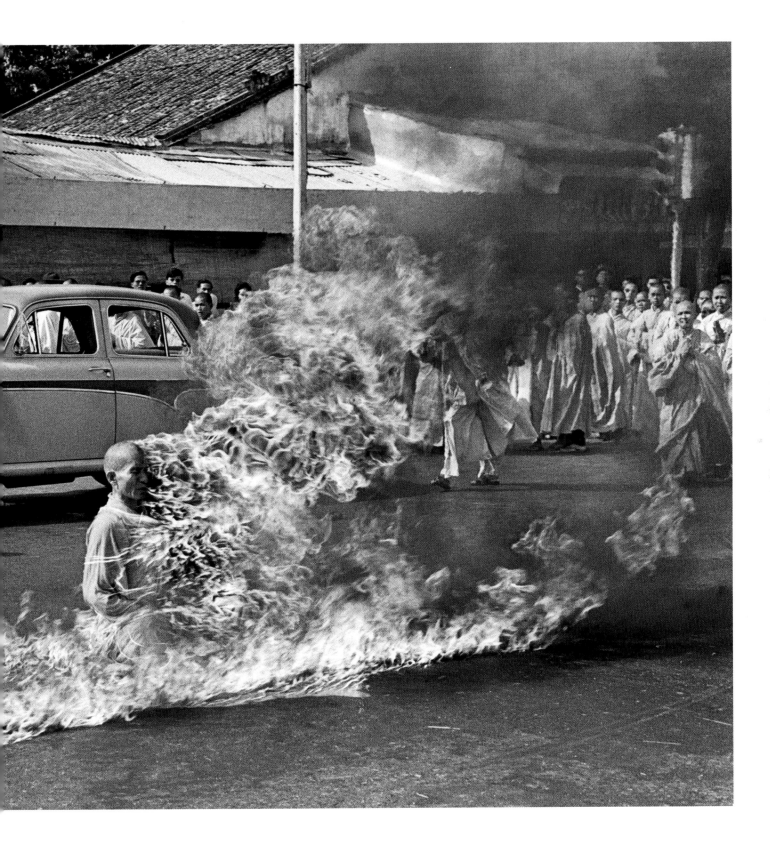

JFK ASSASSINATION, FRAME 313
Abraham Zapruder, 1963

'After that tragedy somehow I lost—I don't know what you'd call it—my appetite, or my desire to take pictures.' –ABRAHAM ZAPRUDER

It is the most famous home movie ever, and the most carefully studied image, an 8-millimeter film that captured the death of a President. The movie is just as well known for what many say it does or does not reveal, and its existence has fostered countless conspiracy theories about that day in Dallas. But no one would argue that what it shows is not utterly heartbreaking, the last moments of life of the youthful and charismatic John Fitzgerald Kennedy as he rode with his wife Jackie through Dealey Plaza. Amateur photographer Abraham Zapruder had eagerly set out with his Bell & Howell camera on the morning of November 22, 1963, to record the arrival of his hero. Yet as Zapruder filmed, one bullet struck Kennedy in the back, and as the President's car passed in front of Zapruder, a second one hit him in the head. LIFE correspondent Richard Stolley bought the film the following day, and the magazine ran 31 of the 486 frames—which meant that the first public viewing of Zapruder's famous film was as a series of still images. At the time, LIFE withheld the gruesome frame No. 313—a picture that became influential by its absence. That one, where the bullet exploded the side of Kennedy's head, is still shocking when seen today, a reminder of the seeming suddenness of death. What Zapruder captured that sunny day would haunt him for the rest of his life. It is something that unsettles America, a dark dream that hovers at the back of our collective psyche, an image from a wisp of 26.5 seconds of film whose gut-wrenching impact reminds us how everything can change in a fraction of a moment.

SAIGON EXECUTION | *Eddie Adams, 1968*

'Two people's lives were destroyed that day.
The general's life was destroyed as well as the life
of the Viet Cong. I don't want to destroy
anyone's life. That's not my job.' –EDDIE ADAMS

The act was stunning in its casualness. Associated Press photographer Eddie Adams was on the streets of Saigon on February 1, 1968, two days after the forces of the People's Army of Vietnam and the Viet Cong set off the Tet offensive and swarmed into dozens of South Vietnamese cities. As Adams photographed the turmoil, he came upon Brigadier General Nguyen Ngoc Loan, chief of the national police, standing alongside Nguyen Van Lem, the captain of a terrorist squad who had just killed the family of one of Loan's friends. Adams thought he was watching the interrogation of a bound prisoner. But as he looked through his viewfinder, Loan calmly raised his .38-caliber pistol and summarily fired a bullet through Lem's head. After shooting the suspect, the general justified the suddenness of his actions by saying, "If you hesitate, if you didn't do your duty, the men won't follow you." The Tet offensive raged into March. Yet while U.S. forces beat back the communists, press reports of the anarchy convinced Americans that the war was unwinnable. The freezing of the moment of Lem's death symbolized for many the brutality over there, and the picture's widespread publication helped galvanize growing sentiment in America about the futility of the fight. More important, Adams' photo ushered in a more intimate level of war photojournalism. He won a Pulitzer Prize for this image, and as he commented three decades later about the reach of his work, "Still photographs are the most powerful weapon in the world."

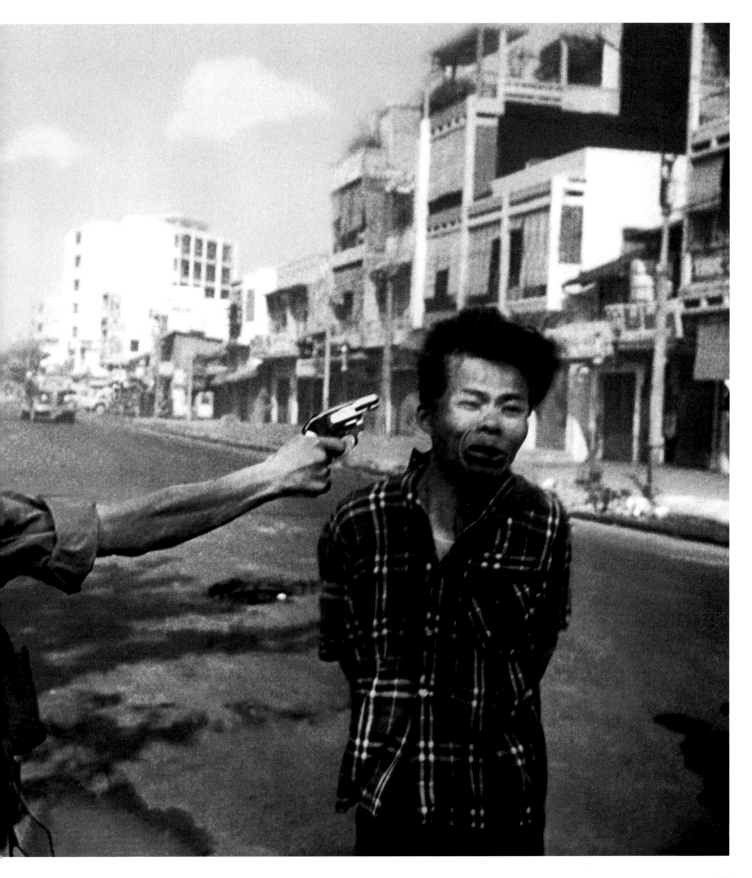

INVASION OF PRAGUE
Josef Koudelka, 1968

'You cannot rely on your memories—but you can rely on your pictures.' –JOSEF KOUDELKA

The Soviets did not care for the "socialism with a human face" that Alexander Dubcek's government brought to Czechoslovakia. Fearing that Dubcek's human-rights reforms would lead to a democratic uprising like the one in Hungary in 1956, Warsaw Bloc forces set out to quash the movement. Their tanks rolled into Czechoslovakia on August 20, 1968. And while they quickly seized control of Prague, they unexpectedly ran up against masses of flag-waving citizens who threw up barricades, stoned tanks, overturned trucks and even removed street signs in order to confuse the troops. Josef Koudelka, a young Moravian-born engineer who had been taking wistful and gritty photos of Czech life, was in the capital when the soldiers arrived. He took pictures of the swirling turmoil and created a groundbreaking record of the invasion that would change the course of his nation. The most seminal piece includes a man's arm in the foreground, showing on his wristwatch a moment of the Soviet invasion with a deserted street in the distance. It beautifully encapsulates time, loss and emptiness—and the strangling of a society.

Koudelka's visual memories of the unfolding conflict—with its evidence of the ticking time, the brutality of the attack and the challenges by Czech citizens—redefined photojournalism. His pictures were smuggled out of Czechoslovakia and appeared in the London *Sunday Times* in 1969, though under the pseudonym P.P. for Prague Photographer since Koudelka feared reprisals. He soon fled, his rationale for leaving the country a testament to the power of photographic evidence: "I was afraid to go back to Czechoslovakia because I knew that if they wanted to find out who the unknown photographer was, they could do it."

A MAN ON THE MOON | *Neil Armstrong, NASA, 1969*

'It is a truly astounding shot and was the result of an entirely serendipitous moment.' –BUZZ ALDRIN

Somewhere in the Sea of Tranquillity, the little depression in which Buzz Aldrin stood on the evening of July 20, 1969, is still there—one of billions of pits and craters and pockmarks on the moon's ancient surface. But it may not be the astronaut's most indelible mark.

Aldrin never cared for being the second man on the moon—to come so far and miss the epochal first-man designation Neil Armstrong earned by a mere matter of inches and minutes. But Aldrin earned a different kind of immortality. Since it was Armstrong who was carrying the crew's 70-millimeter Hasselblad, he took all of the pictures—meaning the only moon man earthlings would see clearly would be the one who took the second steps. That this image endured the way it has was not likely. It has none of the action of the shots of Aldrin climbing down the ladder of the lunar module, none of the patriotic resonance of his saluting the American flag. He's just standing in place, a small, fragile man on a distant world—a world that would be happy to kill him if he removed so much as a single article of his exceedingly complex clothing. His arm is bent awkwardly—perhaps, he has speculated, because he was glancing at the checklist on his wrist. And Armstrong, looking even smaller and more spectral, is reflected in his visor. It's a picture that in some ways did everything wrong if it was striving for heroism. As a result, it did everything right.

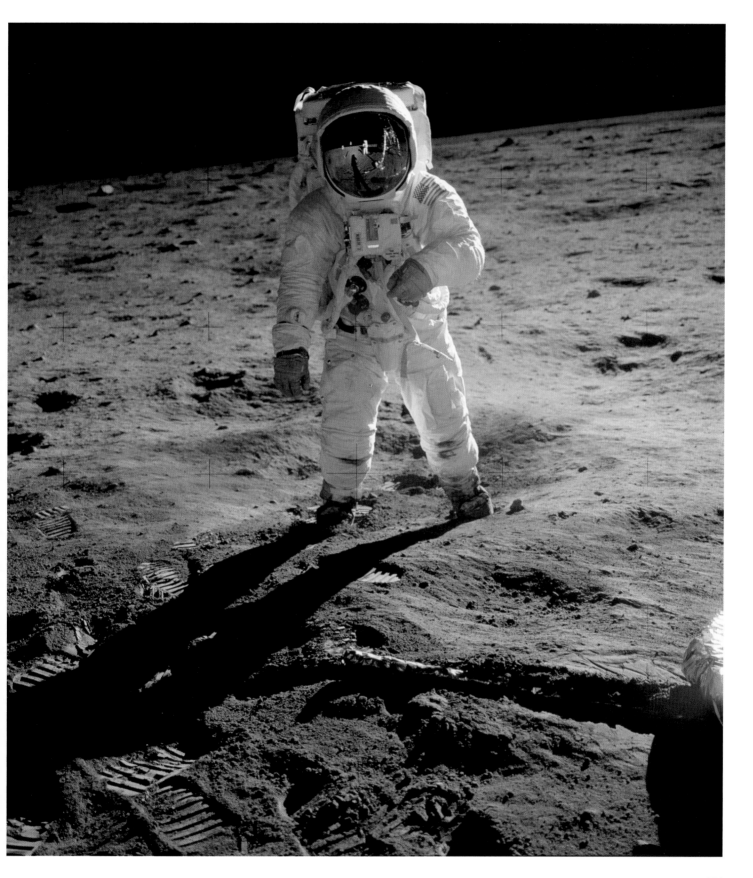

KENT STATE SHOOTINGS
John Paul Filo, 1970

'I could see the tension building in this girl, and finally she let out with the scream, and I sort of reacted to the scream and shot that picture.' –JOHN PAUL FILO

The shooting at Kent State University in Ohio lasted 13 seconds. When it was over, four students were dead, nine were wounded, and the innocence of a generation was shattered. The demonstrators were part of a national wave of student discontent spurred by the new presence of U.S. troops in Cambodia. At the Kent State Commons, protesters assumed that the National Guard troops that had been called to contain the crowds were firing blanks. But when the shooting stopped and students lay dead, it seemed that the war in Southeast Asia had come home. John Filo, a student and part-time news photographer, distilled that feeling into a single image when he captured Mary Ann Vecchio crying out and kneeling over a fatally wounded Jeffrey Miller. Filo's photograph was put out on the AP wire and printed on the front page of the New York *Times*. It went on to win the Pulitzer Prize and has since become the visual symbol of a hopeful nation's lost youth. As Neil Young wrote in the song "Ohio," inspired by a LIFE story featuring Filo's images, "Tin soldiers and Nixon coming/ We're finally on our own/ This summer I hear the drumming/ Four dead in Ohio."

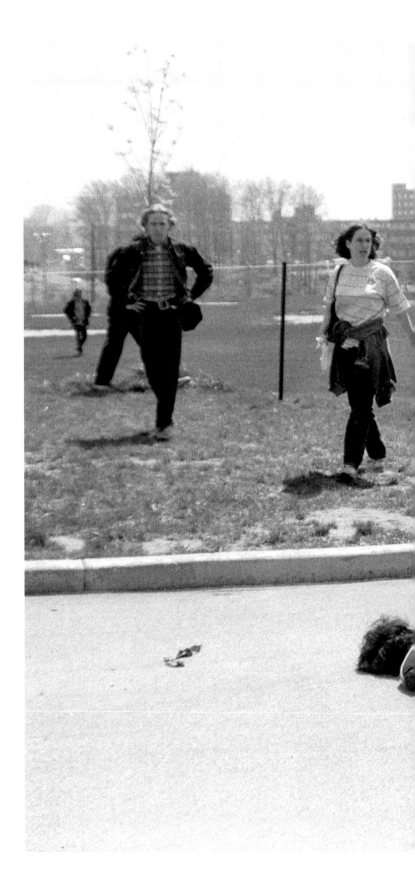

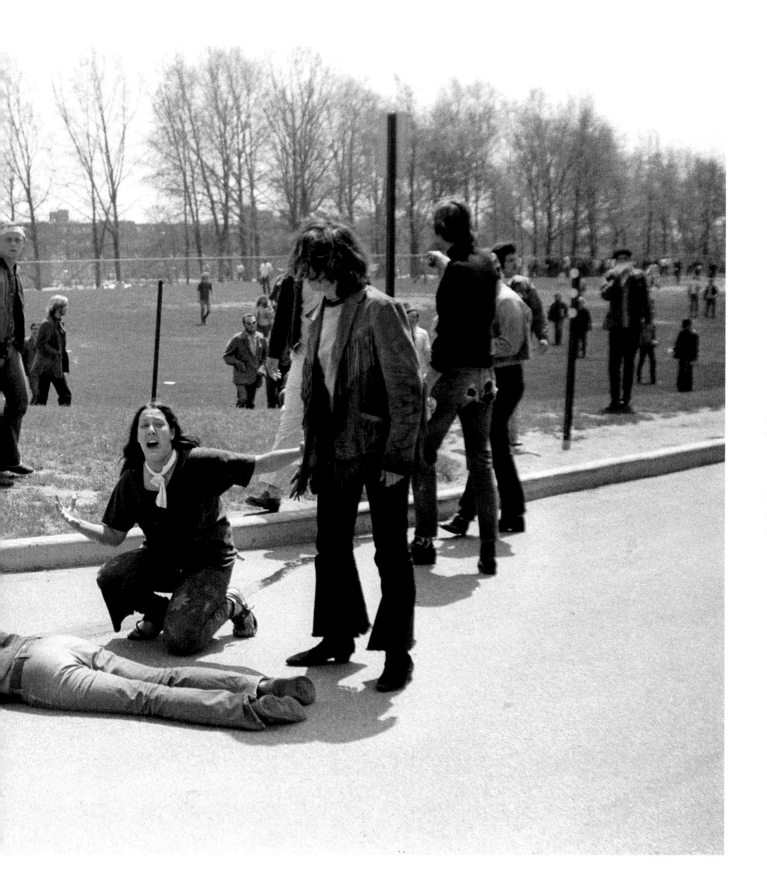

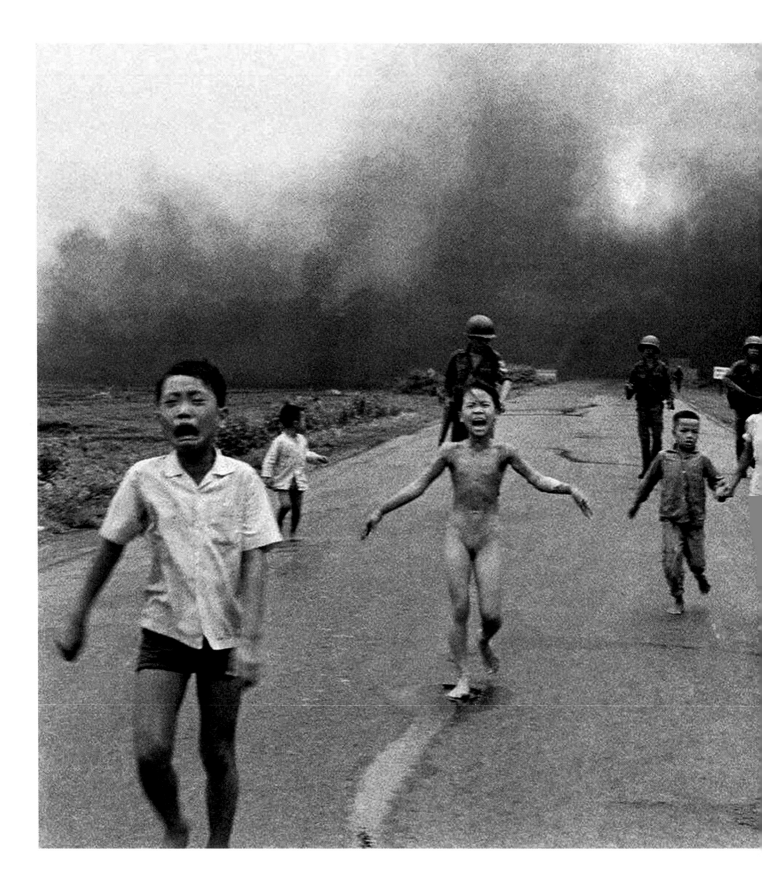

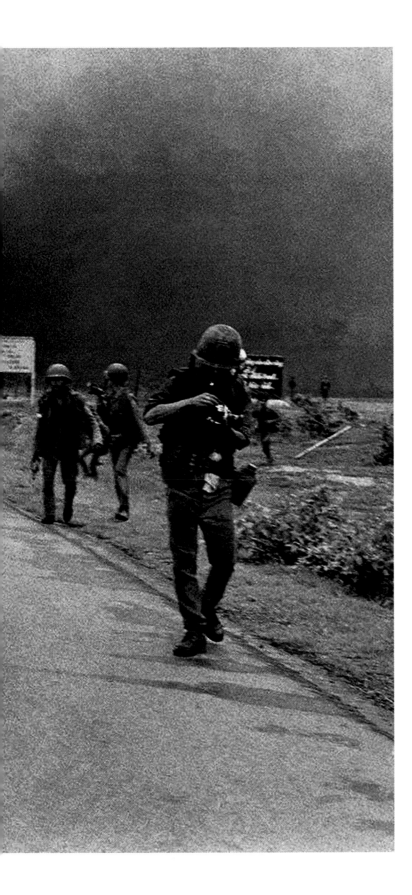

THE TERROR OF WAR | *Nick Ut, 1972*

'I saw fire everywhere around me. Then I saw the fire over my body.' –KIM PHUC

The faces of collateral damage and friendly fire are generally not seen. This was not the case with 9-year-old Phan Thi Kim Phuc. On June 8, 1972, Associated Press photographer Nick Ut was outside Trang Bang, about 25 miles northwest of Saigon, when the South Vietnamese air force mistakenly dropped a load of napalm on the village. As the Vietnamese photographer took pictures of the carnage, he saw a group of children and soldiers along with a screaming naked girl running up the highway toward him. Ut wondered, Why doesn't she have clothes? He then realized that she had been hit by napalm. "I took a lot of water and poured it on her body. She was screaming, 'Too hot! Too hot!'" Ut took Kim Phuc to a hospital, where he learned that she might not survive the third-degree burns covering 30 percent of her body. So with the help of colleagues he got her transferred to an American facility for treatment that saved her life. Ut's photo of the raw impact of conflict underscored that the war was doing more harm than good. It also sparked newsroom debates about running a photo with nudity, pushing many publications, including the New York *Times,* to override their policies. The photo quickly became a cultural shorthand for the atrocities of the Vietnam War and joined Malcolm Browne's *Burning Monk* and Eddie Adams' *Saigon Execution* as defining images of that brutal conflict. When President Richard Nixon wondered if the photo was fake, Ut commented, "The horror of the Vietnam War recorded by me did not have to be fixed." In 1973 the Pulitzer committee agreed and awarded him its prize. That same year, America's involvement in the war ended.

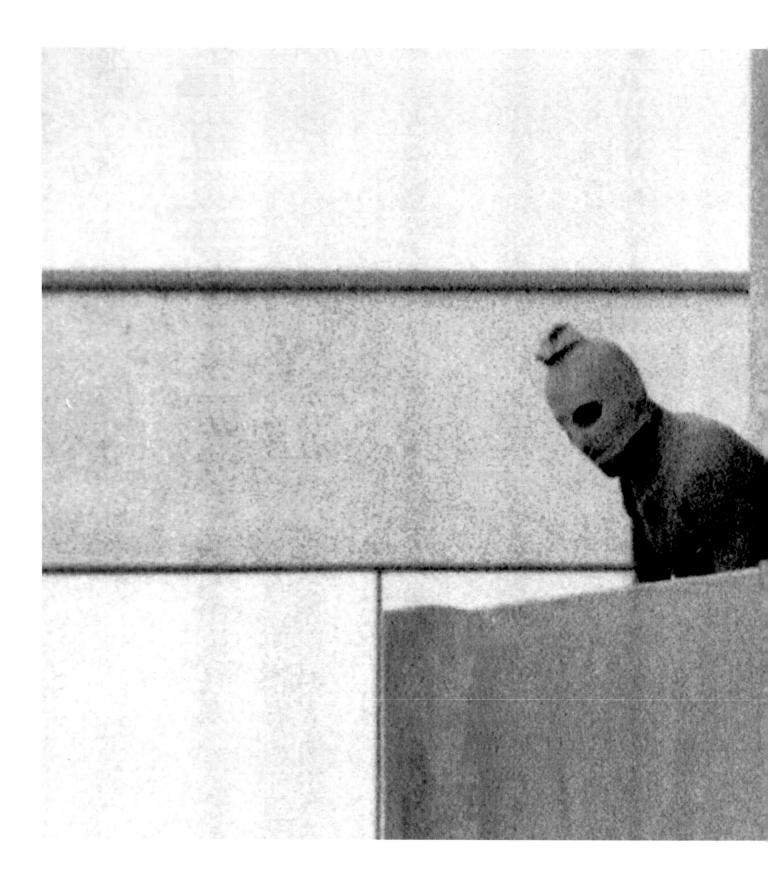

MUNICH MASSACRE | *Kurt Strumpf, 1972*

'The violence emerges unexpectedly
and faceless out of the predictable order.'
–KURT STRUMPF

The Olympics celebrate the best of humanity, and in 1972 Germany welcomed the Games to exalt its athletes, tout its democracy and purge the stench of Adolf Hitler's 1936 Games. The Germans called it "the Games of peace and joy," and as Israeli fencer Dan Alon recalled, "Taking part in the opening ceremony, only 36 years after Berlin, was one of the most beautiful moments in my life." Security was lax so as to project the feeling of harmony. Unfortunately, this made it easy on September 5 for eight members of the Palestinian terrorist group Black September to raid the Munich Olympic Village building housing Israeli Olympians. Armed with grenades and assault rifles, the terrorists killed two team members, took nine hostage and demanded the release of 234 of their jailed compatriots. The 21-hour hostage standoff presented the world with its first live window on terrorism, and 900 million people tuned in. During the siege, one of the Black Septemberists made his way out onto the apartment's balcony. As he did, Associated Press photographer Kurt Strumpf froze this haunting image, the faceless look of terror. As the Palestinians attempted to flee, German snipers tried to take them out, and the Palestinians killed the hostages and a policeman. The already fraught Arab-Israeli relationship became even more so, and the siege led to retaliatory attacks on Palestinian bases. Strumpf's photo of that specter with cutout eyes is a sobering reminder of how we were all diminished when the world realized that nothing was secure.

FIRE ESCAPE COLLAPSE | *Stanley Forman, 1975*

'I was shooting a routine rescue when it suddenly went to hell.' –STANLEY FORMAN

Stanley Forman was working for the Boston *Herald American* on July 22, 1975, when he got a call about a fire on Marlborough Street. He raced over in time to see a woman and child on a fifth-floor fire escape. A fireman had set out to help them, and Forman figured he was shooting another routine rescue. "Suddenly the fire escape gave way," he recalled, and Diana Bryant, 19, and her goddaughter Tiare Jones, 2, were swimming through the air. "I was shooting pictures as they were falling—then I turned away. It dawned on me what was happening, and I didn't want to see them hit the ground. I can still remember turning around and shaking." Bryant died from the fall, her body cushioning the blow for her goddaughter, who survived. While the event was no different from the routine tragedies that fill the local news, Forman's picture of it was. Using a motor-drive camera, Forman was able to freeze the horrible tumbling moment down to the expression on young Tiare's face. The photo earned Forman the Pulitzer Prize and led municipalities around the country to enact tougher fire-escape-safety codes. But its lasting legacy is as much ethical as temporal. Many readers objected to the publication of Forman's picture, and it remains a case study in the debate over when disturbing images are worth sharing.

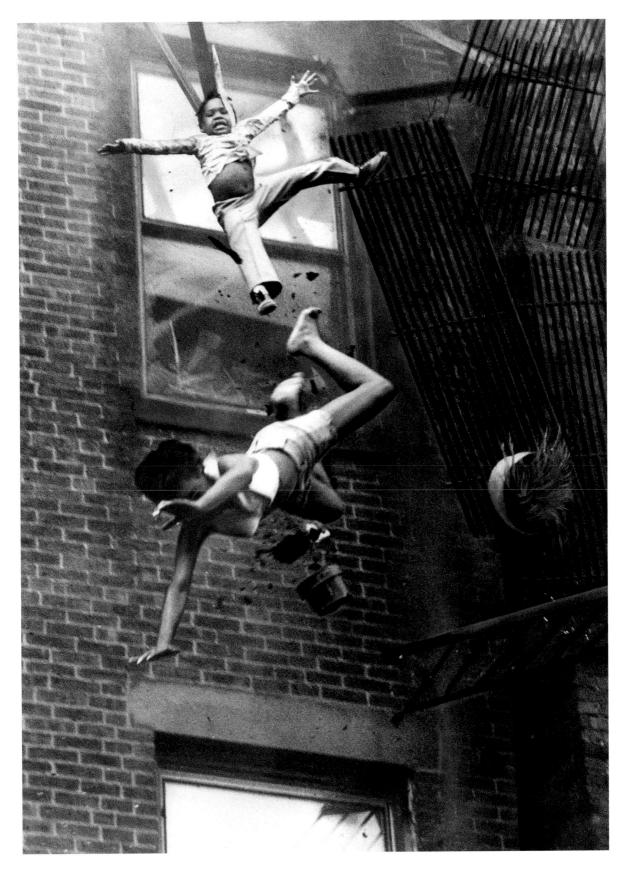

SOWETO UPRISING | *Sam Nzima, 1976*

'The police were flying in front of me, shooting the students on the side.' –SAM NZIMA

Few outside South Africa paid much attention to apartheid before June 16, 1976, when several thousand Soweto students set out to protest the introduction of mandatory Afrikaans-language instruction in their township schools. Along the way they gathered youngsters from other schools, including a 13-year-old student named Hector Pieterson. Skirmishes started to break out with the police, and at one point officers fired tear gas. When students hurled stones, the police shot real bullets into the crowd. "At first, I ran away from the scene," recalled Sam Nzima, who was covering the protests for the *World*, the paper that was the house organ of black Johannesburg. "But then, after recovering myself, I went back." That is when Nzima says he spotted Pieterson fall down as gunfire showered above. He kept taking pictures as terrified high schooler Mbuyisa Makhubu picked up the lifeless boy and ran with Pieterson's sister, Antoinette Sithole. What began as a peaceful protest soon turned into a violent uprising, claiming hundreds of lives across South Africa. Prime Minister John Vorster warned, "This government will not be intimidated." But the armed rulers were powerless against Nzima's photo of Pieterson, which showed how the South African regime killed its own people. The picture's publication forced Nzima into hiding amid death threats, but its effect could not have been more visible. Suddenly the world could no longer ignore apartheid. The seeds of international opposition that would eventually topple the racist system had been planted by a photograph.

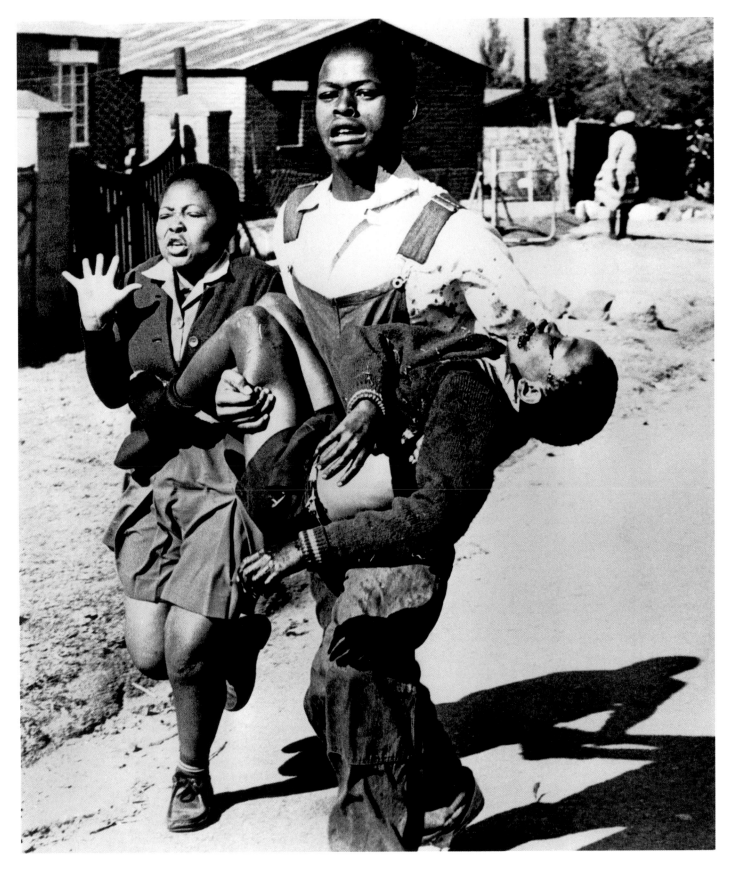

BOAT OF NO SMILES | *Eddie Adams, 1977*

'This is the first time in my life that nobody smiled, not even the children.' –EDDIE ADAMS

It's easy to ignore the plight of refugees. They are seen as numbers more than people, moving from one distant land to the next. But a picture can puncture that illusion. The sun hadn't yet risen on Thanksgiving Day in 1977 when Associated Press photographer Eddie Adams watched a fishing boat packed with South Vietnamese refugees drift toward Thailand. He was on patrol with Thai maritime authorities as the unstable vessel carrying about 50 people came to shore after days at sea. Thousands of refugees had streamed from postwar Vietnam since the American withdrawal more than two years earlier, fleeing communism by fanning out across Southeast Asia in search of safe harbor. Often they were pushed back into the abyss and told to go somewhere else. Adams boarded the packed fishing boat and began shooting. He didn't have long. Eventually Thai authorities demanded that he disembark—wary, Adams believed, that his presence would create sympathy for the refugees that might compel Thailand to open its doors. On that score, they were right. Adams transmitted his pictures and wrote a short report, and within days they were published widely. The images were presented to Congress, helping to open the doors for more than 200,000 refugees from Vietnam to enter the U.S. from 1978 to 1981. "The pictures did it," Adams said, "pushed it over."

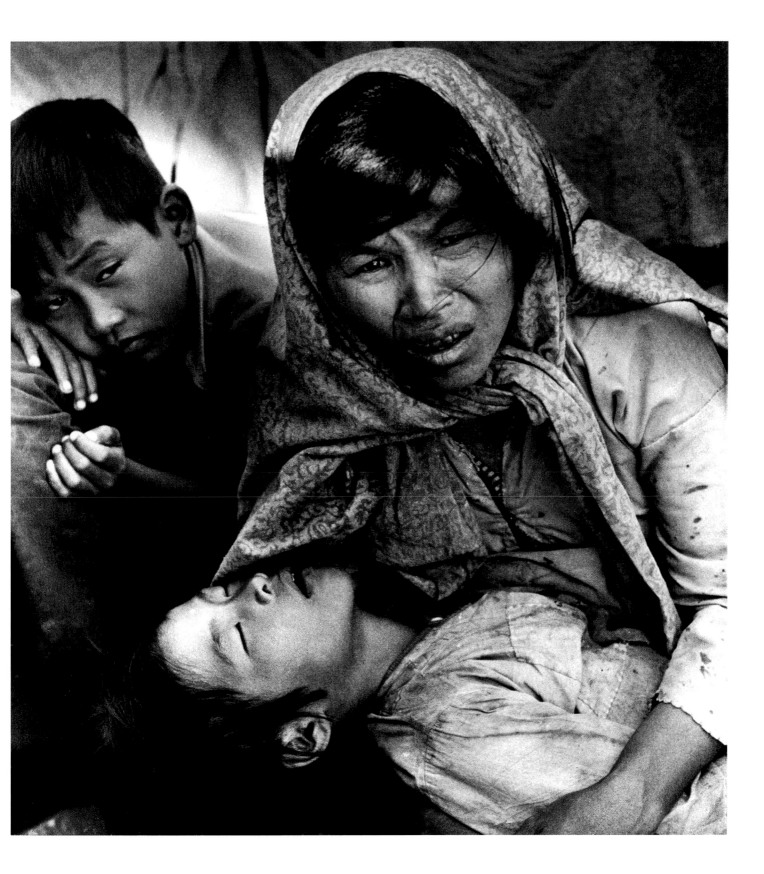

FIRING SQUAD IN IRAN
Jahangir Razmi, 1979

Few images are as stark as one of an execution. On August 27, 1979, 11 men who had been convicted of being "counterrevolutionary" by the regime of Iranian ruler Ayatullah Ruhollah Khomeini were lined up on a dirt field at Sanandaj Airport and gunned down side by side. No international journalists witnessed the killings. They had been banned from Iran by Khomeini, which meant it was up to the domestic press to chronicle the bloody conflict between the theocracy and the local Kurds, who had been denied representation in Khomeini's government. The Iranian photographer Jahangir Razmi had been tipped off to the trial, and he shot two rolls of film at the executions. One image, with bodies crumpled on the ground and another man moments from joining them, was published anonymously on the front page of the Iranian daily *Ettela'at*. Within hours, members of the Islamic Revolutionary Council appeared at the paper's office and demanded the photographer's name. The editor refused. Days later, the picture was picked up by the news service UPI and trumpeted in papers around the world as evidence of the murderous nature of Khomeini's brand of religious government. The following year, *Firing Squad in Iran* was awarded the Pulitzer Prize—the only anonymous winner in history. It was not until 2006 that Razmi was revealed as the photographer.

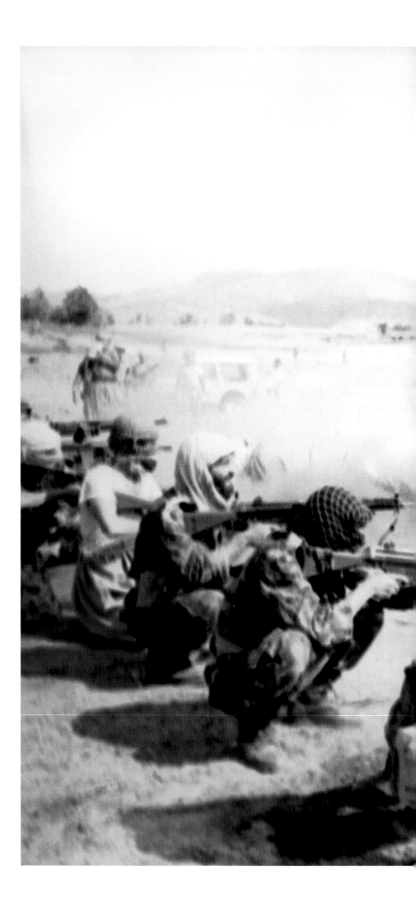

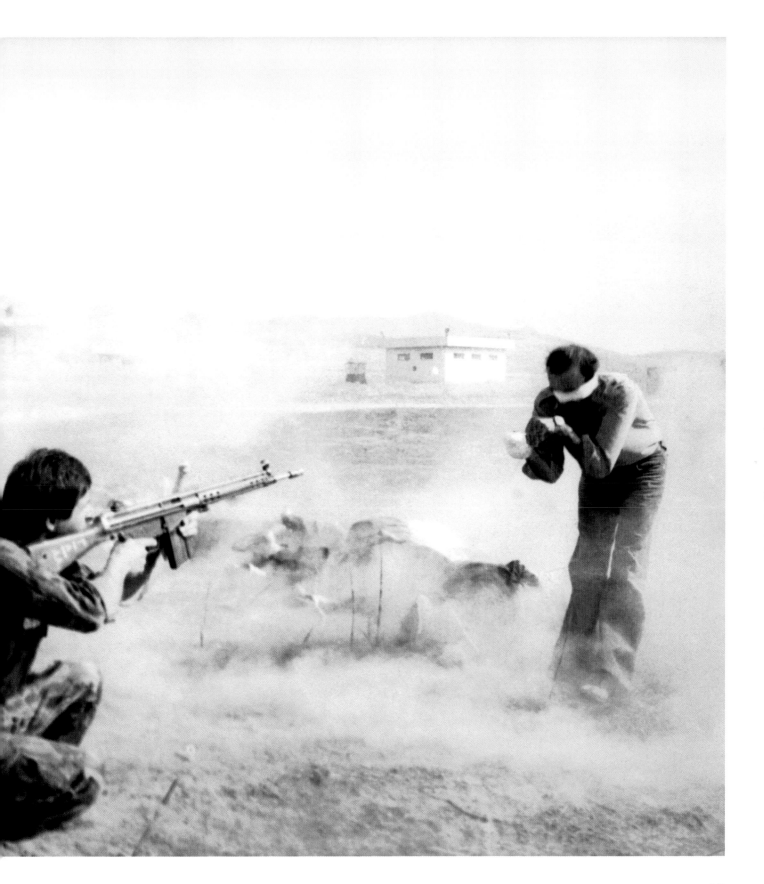

BEHIND CLOSED DOORS | *Donna Ferrato, 1982*

'I also was thinking if I get a picture of this,
at least people will believe that it really happened.'
–DONNA FERRATO

There was nothing particularly special about Garth and Lisa or the violence that happened in the bathroom of their suburban New Jersey home one night in 1982. Enraged by a perceived slight, Garth beat his wife while she cowered in a corner. Such acts of intimate-partner violence are not uncommon, but they usually happen in private. This time another person was in the room, photographer Donna Ferrato.

Ferrato, who had come to know the couple through a photo project on wealthy swingers, knew that simply bearing witness wasn't enough. Her shutter clicked again and again. Ferrato approached magazine editors to publish the images, but all refused. So Ferrato did, in her 1991 book *Living With the Enemy.* The landmark volume chronicled domestic-violence episodes and their aftermaths, including those of the pseudonymous Garth and Lisa. Their real names are Elisabeth and Bengt; his identity was revealed for the first time as part of this project. Ferrato captured incidents and victims while living inside women's shelters and shadowing police. Her work helped bring violence against women out of the shadows and forced policy-makers to confront the issue. In 1994, Congress passed the Violence Against Women Act, increasing penalties against offenders and helping train police to treat it as a serious crime. Thanks to Ferrato, a private tragedy became a public cause.

TANK MAN | *Jeff Widener, 1989*

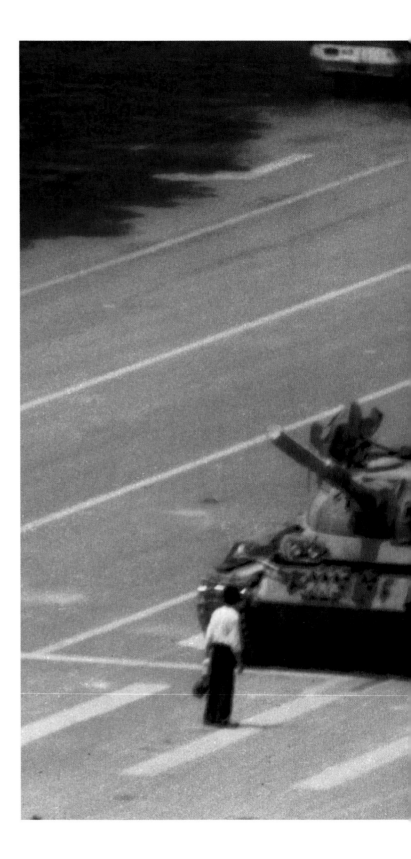

'When I got up to the room, what made me totally unsettled was that there was a bullet hole right behind me on the wall, so I knew I was easy pickins for anybody that wanted to get me.' –JEFF WIDENER

On the morning of June 5, 1989, photographer Jeff Widener was perched on a sixth-floor balcony of the Beijing Hotel. It was a day after the Tiananmen Square massacre, when Chinese troops attacked pro-democracy demonstrators camped on the plaza, and the Associated Press sent Widener to document the aftermath. As he photographed bloody victims, passersby on bicycles and the occasional scorched bus, a column of tanks began rolling out of the plaza. Widener lined up his lens just as a man carrying shopping bags stepped in front of the war machines, waving his arms and refusing to move.

The tanks tried to go around the man, but he stepped back into their path, climbing atop one briefly. Widener assumed the man would be killed, but the tanks held their fire. Eventually the man was whisked away, but not before Widener immortalized his singular act of resistance. Others also captured the scene, but Widener's image was transmitted over the AP wire and appeared on front pages all over the world. Decades after Tank Man became a global hero, he remains unidentified. The anonymity makes the photograph all the more universal, a symbol of resistance to unjust regimes everywhere.

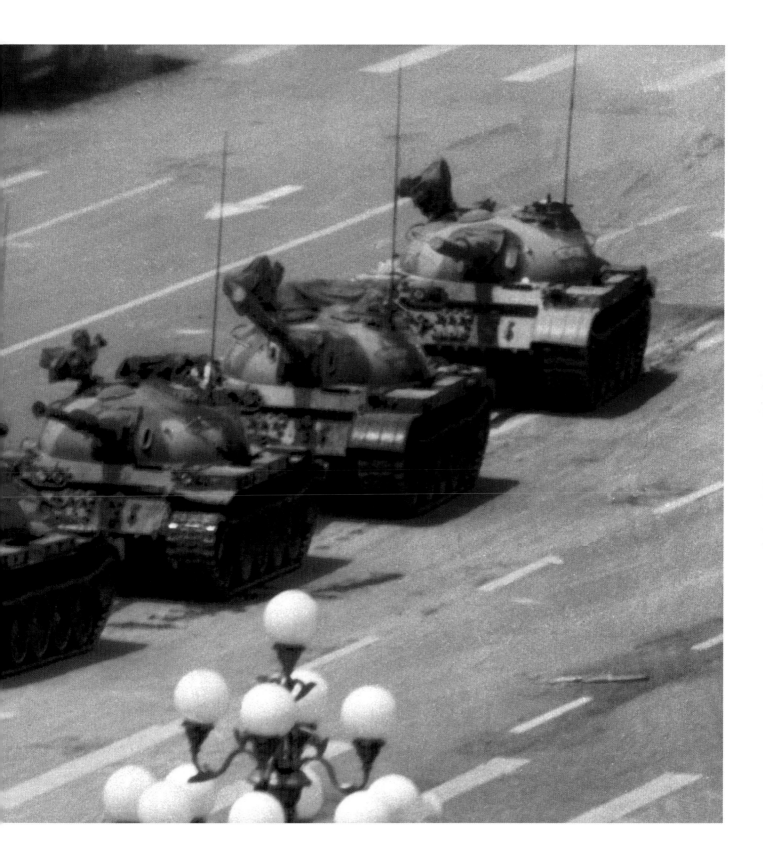

BOSNIA | *Ron Haviv, 1992*

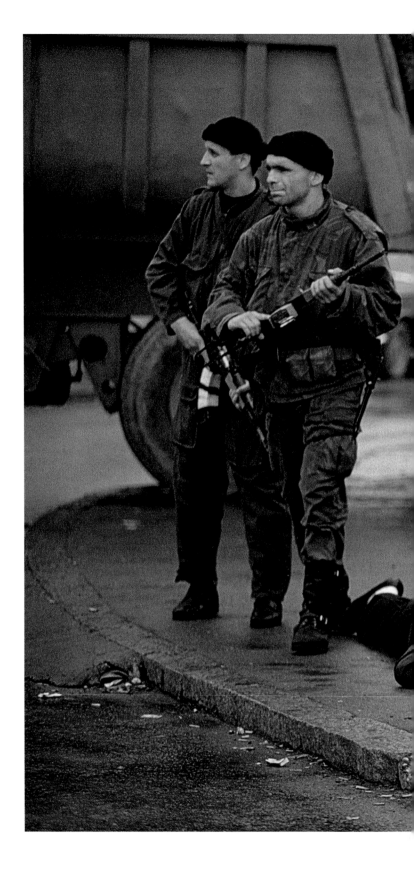

'He introduced the world to the brutality of Arkan's men.' –DERMOT GROOME, INTERNATIONAL COURT OF JUSTICE PROSECUTOR

It can take time for even the most shocking images to have an effect. The war in Bosnia had not yet begun when American Ron Haviv took this picture of a Serb kicking a Muslim woman who had been shot by Serb forces. Haviv had gained access to the Tigers, a brutal nationalist militia that had warned him not to photograph any killings. But Haviv was determined to document the cruelty he was witnessing and, in a split second, decided to risk it. TIME published the photo a week later, and the image of casual hatred ignited broad debate over the international response to the worsening conflict. Still, the war continued for more than three years, and Haviv—who was put on a hit list by the Tigers' leader, Zeljko Raznatovic, or Arkan—was frustrated by the tepid reaction. Almost 100,000 people lost their lives. Before his assassination in 2000, Arkan was indicted for crimes against humanity. Haviv's image was used as evidence against him and other perpetrators of what became known as ethnic cleansing.

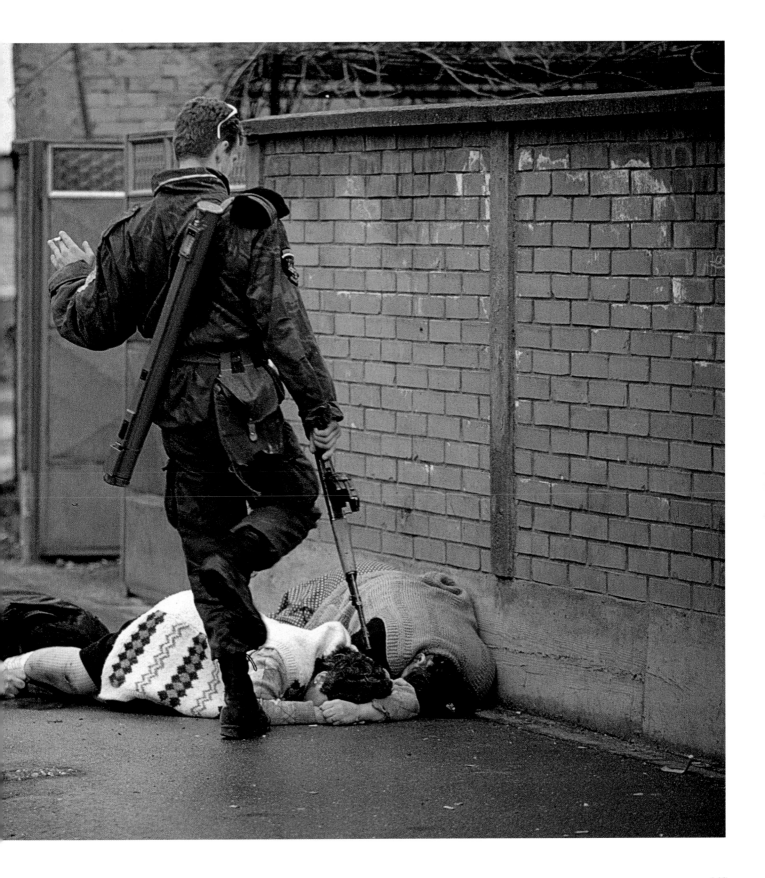

FAMINE IN SOMALIA
James Nachtwey, 1992

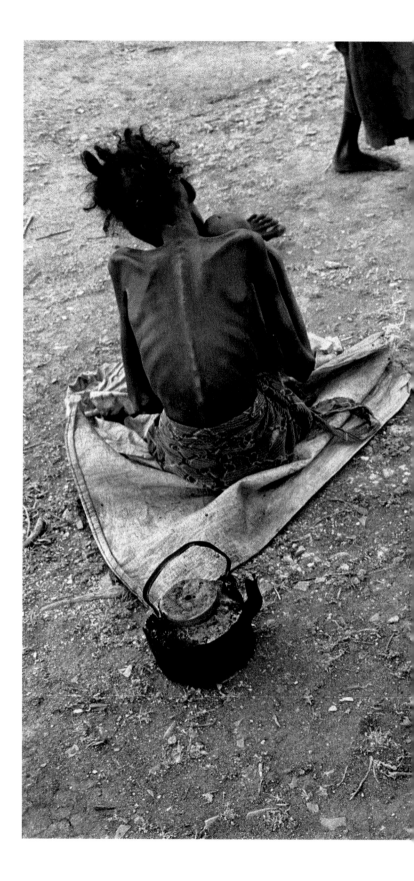

'If people are in need, or if they are suffering, it does not mean they don't express dignity.' –JAMES NACHTWEY

James Nachtwey couldn't get an assignment in 1992 to document the spiraling famine in Somalia. Mogadishu had become engulfed in armed conflict as food prices soared and international assistance failed to keep pace. Yet few in the West took much notice, so the American photographer went on his own to Somalia, where he received support from the International Committee of the Red Cross. Nachtwey brought back a cache of haunting images, including this scene of a woman waiting to be taken to a feeding center in a wheelbarrow. After it was published as part of a cover feature in the New York *Times* Magazine, one reader wrote, "Dare we say that it doesn't get any worse than this?" The world was similarly moved. The Red Cross said public support resulted in what was then its largest operation since World War II. One and a half million people were saved, the ICRC's Jean-Daniel Tauxe told the *Times*, and "James' pictures made the difference."

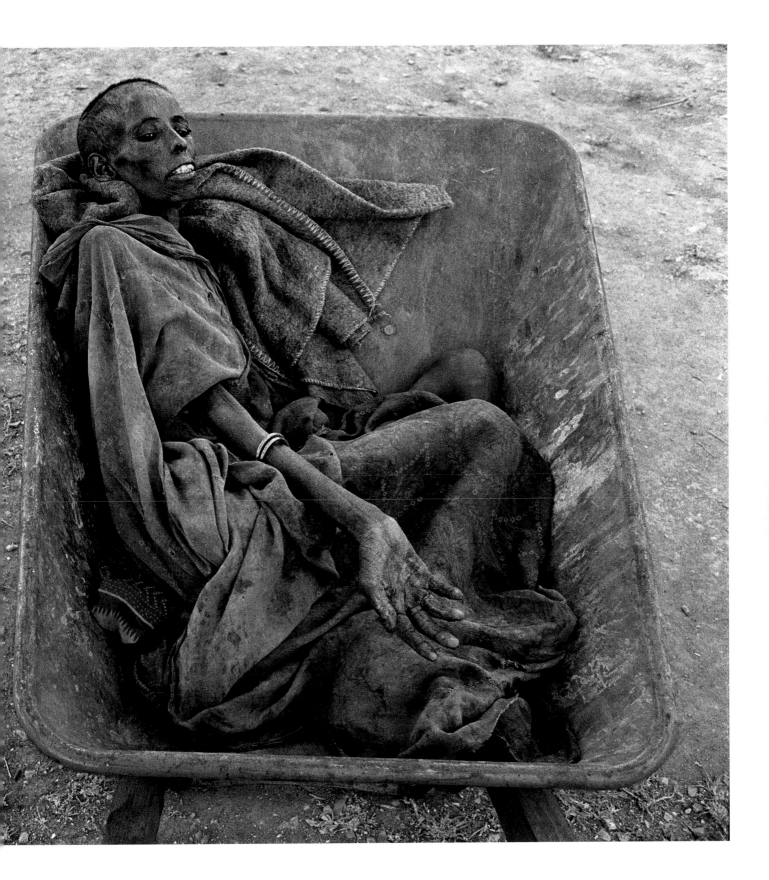

STARVING CHILD AND VULTURE
Kevin Carter, 1993

'This is my most successful image after
10 years of taking pictures, but I do not hang it
on my wall. I hate it.' –KEVIN CARTER

Kevin Carter knew the stench of death. As a member of the Bang-Bang Club, a quartet of brave photographers who chronicled apartheid-era South Africa, he had seen more than his share of heartbreak. In 1993 he flew to Sudan to photograph the famine racking that land. Exhausted after a day of taking pictures in the village of Ayod, he headed out into the open bush. There he heard whimpering and came across an emaciated toddler who had collapsed on the way to a feeding center. As he took the child's picture, a plump vulture landed nearby. Carter had reportedly been advised not to touch the victims because of disease, so instead of helping, he spent 20 minutes waiting in the hope that the stalking bird would open its wings. It did not. Carter scared the creature away and watched as the child continued toward the center. He then lit a cigarette, talked to God and wept. The New York *Times* ran the photo, and readers were eager to find out what happened to the child—and to criticize Carter for not coming to his subject's aid. His image quickly became a wrenching case study in the debate over when photographers should intervene. Subsequent research seemed to reveal that the child did survive yet died 14 years later from malarial fever. Carter won a Pulitzer for his image, but the darkness of that bright day never lifted from him. In July 1994 he took his own life, writing, "I am haunted by the vivid memories of killings & corpses & anger & pain."

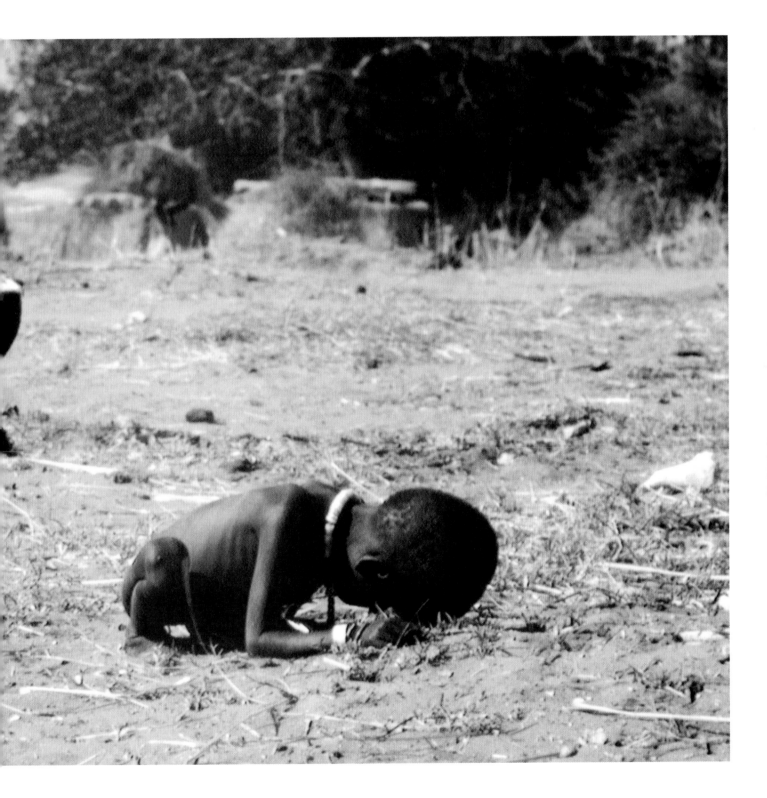

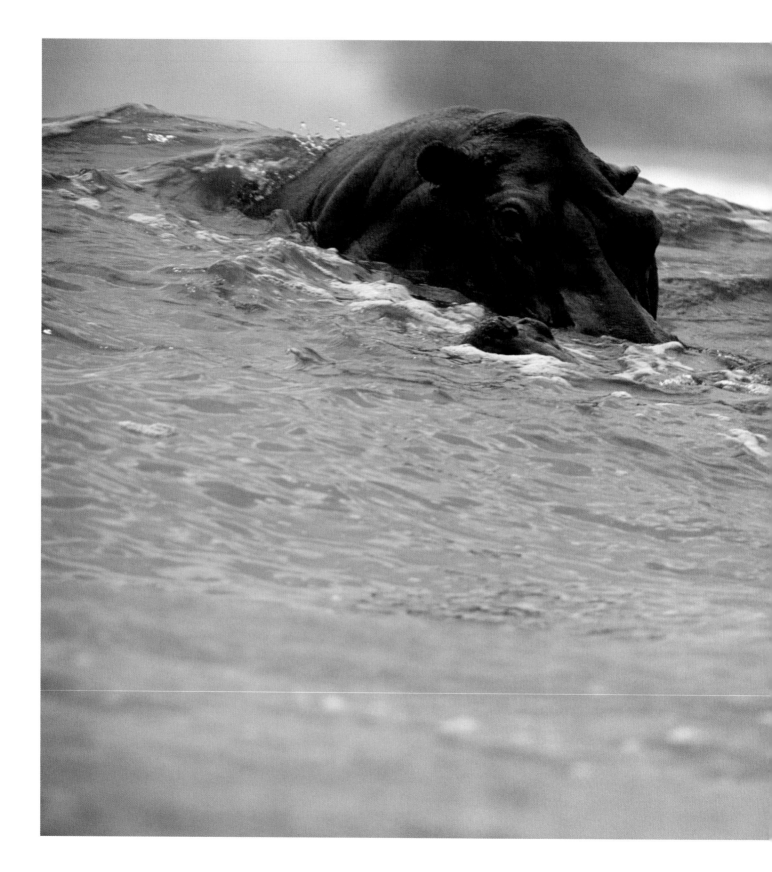

SURFING HIPPOS
Michael Nichols, 2000

'If you want to bring governments and the common man to move on something, they have to be captivated by it.' –J. MICHAEL FAY, EXPLORER

Seven billion human beings take up a certain amount of space, which is one reason why wilderness—true, untouched wilderness—is fast dwindling around the world. Even in Africa, where lions and elephants still roam, the space for wild animals is shrinking. That's what makes Michael Nichols' photograph so special. Nichols and the National Geographic Society explorer Michael Fay undertook an arduous 2,000-mile trek from the Congo in central Africa to Gabon on the continent's west coast. That was where Nichols captured a photograph of something astonishing— hippopotamuses swimming in the midnight blue Atlantic Ocean. It was an event few had seen before— while hippos spend most of their time in water, their habitat is more likely to be an inland river or swamp than the crashing sea.

The photograph itself is reliably beautiful, the eyes and snout of the hippo peeking just above the rippling ocean surface. But its effect was more than aesthetic. Gabon President Omar Bongo was inspired by Nichols' pictures to create a system of national parks that now cover 11 percent of the country, ensuring that there will be at least some space left for the wild.

FALLING MAN | *Richard Drew, 2001*

The most widely seen images from 9/11 are of planes and towers, not people. *Falling Man* is different. The photo, taken by Richard Drew in the moments after the September 11, 2001, attacks, is one man's distinct escape from the collapsing buildings, a symbol of individuality against the backdrop of faceless skyscrapers. On a day of mass tragedy, *Falling Man* is one of the only widely seen pictures that shows someone dying. The photo was published in newspapers around the U.S. in the days after the attacks, but backlash from readers forced it into temporary obscurity. It can be a difficult image to process, the man perfectly bisecting the iconic towers as he darts toward the earth like an arrow. Falling Man's identity is still unknown, but he is believed to have been an employee at the Windows on the World restaurant, which sat atop the north tower. The true power of *Falling Man*, however, is less about who its subject was and more about what he became: a makeshift Unknown Soldier in an often unknown and uncertain war, suspended forever in history.

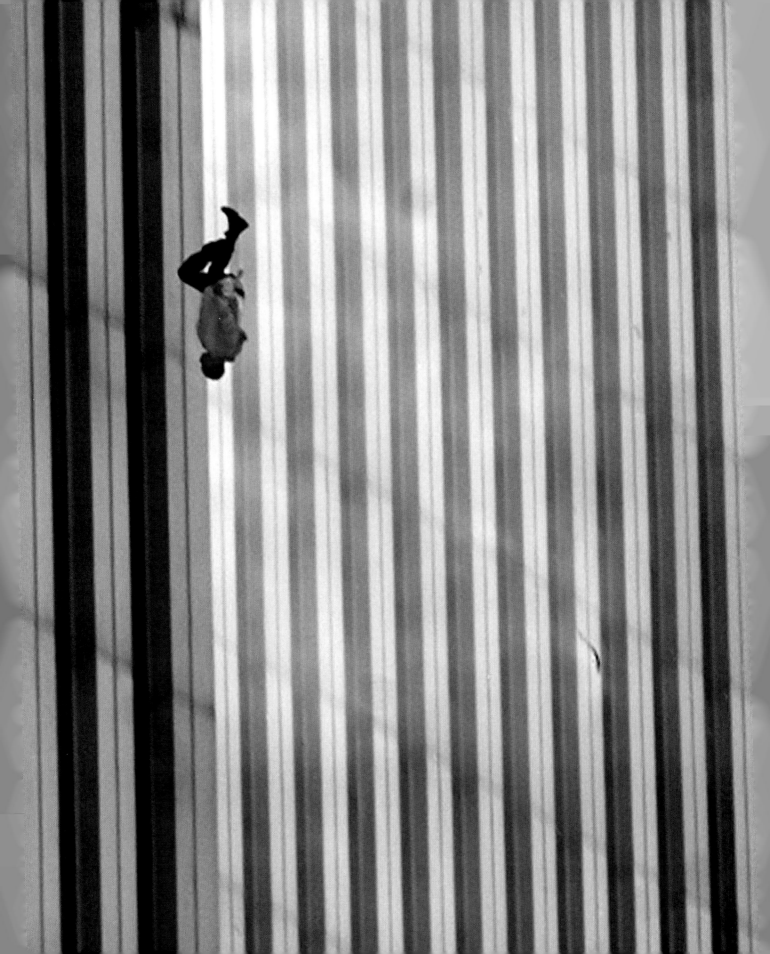

THE HOODED MAN | *Sergeant Ivan Frederick, 2003*

'The war in Iraq, like Vietnam, will probably be
remembered as the one time that we were not the heroes.
We were not the saviors. And these photographs will play
a big part in that.' –BRENT PACK, ARMY INVESTIGATOR

Hundreds of photojournalists covered the conflict in Iraq, but the most memorable image from the war was taken not by a professional but by a U.S. Army staff sergeant named Ivan Frederick. In the last three months of 2003, Frederick was the senior enlisted man at Abu Ghraib prison, the facility on the outskirts of Baghdad that Saddam Hussein had made into a symbol of terror for all Iraqis, then being used by the U.S. military as a detention center for suspected insurgents. Even before the Iraq War began, many questioned the motives of the American, British and allied governments for the invasion that toppled Saddam. But nothing undermined the allies' claim that they were helping bring democracy to the country more than the scandal at Abu Ghraib. Frederick was one of several soldiers who took part in the torture of Iraqi prisoners in Abu Ghraib. All the more incredible was that they took thousands of images of their mistreatment, humiliation and torture of detainees with digital cameras and shared the photographs. The most widely disseminated was "the Hooded Man," partly because it was less explicit than many of the others and so could more easily appear in mainstream publications. The man with outstretched arms in the photograph was deprived of his sight, his clothes, his dignity and, with electric wires, his sense of personal safety. And his pose? It seemed deliberately, unnervingly Christlike. The liberating invaders, it seemed, held nothing sacred.

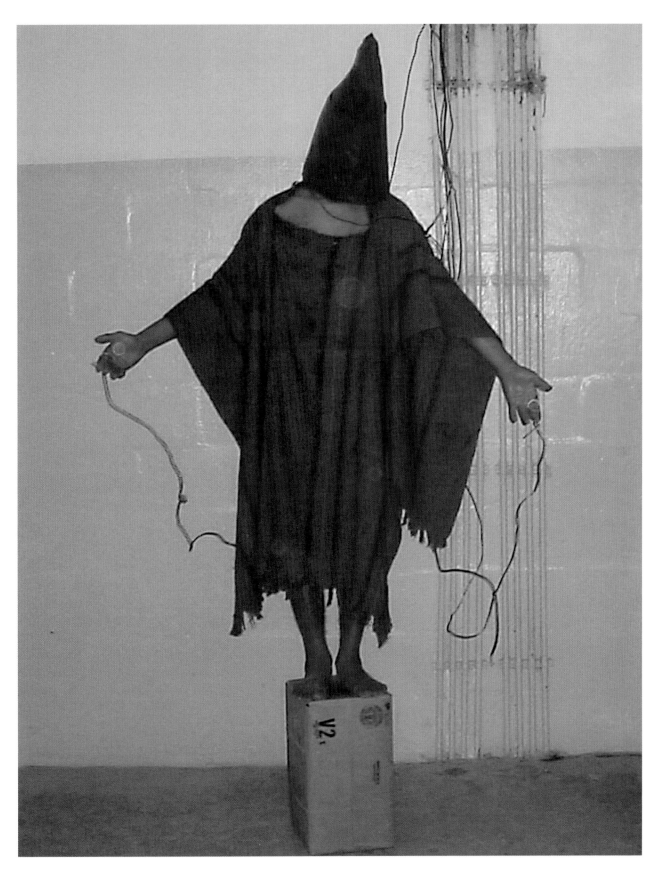

COFFIN BAN | *Tami Silicio, 2004*

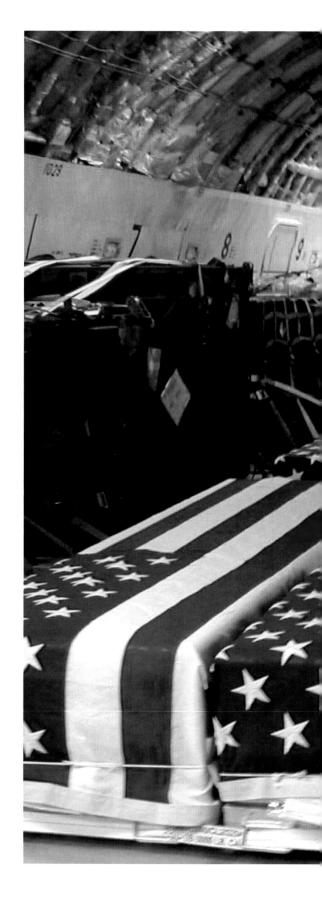

'My feelings were so built up—my heart
was so full of grief. And it came out in the picture.'
—TAMI SILICIO

By April 2004, some 700 U.S. troops had been killed on the battlefield in Iraq, but images of the dead returning home in coffins were never seen. The U.S. government had banned news organizations from photographing such scenes in 1991, arguing that they violated families' privacy and the dignity of the dead. To critics, the policy was simply a way of sanitizing an increasingly bloody conflict. As a government contractor working for a cargo company in Kuwait, Tami Silicio was moved by the increasingly human freight she was loading and felt compelled to share what she was seeing. On April 7, Silicio used her Nikon Coolpix to photograph more than 20 flag-draped coffins as they passed through Kuwait on their way to Dover Air Force Base in Delaware. She emailed the picture to a friend in the U.S., who forwarded it to a photo editor at the Seattle *Times*. With Silicio's permission, the *Times* put the photo on its front page on April 18—and immediately set off a firestorm. Within days, Silicio was fired from her job and a debate raged over the ethics of publishing the images. While the government claimed that families of troops killed in action agreed with its policy, many felt that the pictures should not be censored. In late 2009, during President Barack Obama's first year in office, the Pentagon lifted the ban.

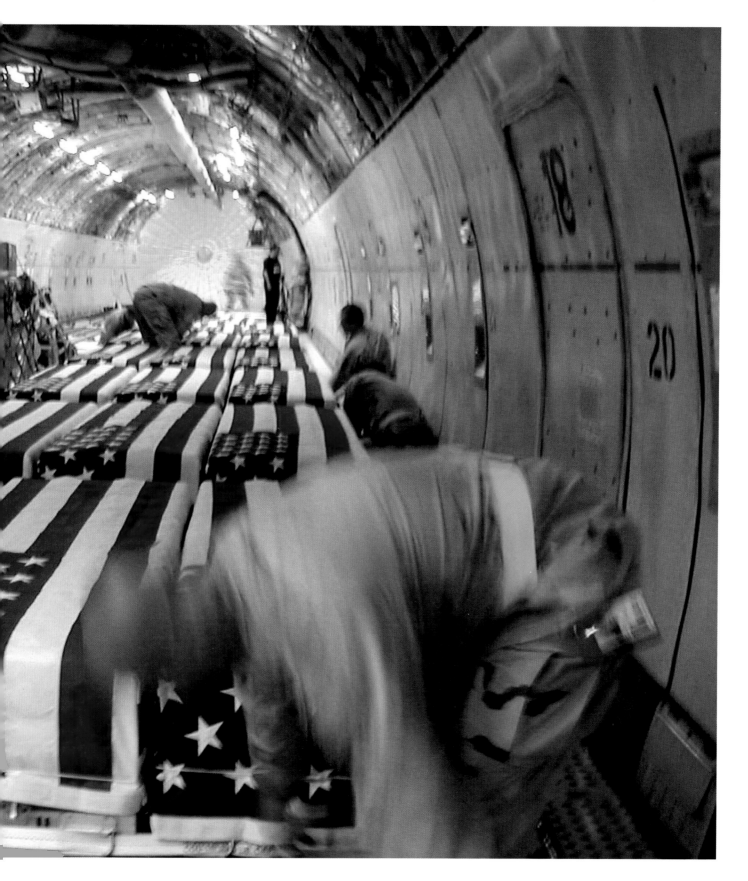

IRAQI GIRL AT CHECKPOINT
Chris Hondros, 2005

'As much as that happens in Iraq, it almost never gets photographed, and so I did realize I was onto an important set of pictures.' –CHRIS HONDROS

Moments before American photojournalist Chris Hondros took this picture of Samar Hassan, the little girl was in the backseat of her family's car as they drove home from the Iraqi city of Tall 'Afar. Now Samar was an orphan, her parents shot dead by U.S. soldiers who had opened fire because they feared the car might be carrying insurgents or a suicide bomber. It was January 2005, and the war in Iraq was at its most brutal. Such horrific accidents were not rare in that chaotic conflict, but they had never been documented in real time. Hondros, who worked for Getty Images, was embedded with the Army unit when the shooting happened. He transmitted his photographs immediately, and by the following day they were published around the world. The images led the U.S. military to revise its checkpoint procedures, but their greater effect was in compelling an already skeptical public to ask why American soldiers were killing the people they had ostensibly come to liberate and protect.

Hondros was killed during the civil war in Libya in 2011.

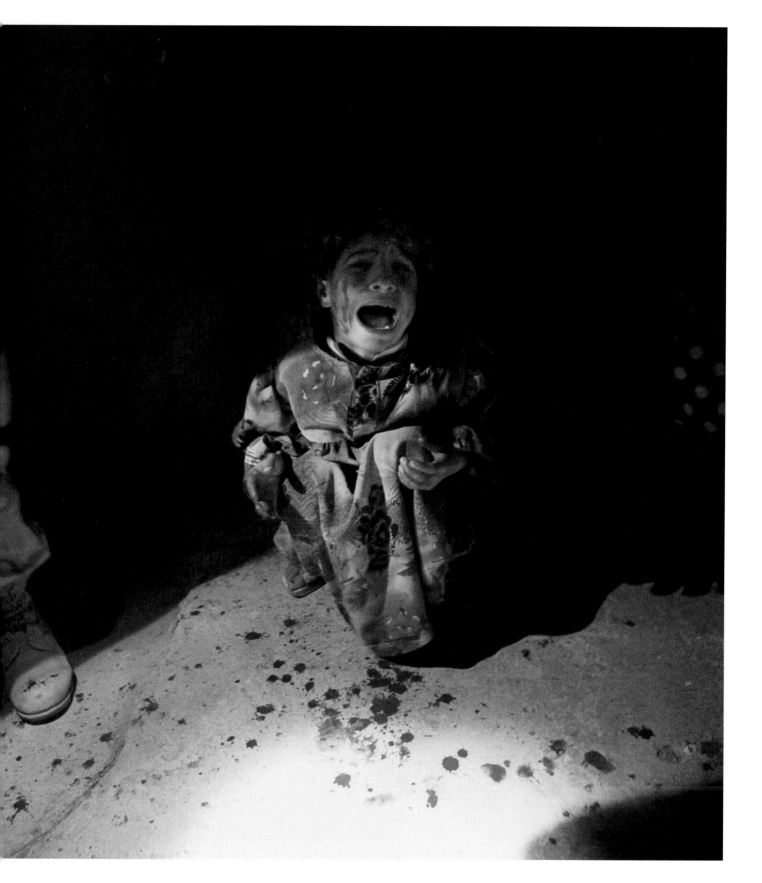

GORILLA IN THE CONGO
Brent Stirton, 2007

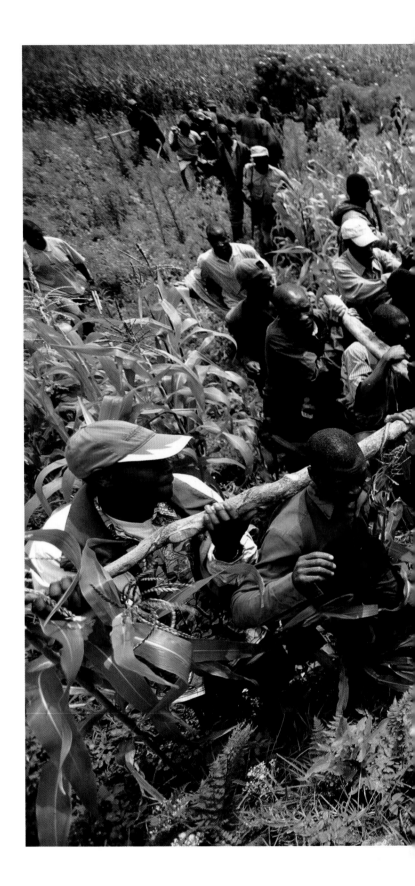

'This wasn't random, this was planned.'
–BRENT STIRTON

Senkwekwe the silverback mountain gorilla weighed at least 500 pounds when his carcass was strapped to a makeshift stretcher, and it took more than a dozen men to hoist it into the air. Brent Stirton captured the scene while in Virunga National Park in the Democratic Republic of Congo. Senkwekwe and several other gorillas were shot dead as a violent conflict engulfed the park, where half the world's critically endangered mountain gorillas live.

When Stirton photographed residents and park rangers respectfully carrying Senkwekwe out of the forest in 2007, the park was under siege by people illegally harvesting wood to be used in a charcoal industry that grew in the wake of the Rwandan genocide. In the photo, Senkwekwe looks huge but vaguely human, a reminder that conflict in Central Africa affects more than just the humans caught in its cross fire; it also touches the region's environment and animal inhabitants. Three months after Stirton's photograph was published in *Newsweek*, nine African countries—including Congo—signed a legally binding treaty to help protect the mountain gorillas in Virunga.

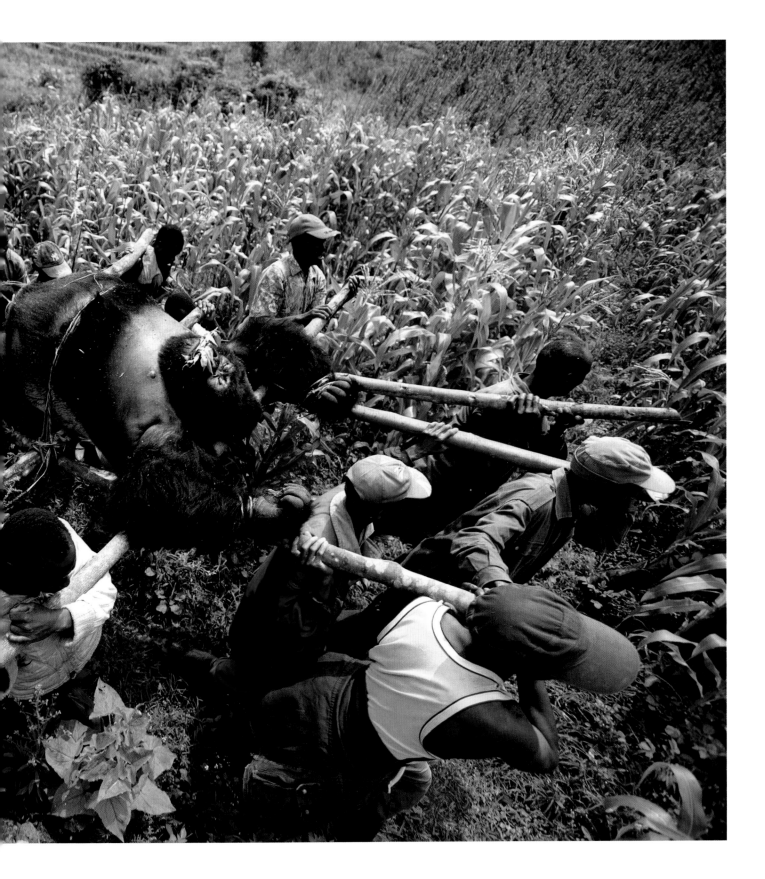

THE SITUATION ROOM
Pete Souza, 2011

'This was the longest 40 minutes of my life.'
–BARACK OBAMA

Official White House photographers document Presidents at play and at work, on the phone with world leaders and presiding over Oval Office meetings. But sometimes the unique access allows them to capture watershed moments that become our collective memory. On May 1, 2011, Pete Souza was inside the Situation Room as U.S. forces raided Osama bin Laden's Pakistan compound and killed the terrorist leader. Yet Souza's picture includes neither the raid nor bin Laden. Instead he captured those watching the secret operation in real time. President Barack Obama made the decision to launch the attack, but like everyone else in the room, he is a mere spectator to its execution. He stares, brow furrowed, at the raid unfolding on monitors. Secretary of State Hillary Clinton covers her mouth, waiting to see its outcome.

In a national address that evening from the White House, Obama announced that bin Laden had been killed. Photographs of the dead body have never been released, leaving Souza's photo and the tension it captured as the only public image of the moment the war on terror notched its most important victory.

166

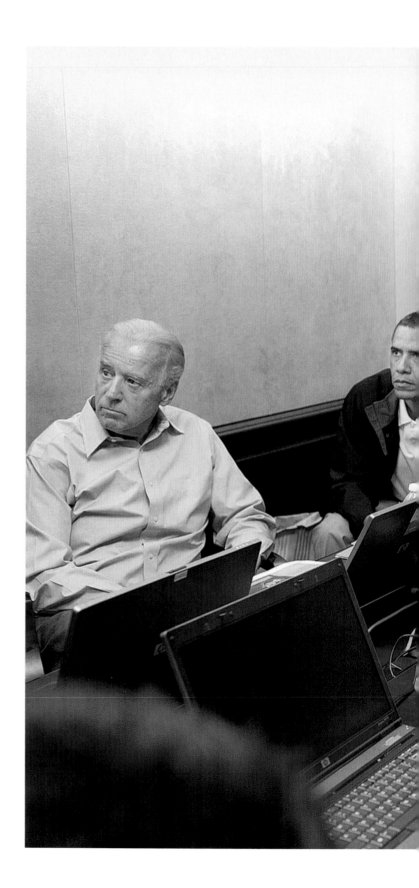

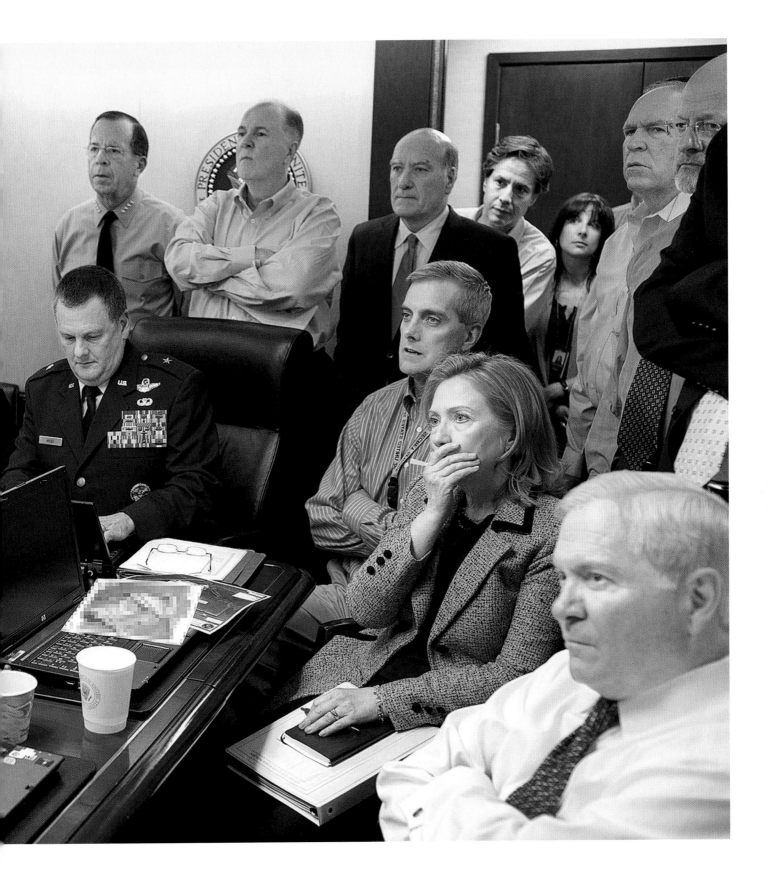

INNOVATION

Art and science—though sometimes sketched as opposites—are really two volumes in the same marvelous book. Both express the human longing to share what we see, in the world and in our imaginations.

Photography began as chemistry. Light will leave its mark indefinitely in certain compounds. First using asphalt, then switching to silver in the presence of iodine and mercury, Frenchmen Joseph Nicéphore Niépce and Louis-Jacques-Mandé Daguerre, working in the 1820s and '30s, preserved the visible character of photons as they reflected off physical objects.

But the chemists were also craftsmen. Even in Daguerre's earliest pictures, artistic principles of composition and form were on display. Early portrait photographers, like Mathew Brady and Julia Margaret Cameron, consciously shared the traditions of painters like Jan van Eyck and John Singer Sargent.

No other art has drawn on such rapid scientific innovation. As media for capturing images evolved and improved, from copper plates to sheets of glass to celluloid rolls to silicon, photography became portable and inexpensive. Faster shutters and higher film speeds made it possible to freeze motion—and to make motion pictures. First in the darkroom, and now with digital tools, photographers learned to layer their pictures with artistic interpretation. Cameras that record light beyond the visible spectrum have shown us both the world inside our own bodies and the nebulae of incomprehensibly distant galaxies.

Now photography is rapidly becoming the first art that every human being will engage in. What started in 1900, when George Eastman introduced the first Kodak Brownie camera, has accelerated exponentially with the invention of the smartphone. Can the art keep up with the science? In the days before photography, William Blake exhorted: "To see a World in a Grain of Sand, and Heaven in a Wild Flower." It is a task for the human eye and spirit, and the camera is but a tool.

VIEW FROM THE WINDOW AT
LE GRAS | *Joseph Nicéphore Niépce, circa 1826*

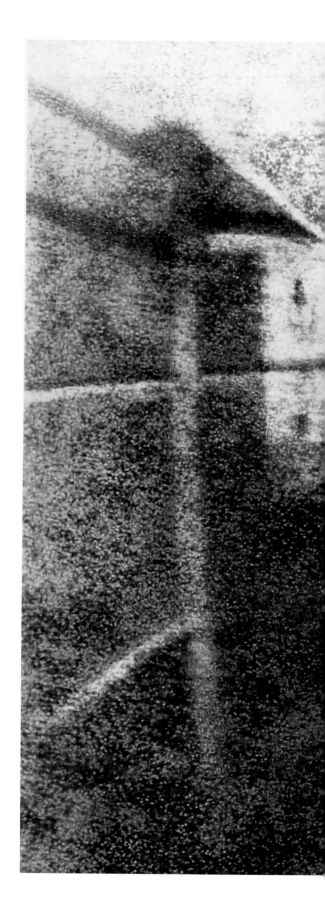

'The discovery I have made and which I call
Heliography, consists in reproducing spontaneously,
by the action of light.' –JOSEPH NICÉPHORE NIÉPCE

It took a unique combination of ingenuity and curiosity to produce the first known photograph, so it's fitting that the man who made it was an inventor and not an artist. In the 1820s, Joseph Nicéphore Niépce had become fascinated with the printing method of lithography, in which images drawn on stone could be reproduced using oil-based ink. Searching for other ways to produce images, Niépce set up a device called a camera obscura, which captured and projected scenes illuminated by sunlight, and trained it on the view outside his studio window in eastern France. The scene was cast on a treated pewter plate that, after many hours, retained a crude copy of the buildings and rooftops outside. The result was the first known permanent photograph.

It is no overstatement to say that Niépce's achievement laid the groundwork for the development of photography. Later, he worked with artist Louis Daguerre, whose sharper daguerreotype images marked photography's next major advancement.

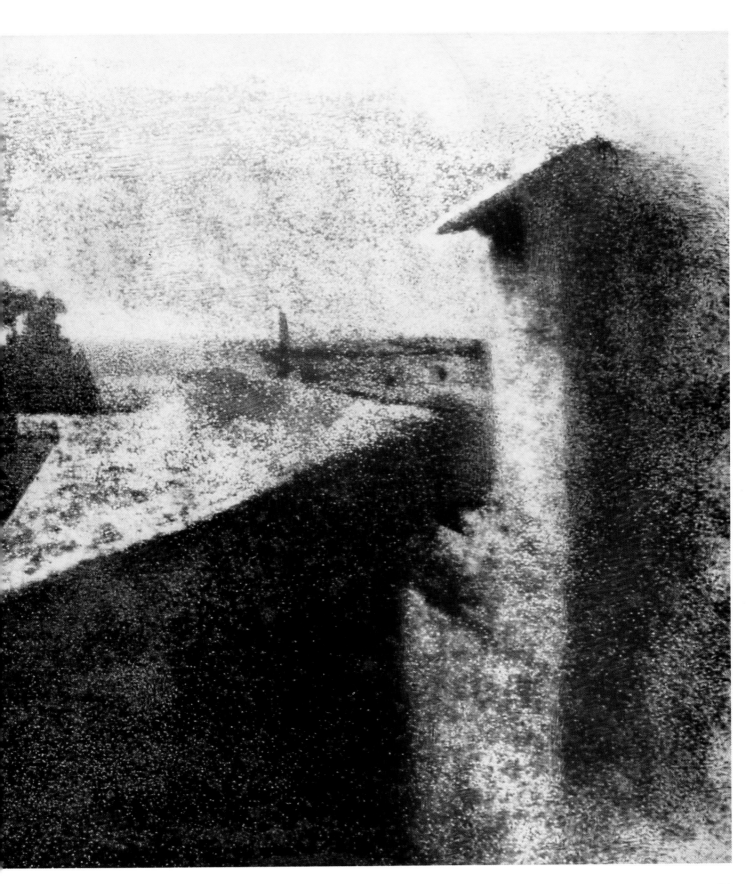

BOULEVARD DU TEMPLE
Louis Daguerre, 1839

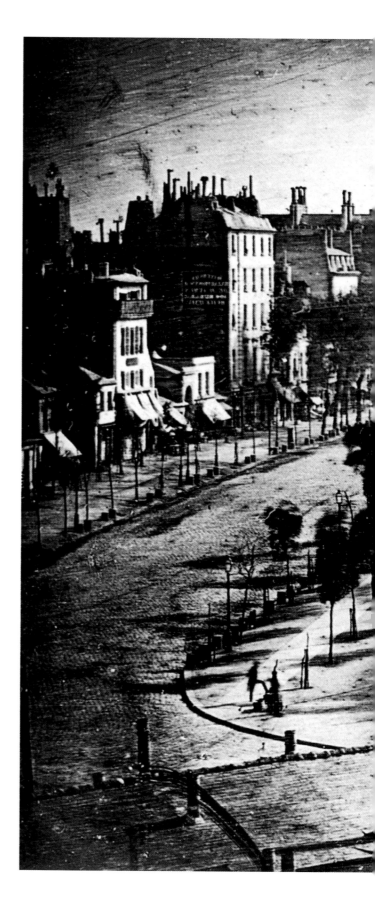

'I have seized the fleeting light and imprisoned it. I have forced the sun to paint pictures for me.'
–LOUIS-JACQUES-MANDÉ DAGUERRE

The shoe shiner working on Paris' Boulevard du Temple one spring day in 1839 had no idea he would make history. But Louis Daguerre's groundbreaking image of the man and a customer is the first known instance of human beings captured in a photograph. Before Daguerre, people had only been represented in artworks. That changed when Daguerre fixed his lens on a Paris street and then exposed a silver-plated sheet of copper for several minutes (though others came into the frame, they did not stay long enough to be captured), developed and fixed the image using chemicals. The result was the first mirror-image photograph.

Unlike earlier efforts, daguerreotypes were sharp and permanent. And though they were eventually outpaced by newer innovations—daguerreotypes were not reproducible, nor could they be printed on paper—Daguerre did more than perhaps anyone else to show the vast potential of the new medium of photography.

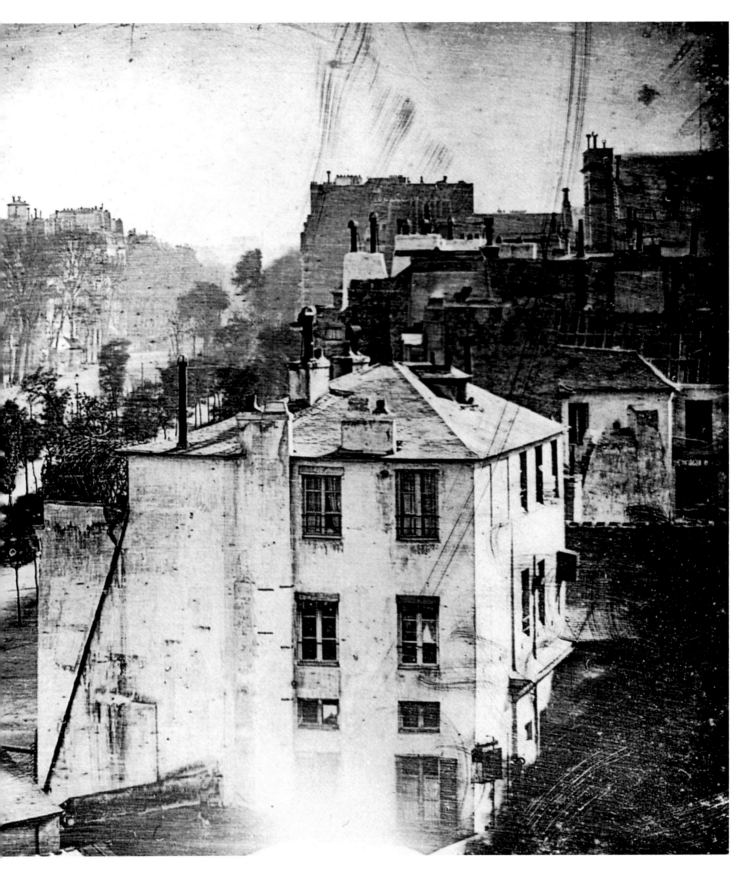

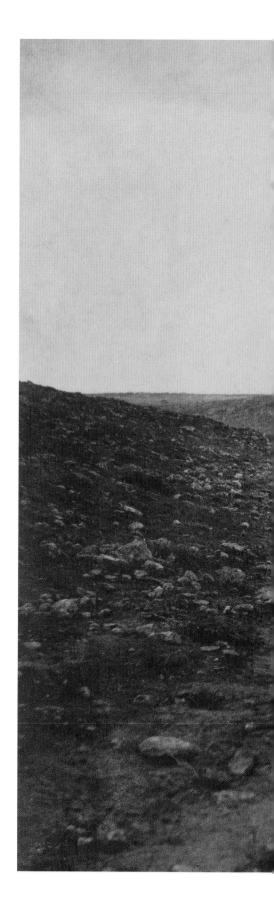

THE VALLEY OF THE SHADOW OF DEATH
Roger Fenton, 1855

While little is remembered of the Crimean War—that nearly three-year conflict
that pitted England, France, Turkey and Sardinia-Piedmont against Russia—
coverage of it radically changed the way we view war. Until then, the general
public learned of battles through heroic paintings and illustrations. But after
the British photographer Roger Fenton landed in 1855 on that far-off peninsula
on the Black Sea, he sent back revelatory views of the conflict that firmly estab-
lished the tradition of war photography. Those 360 photos of camp life and men
manning mortar batteries may lack the visceral brutality we have since become
accustomed to, yet Fenton's work showed that this new artistic medium could ri-
val the fine arts. This is especially clear in *The Valley of the Shadow of Death*, which
shows a cannonball-strewn gully not far from the spot immortalized in Alfred,
Lord Tennyson's "The Charge of the Light Brigade." That haunting image,
which for many evokes the poem's "Cannon to right of them,/ Cannon to left of
them,/ Cannon in front of them" as the troops race "into the valley of Death,"
also revealed to the general public the reality of the lifeless desolation left in the
wake of senseless slaughter. Scholars long believed that this was Fenton's only
image of the valley. But a second version with fewer of the scattered projectiles
turned up in 1981, fueling a fierce debate over which came first. That the more
recently discovered picture is thought to be the first indicates that Fenton may
have been one of the earliest to stage a news photograph.

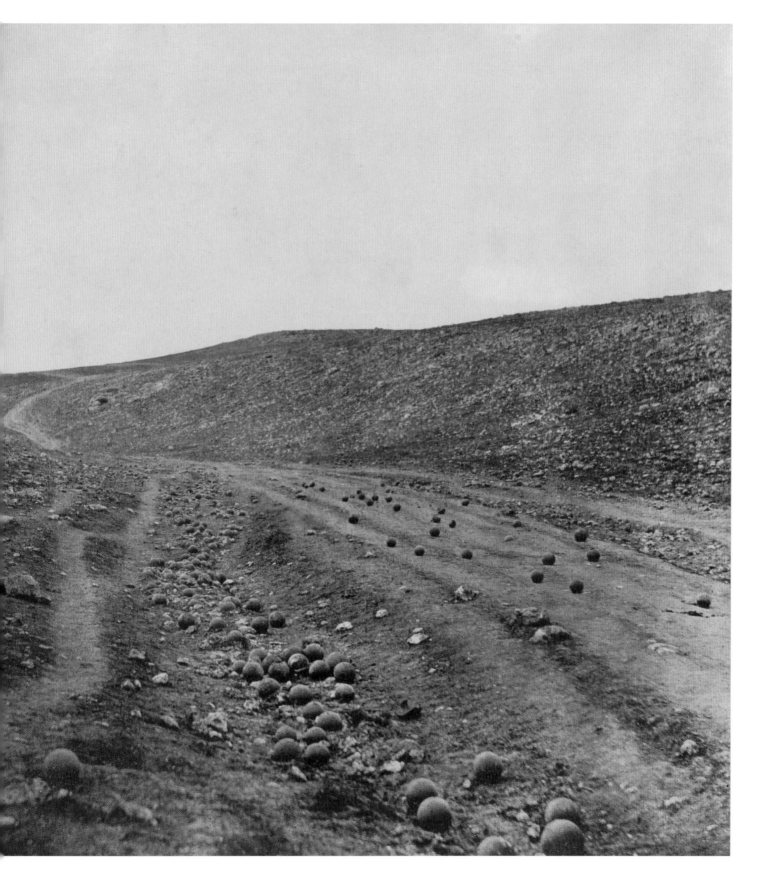

THE HORSE IN MOTION
Eadweard Muybridge, 1878

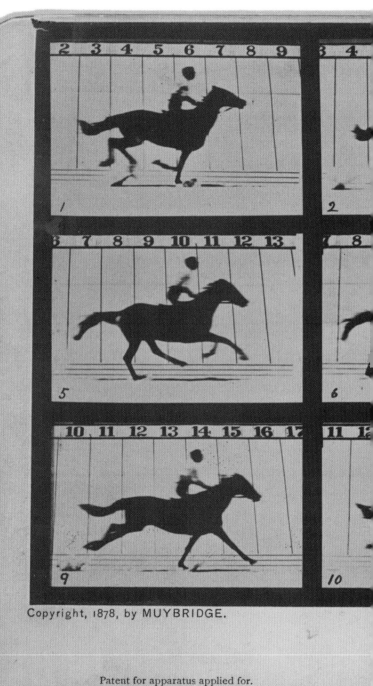

Copyright, 1878, by MUYBRIDGE.

Patent for apparatus applied for.

"SALLIE GARDNER," owned by LELAND

The negatives of these photographs were made at
during a single stride of the m
The negative.

'We think the representation to
be unimpeachable, until we throw all our
preconceived impressions on one side, and seek
the truth by independent observations
from Nature herself.' –EADWEARD MUYBRIDGE

When a horse trots or gallops, does it ever become fully airborne? This was the question photographer Eadweard Muybridge set out to answer in 1878. Railroad tycoon and former California governor Leland Stanford was convinced the answer was yes and commissioned Muybridge to provide proof. Muybridge developed a way to take photos with an exposure lasting a fraction of a second and, with reporters as witnesses, arranged 12 cameras along a track on Stanford's estate.

As a horse sped by, it tripped wires connected to the cameras, which took 12 photos in rapid succession. Muybridge developed the images on site and, in the frames, revealed that a horse is completely aloft with its hooves tucked underneath it for a brief moment during a stride. The revelation, imperceptible to the naked eye but apparent through photography, marked a new purpose for the medium. It could capture truth through technology. Muybridge's stop-motion technique was an early form of animation that helped pave the way for the motion-picture industry, born a short decade later.

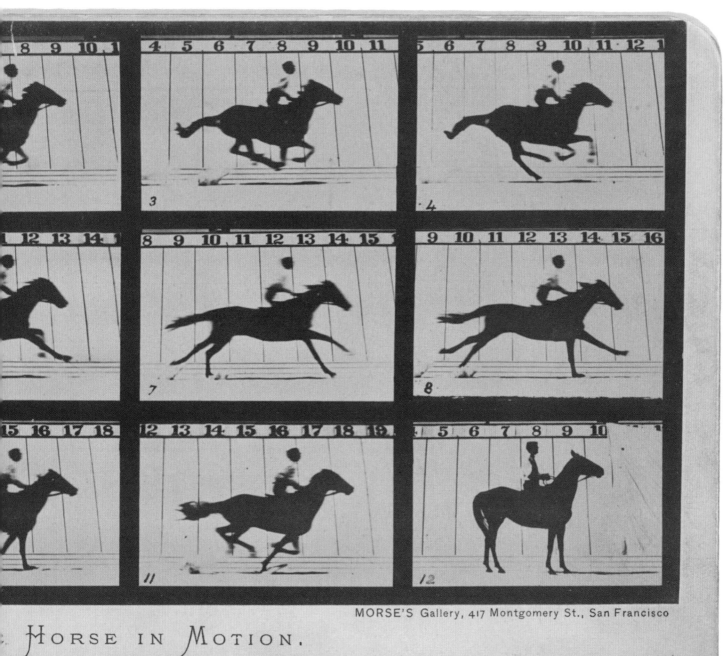

MORSE'S Gallery, 417 Montgomery St., San Francisco

HORSE IN MOTION.

Illustrated by
MUYBRIDGE. AUTOMATIC ELECTRO-PHOTOGRAPH.

RD; ridden by G. DOMM, running at a 1.40 gait over the Palo Alto track, 19th June, 1878.
ty-seven inches of distance, and about the twenty-fifth part of a second of time; they illustrate consecutive positions assumed
lines were twenty-seven inches apart; the horizontal lines represent elevations of four inches each.
sed during the two-thousandth part of a second, and are absolutely "untouched."

BANDIT'S ROOST, 59½ MULBERRY STREET | *Jacob Riis, circa 1888*

'Hence, I say, in the battle with the slum we win or we perish.
There is no middle way.' –JACOB RIIS

Late 19th-century New York City was a magnet for the world's immigrants, and the vast majority of them found not streets paved with gold but nearly subhuman squalor. While polite society turned a blind eye, brave reporters like the Danish-born Jacob Riis documented this shame of the Gilded Age. Riis did this by venturing into the city's most ominous neighborhoods with his blinding magnesium flash powder lights, capturing the casual crime, grinding poverty and frightful overcrowding. Most famous of these was Riis' image of a Lower East Side street gang, which conveys the danger that lurked around every bend. Such work became the basis of his revelatory book *How the Other Half Lives*, which forced Americans to confront what they had long ignored and galvanized reformers like the young New York politician Theodore Roosevelt, who wrote to the photographer, "I have read your book, and I have come to help." Riis' work was instrumental in bringing about New York State's landmark Tenement House Act of 1901, which improved conditions for the poor. And his crusading approach and direct, confrontational style ushered in the age of documentary and muckraking photojournalism.

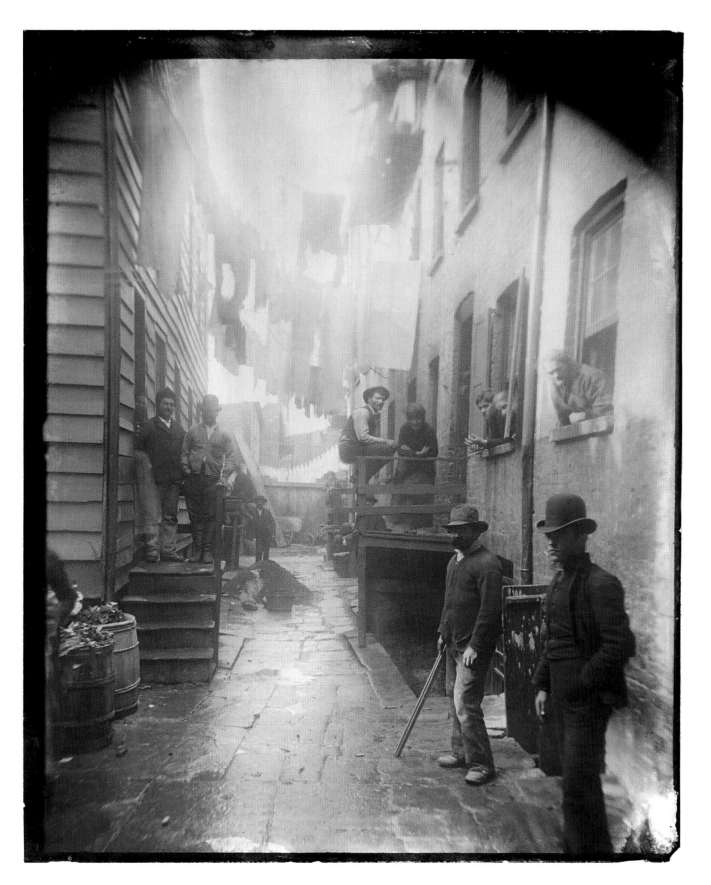

THE HAND OF MRS. WILHELM RÖNTGEN | *Wilhelm Conrad Röntgen, 1895*

'I did not think; I investigated.' –DR. WILHELM CONRAD RÖNTGEN

There's no way of knowing how many pictures were taken of Anna Bertha Röntgen, and most are surely lost to history. But one of them isn't: it is of her hand—more precisely, the bones in her hand—an image captured by her husband Wilhelm when he took the first medical x-ray in 1895. Wilhelm had spent weeks working in his lab, experimenting with a cathode tube that emitted different frequencies of electromagnetic energy. Some, he noticed, appeared to penetrate solid objects and expose sheets of photographic paper. He used the strange rays, which he aptly dubbed x-rays, to create shadowy images of the inside of various inanimate objects and then, finally, one very animate one. The picture of Anna's hand created a sensation, and the discovery of x-rays won Wilhelm the first Nobel Prize ever granted for physics in 1901. His breakthrough quickly went into use around the world, revolutionizing the diagnosis and treatment of injuries and illnesses that had always been hidden from sight. Anna, however, was never taken with the picture. "I have seen my death," she said when she first glimpsed it. For many millions of other people, it has meant life.

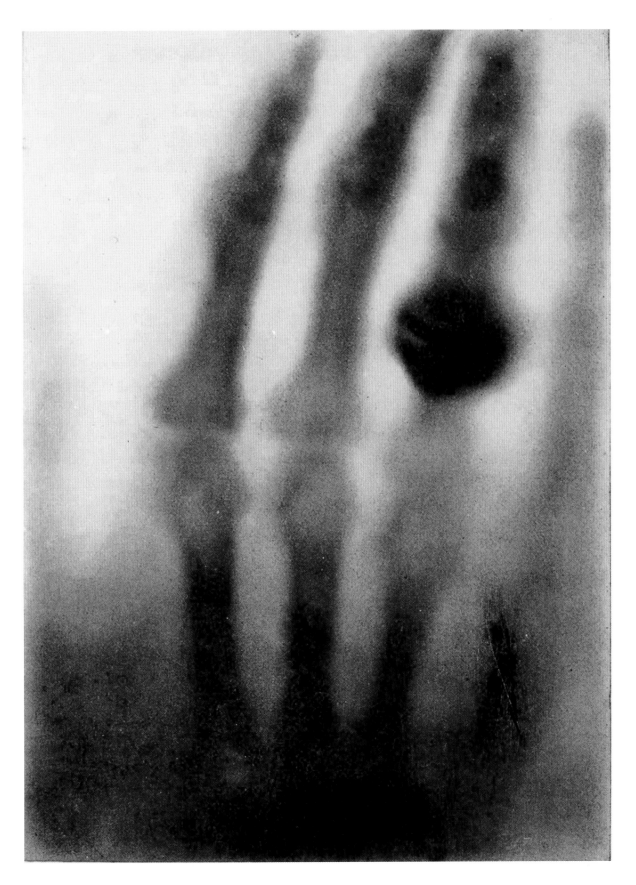

MOONLIGHT: THE POND | *Edward Steichen, 1904*

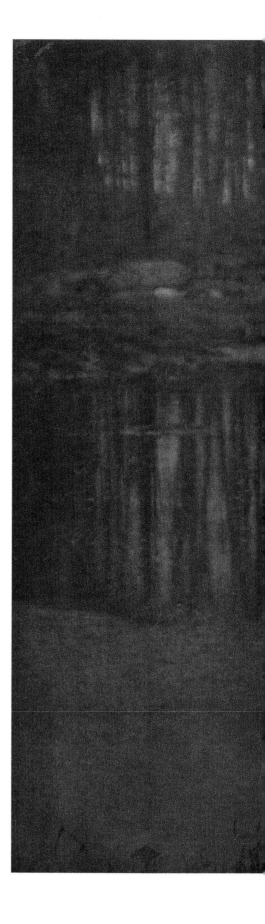

'In fact, every photograph is a fake from start to finish.' –EDWARD STEICHEN

Is Edward Steichen's ethereal image a photograph or a painting? It's both, and that was exactly his point. Steichen photographed the wooded scene in Mamaroneck, N.Y., hand-colored the black-and-white prints with blue tones and may have even added the glowing moon. The blurring of two mediums was the aim of Pictorialism, which was embraced by professional photographers at the turn of the 20th century as a way to differentiate their work from amateur snapshots taken with newly available handheld cameras. And no single image was more formative than *Moonlight*.

The year before he created *Moonlight*, Steichen wrote an essay arguing that altering photos was no different than choosing when and where to click the shutter. Photographers, he said, always have a perspective that necessarily distorts the authenticity of their images. Although Steichen eventually abandoned Pictorialism, the movement's influence can be seen in every photographer who seeks to create scenes, not merely capture them. *Moonlight*, too, continues to resonate. A century after Steichen made the image, a print sold for nearly $3 million.

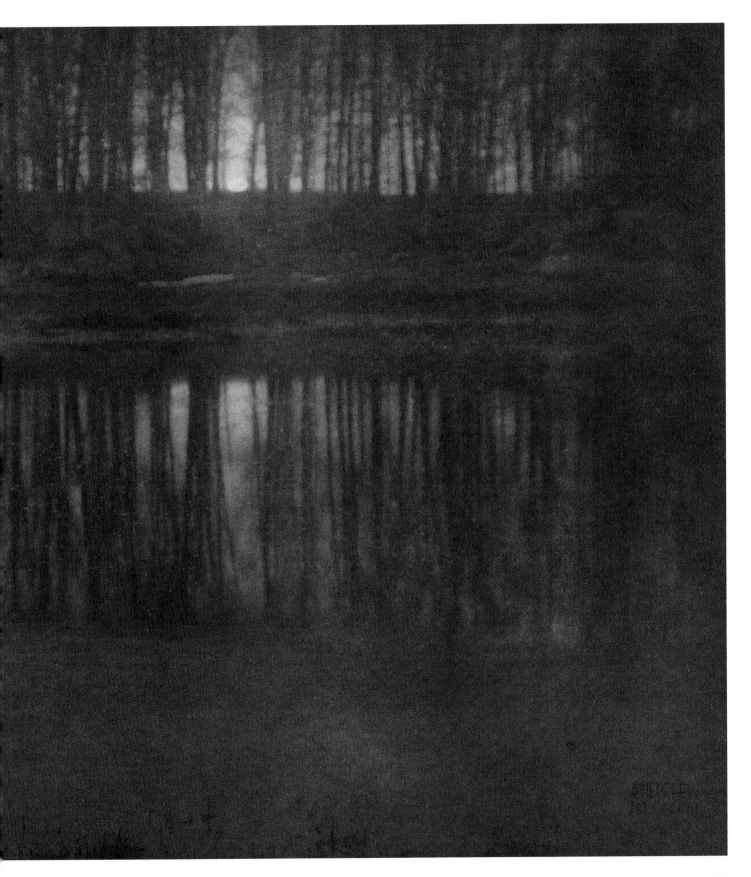

BLIND | *Paul Strand, 1916*

'I felt they were all people whom life had battered into some sort of extraordinary interest and, in a way, nobility.' –PAUL STRAND

Even if she could see, the woman in Paul Strand's pioneering image might not have known she was being photographed. Strand wanted to capture people as they were, not as they projected themselves to be, and so when documenting immigrants on New York City's Lower East Side, he used a false lens that allowed him to shoot in one direction even as his large camera was pointed in another. The result feels spontaneous and honest, a radical departure from the era's formal portraits of people in stilted poses. Strand's photograph of the blind woman, who he said was selling newspapers on the street, is candid, with the woman's face turned away from the camera. But Strand's work did more than offer an unflinching look at a moment when the nation was being reshaped by a surge of immigrants. By depicting subjects without their knowledge—or consent—and using their images to promote social awareness, Strand helped pave the way for an entirely new form of documentary art: street photography.

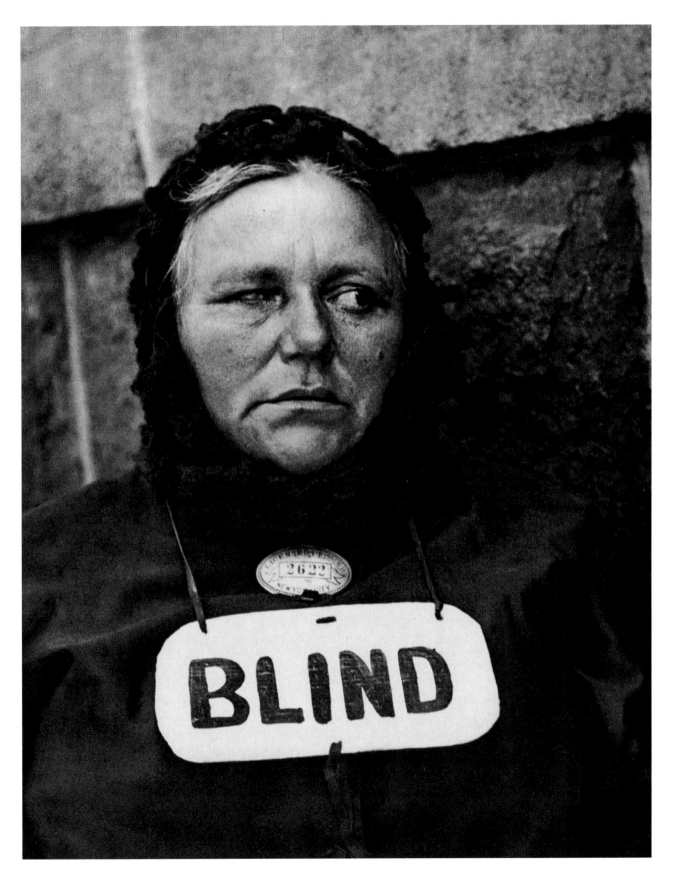

BRICKLAYER | *August Sander, 1928*

There is a certain formulaic approach to August Sander's photography. But that was his aim. By presenting doctors, farmers, chefs and beggars all with the same stark directness, the German-born Sander made everyone the everyman. He set out to show that there is much to learn from all layers of society, noting, "We can tell from appearance the work someone does or does not do; we can read in his face whether he is happy or troubled, for life unavoidably leaves its trace there." Sander's most celebrated portrait, of a bricklayer in Cologne, Germany, embodies that insight. For while the laborer's work entails toil and sweat, he maintains a proud bearing. The classical framing, with the lines of the bricks evoking the lines of the bricklayer's vest, reinforces the dignity of the subject. Which was no small thing for a nation still reeling from the humiliation of World War I. Sander gathered *Bricklayer* and his other portraits in the monumental *People of the 20th Century*, the first body of work to document a culture through photography. Sander's photographs celebrate the importance of the individual, elevating portraiture of ordinary people to art.

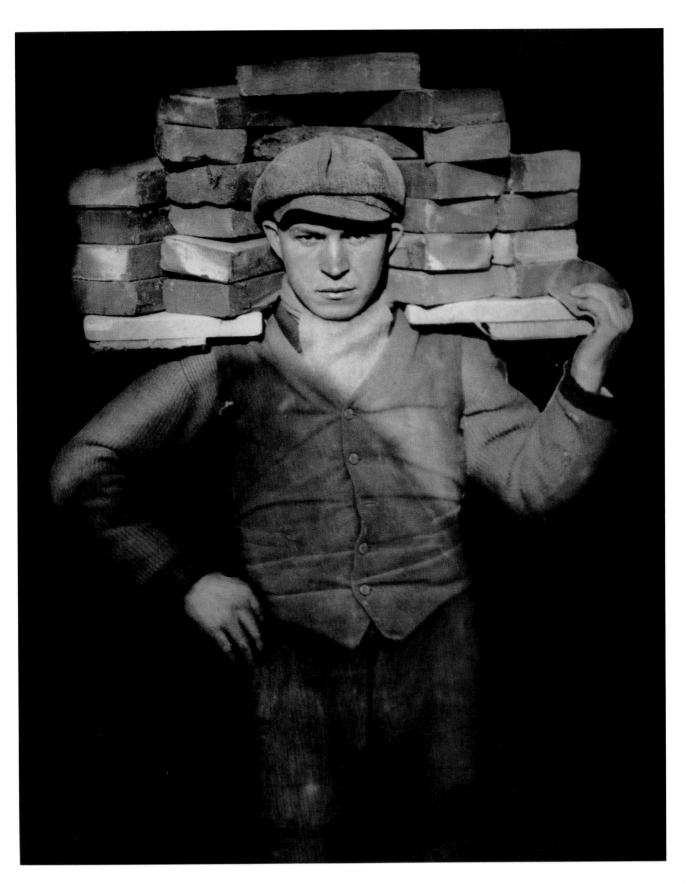

THE HAGUE | *Erich Salomon, 1930*

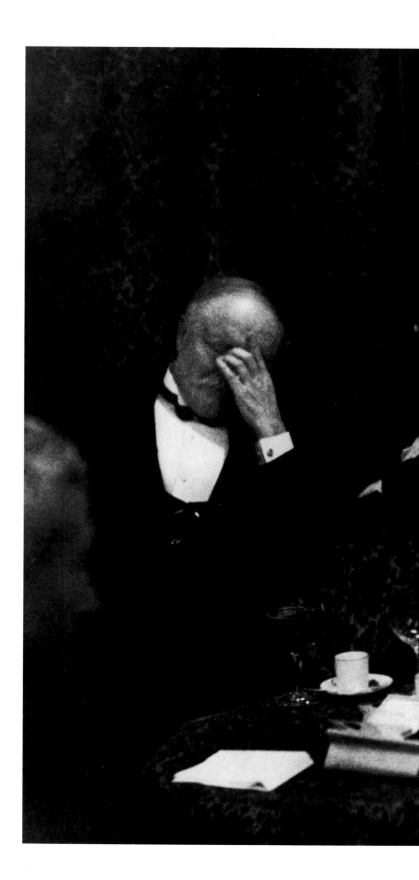

'What's a meeting that isn't photographed by Salomon? People won't believe it's important at all!' –ARISTIDE BRIAND, PRIME MINISTER OF FRANCE

Portly statesmen have long gathered to weigh the fate of nations, cigars and brandy at the ready. But they were always sequestered far from prying eyes. The German photojournalist Erich Salomon changed all that, slipping into those smoke-filled back rooms with a small Leica camera built to shoot in low light. Nowhere was his skill on greater display than during a 1930 meeting in the Hague over German World War I reparations. There, at 2 a.m., Salomon candidly shot exhausted Foreign Ministers after a long day of negotiations. The picture created a sensation when it was published in the London *Graphic*. For the first time, the public could look through the doors of power and see world leaders with their guard down. Salomon, who died in Auschwitz 12 years later, had created backstage political photojournalism.

BEHIND THE GARE SAINT-LAZARE | *Henri Cartier-Bresson, 1932*

'Photography is just luck. There was a fence, and I poked my camera through the fence. It's a fraction of a second.' –HENRI CARTIER-BRESSON

Speed and instinct were at the heart of Henri Cartier-Bresson's brilliance as a photographer. And never did he combine the two better than on the day in 1932 when he pointed his Leica camera through a fence behind Paris' Saint-Lazare train station. The resulting image is a masterpiece of form and light. As a man leaps across the water, evoking the dancers in a poster on the wall behind him, the ripples in the puddle around the ladder mimic the curved metal pieces nearby. Cartier-Bresson, shooting with a nimble 35-millimeter camera and no flash, saw these components all come together for a brief moment and clicked his shutter. Timing is everything, and no other photographer's was better. The image would become the quintessential example of Cartier-Bresson's "Decisive Moment," his lyrical term for the ability to immortalize a fleeting scene on film. It was a fast, mobile, detail-obsessed style that would help chart the course for all of modern photography.

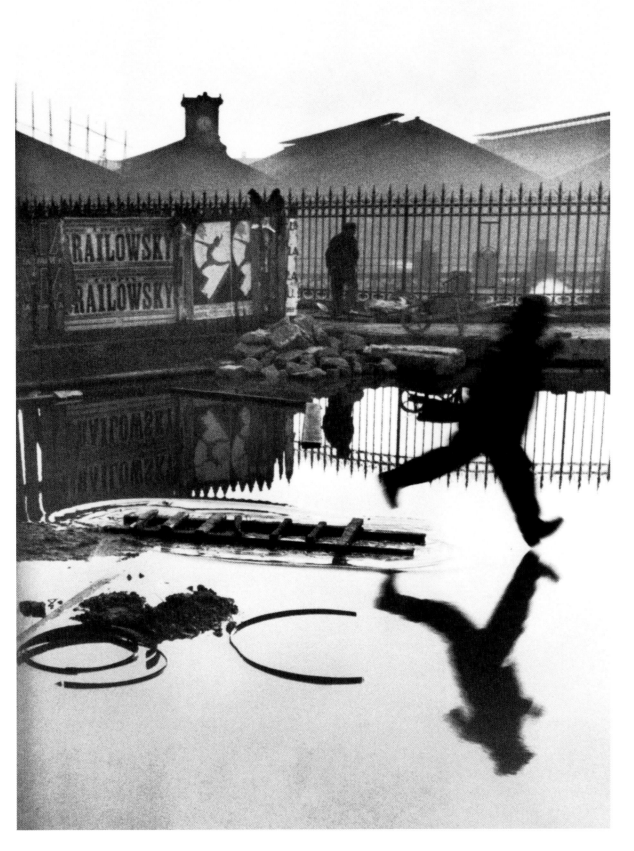

THE LOCH NESS MONSTER
Unknown, 1934

'All right, we'll give them their monster.'
–MARMADUKE WETHERELL

If the giraffe never existed, we'd have to invent it. It's our nature to grow bored with the improbable but real and look for the impossible. So it is with the photo of what was said to be the Loch Ness monster, purportedly taken by British doctor Robert Wilson in April 1934. Wilson, however, had simply been enlisted to cover up an earlier fraud by wild-game hunter Marmaduke Wetherell, who had been sent to Scotland by London's *Daily Mail* to bag the monster. There being no monster to bag, Wetherell brought home photos of hippo prints that he said belonged to Nessie. The *Mail* caught wise and discredited Wetherell, who then returned to the loch with a monster made out of a toy submarine. He and his son used Wilson, a respected physician, to lend the hoax credibility. The *Mail* endures; Wilson's reputation doesn't.

The Loch Ness image is something of a lodestone for conspiracy theorists and fable seekers, as is the absolutely authentic picture of the famous face on Mars taken by the Viking probe in 1976. The thrill of that find lasted only until 1998, when the Mars Global Surveyor proved the face was, as NASA said, a topographic formation, one that by that time had been nearly windblown away. We were innocents in those sweet, pre-Photoshop days. Now we know better—and we trust nothing. The art of the fake has advanced, but the charm of it, like the Martian face, is all but gone.

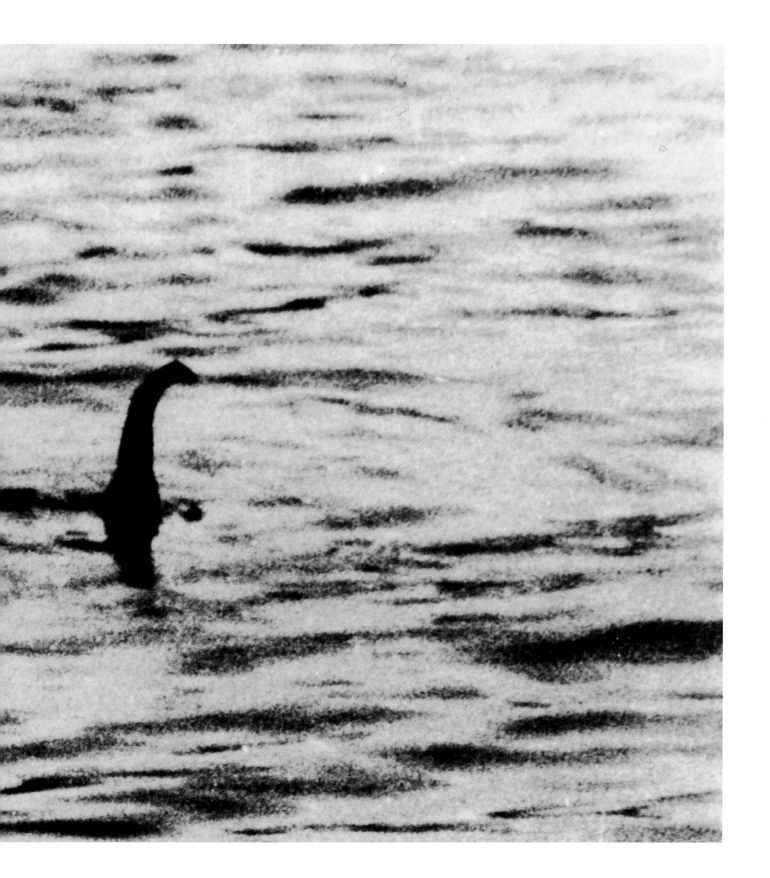

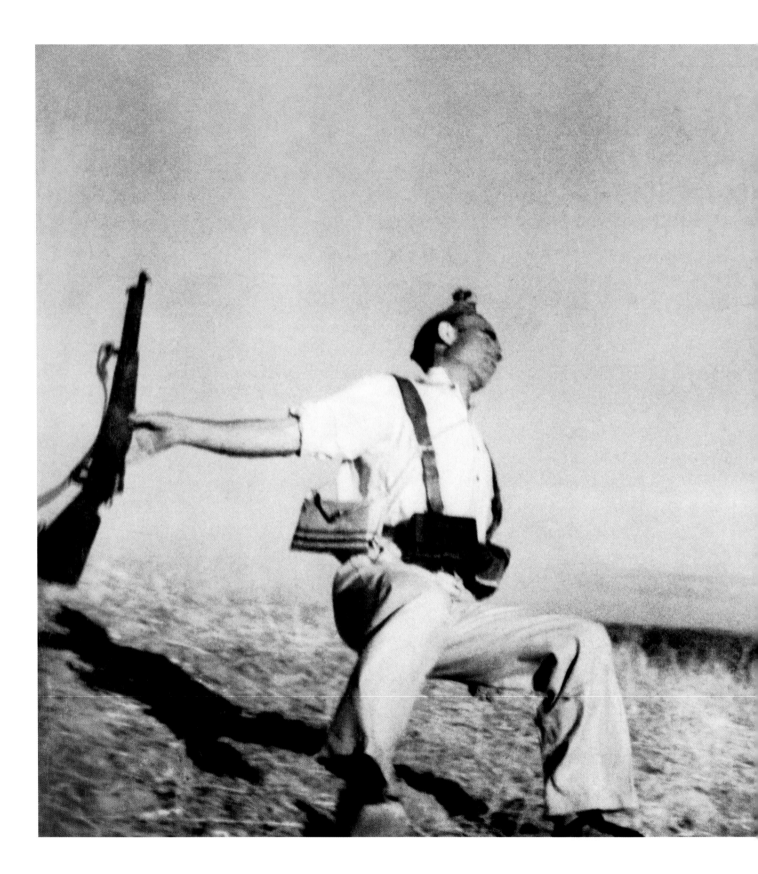

THE FALLING SOLDIER
Robert Capa, 1936

'That camera, which I held above my head, just caught a man at the moment when he was shot. That was probably the best picture I ever took.' –ROBERT CAPA

Robert Capa made his seminal photograph of the Spanish Civil War without ever looking through his viewfinder. Widely considered one of the best combat photographs ever made, and the first to show battlefield death in action, Capa said in a 1947 radio interview that he was in the trenches with Republican militiamen. The men would pop aboveground to charge and fire old rifles at a machine gun manned by troops loyal to Francisco Franco. Each time, the militiamen would get gunned down. During one charge, Capa held his camera above his head and clicked the shutter. The result is an image that is full of drama and movement as the shot soldier tumbles backward.

In the 1970s, decades after it was published in the French magazine *Vu* and LIFE, a South African journalist named O.D. Gallagher claimed that Capa had told him the image was staged. But no confirmation was ever presented, and most believe that Capa's is a genuine candid photograph of a Spanish militiaman being shot. Capa's image elevated war photography to a new level long before journalists were formally embedded with combat troops, showing how crucial, if dangerous, it is for photographers to be in the middle of the action.

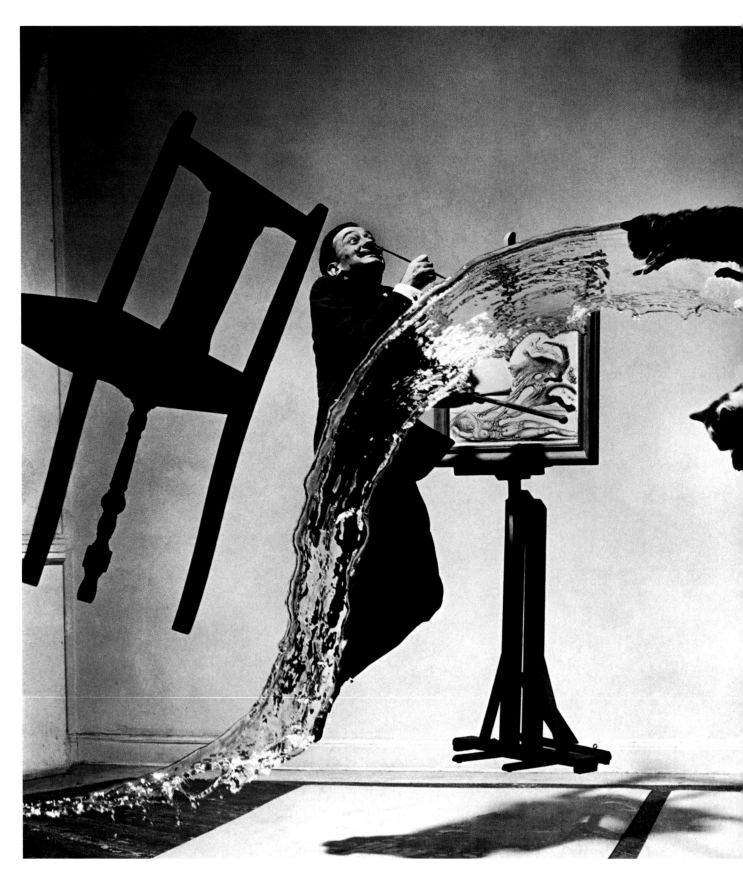

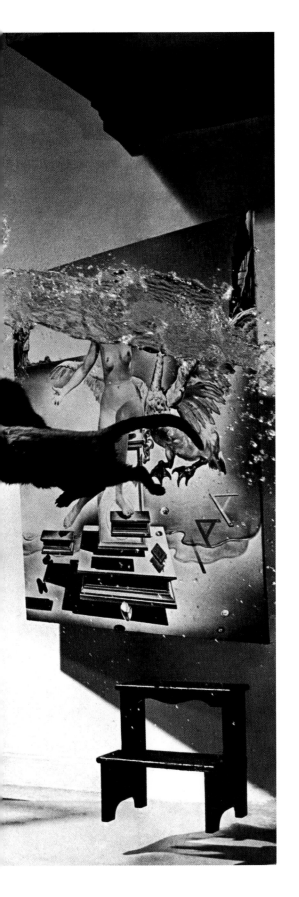

DALÍ ATOMICUS | *Philippe Halsman, 1948*

'Before there was Photoshop, there was Philippe.'
—IRENE HALSMAN, DAUGHTER OF PHILIPPE HALSMAN

Capturing the essence of those he photographed was Philippe Halsman's life's work. So when Halsman set out to shoot his friend and longtime collaborator the Surrealist painter Salvador Dalí, he knew a simple seated portrait would not suffice. Inspired by Dalí's painting *Leda Atomica*, Halsman created an elaborate scene to surround the artist that included the original work, a floating chair and an in-progress easel suspended by thin wires. Assistants, including Halsman's wife and young daughter Irene, stood out of the frame and, on the photographer's count, threw three cats and a bucket of water into the air while Dalí leaped up. It took the assembled cast 26 takes to capture a composition that satisfied Halsman. And no wonder. The final result, published in LIFE, evokes Dalí's own work. The artist even painted an image directly onto the print before publication.

Before Halsman, portrait photography was often stilted and softly blurred, with a clear sense of detachment between the photographer and the subject. Halsman's approach, to bring subjects such as Albert Einstein, Marilyn Monroe and Alfred Hitchcock into sharp focus as they moved before the camera, redefined portrait photography and inspired generations of photographers to collaborate with their subjects.

TROLLEY—NEW ORLEANS
Robert Frank, 1955

'With one hand he sucked a sad poem right out of America onto film.' –JACK KEROUAC, INTRODUCTION TO *THE AMERICANS*

Uncomfortable truths tend to carry consequences for the teller. When Robert Frank's book *The Americans* was released, *Practical Photography* magazine dismissed the Swiss-born photographer's work as a collection of "meaningless blur, grain, muddy exposures, drunken horizons and general sloppiness." The book's 83 images were taken as Frank crisscrossed the U.S. on several road trips in the mid-1950s, and they captured a country on the cusp of change: rigidly segregated but with the civil rights movement stirring, rooted in family and rural tradition yet moving headlong into the anonymity of urban life.

Nowhere is this tension higher than in *Trolley—New Orleans,* a fleeting moment that conveys the brutal social order of postwar America. The picture, shot a few weeks before Rosa Parks refused to give up her seat on a bus in Montgomery, Ala., was unplanned. Frank was shooting a street parade when he saw the trolley passing. Spinning around, Frank raised his camera and shot just before the trolley disappeared from view. The picture was used on the cover of early editions of *The Americans,* fueling criticism that the work was anti-American. Of course Frank—who became a U.S. citizen in 1963, five years after *The Americans* was published—simply saw his adopted country as it was, not as it imagined itself to be. Half a century later, that candor has made *The Americans* a monument of documentary and street photography. Frank's loose and subjective style liberated the form from the conventions of photojournalism established by LIFE magazine, which he dismissed as "goddamned stories with a beginning and an end."

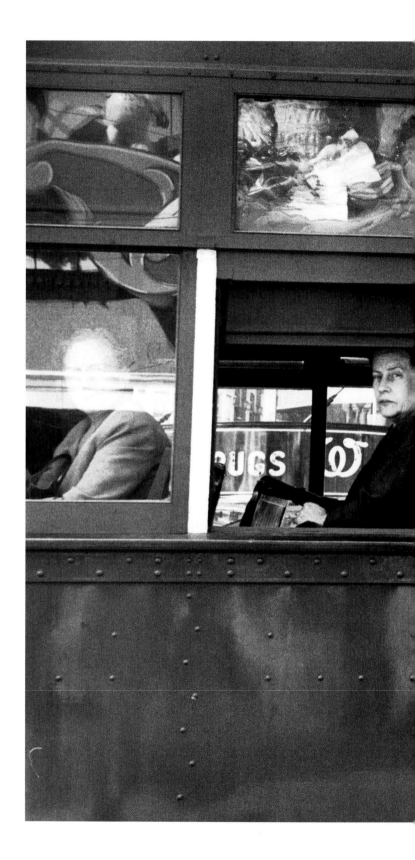

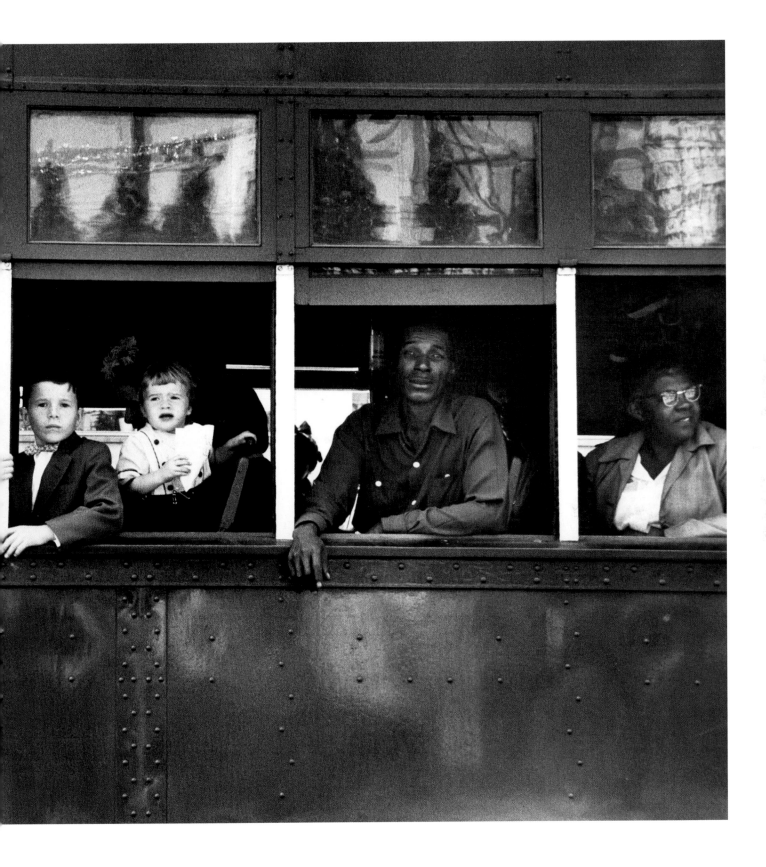

MILK DROP CORONET | *Harold Edgerton, 1957*

'Seconds. There it is. Sometimes it's no use at all. Sometimes it's tremendous value.' –HAROLD EDGERTON

Before Harold Edgerton rigged a milk dropper next to a timer and a camera of his own invention, it was virtually impossible to take a good photo in the dark without bulky equipment. It was similarly futile to try to photograph a fleeting moment. But in the 1950s at his lab at MIT, Edgerton started tinkering with a process that would change the future of photography. There the electrical-engineering professor combined high-tech strobe lights with camera shutter motors to capture moments imperceptible to the naked eye. *Milk Drop Coronet,* his revolutionary stop-motion photograph, freezes the impact of a drop of milk on a table, a crown of liquid discernible to the camera for only a millisecond. The picture proved that photography could advance human understanding of the physical world, and the technology Edgerton used to take it laid the foundation for the modern electronic flash.

Edgerton worked for years to perfect his milk-drop photographs, many of which were black and white; one version was featured in the first photography exhibition at New York City's Museum of Modern Art, in 1937. And while the man known as Doc captured other blink-and-you-missed-it moments, like balloons bursting and a bullet piercing an apple, his milk drop remains a quintessential example of photography's ability to make art out of evidence.

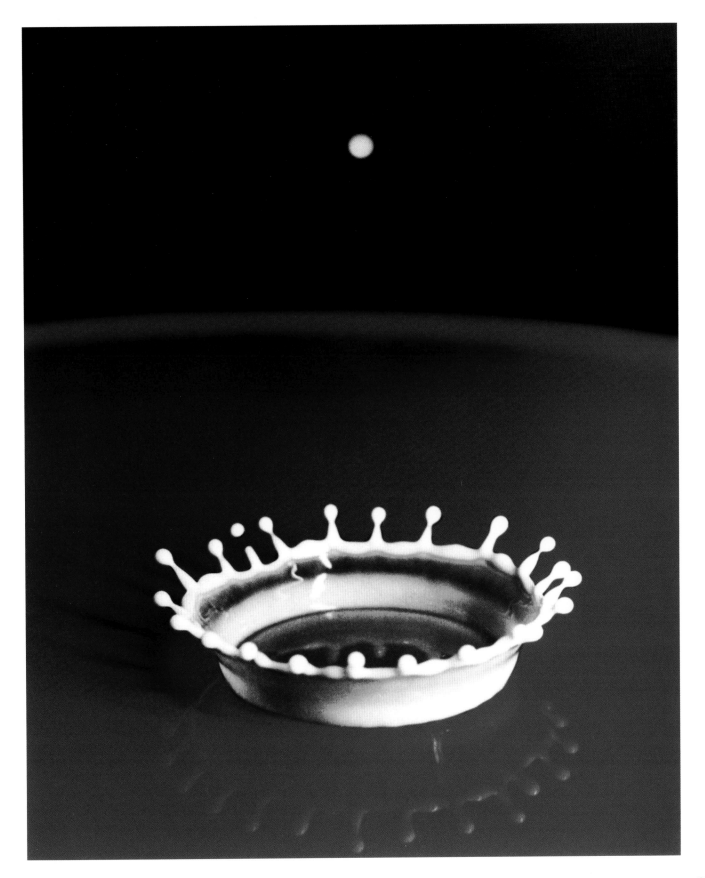

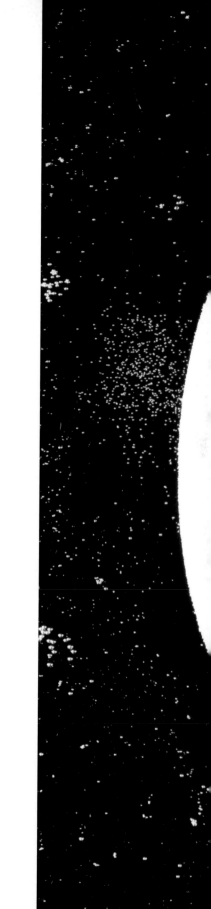

FETUS, 18 WEEKS | *Lennart Nilsson, 1965*

'We try to create or see something, which has not been
known before.' –LENNART NILSSON

When LIFE published Lennart Nilsson's photo essay "Drama of Life Before Birth" in
1965, the issue was so popular that it sold out within days. And for good reason. Nilsson's
images publicly revealed for the first time what a developing fetus looks like, and in the
process raised pointed new questions about when life begins. In the accompanying story,
LIFE explained that all but one of the fetuses pictured were photographed outside the
womb and had been removed—or aborted—"for a variety of medical reasons." Nilsson
had struck a deal with a hospital in Stockholm, whose doctors called him whenever a
fetus was available to photograph. There, in a dedicated room with lights and lenses
specially designed for the project, Nilsson arranged the fetuses so they appeared to be
floating as if in the womb.

In the years since Nilsson's essay was published, the images have been widely appro-
priated without his permission. Antiabortion activists in particular have used them to
advance their cause. (Nilsson has never taken a public stand on abortion.) Still, decades
after they first appeared, Nilsson's images endure for their unprecedentedly clear, detailed
view of human life at its earliest stages.

EARTHRISE | *William Anders, NASA, 1968*

'It was the first time that people actually knew what the Earth looked like.' –WILLIAM ANDERS

It's never easy to identify the moment a hinge turns in history. When it comes to humanity's first true grasp of the beauty, fragility and loneliness of our world, however, we know the precise instant. It was on December 24, 1968, exactly 75 hours, 48 minutes and 41 seconds after the Apollo 8 spacecraft lifted off from Cape Canaveral en route to becoming the first manned mission to orbit the moon. Astronauts Frank Borman, Jim Lovell and Bill Anders entered lunar orbit on Christmas Eve of what had been a bloody, war-torn year for America. At the beginning of the fourth of 10 orbits, their spacecraft was emerging from the far side of the moon when a view of the blue-white planet filled one of the hatch windows. "Oh, my God! Look at that picture over there! Here's the Earth coming up. Wow, is that pretty!" Anders exclaimed. He snapped a picture—in black and white. Lovell scrambled to find a color canister. "Well, I think we missed it," Anders said. Lovell looked through windows three and four. "Hey, I got it right here!" he exclaimed. A weightless Anders shot to where Lovell was floating and fired his Hasselblad. "You got it?" Lovell asked. "Yep," Anders answered. The image—our first full-color view of our planet from off of it—helped to launch the environmental movement. And, just as important, it helped human beings recognize that in a cold and punishing cosmos, we've got it pretty good.

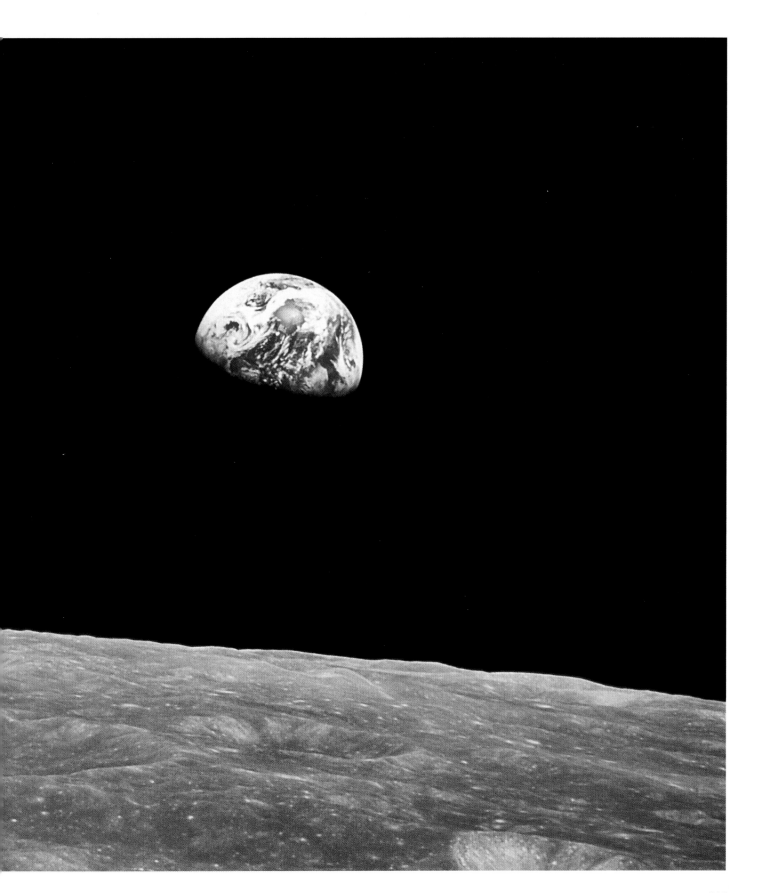

UNTITLED FILM STILL #21 | *Cindy Sherman, 1978*

'She was one of the first image-makers who worked
exclusively in the medium to be called an artist rather than
a photographer.' –MARY LOU MARIEN, ART HISTORIAN

Since she burst onto the art scene in the late 1970s, Cindy Sherman the person has
always been obscured by Cindy Sherman the subject. Through inventive, deliber-
ately confusing self-portraits taken in familiar but artificial circumstances, Sherman
introduced photography as postmodern performance art. From her *Untitled Film Stills*
series, #21 ("City Girl") calls to mind a frame from a B movie or an opening scene
from a long-since-canceled television show. Yet the images are entirely Sherman's
creations, placing the viewer in the role of unwitting voyeur. Rather than capture
real life in the click of a shutter, Sherman uses photography as an artistic tool to de-
ceive and captivate. Her images have become some of the most valuable photographs
ever produced. By manipulating viewers and recasting her own identity, Sherman
carved out a new place for photography in fine art. And she showed that even pho-
tography allows people to be something they're not.

BRIAN RIDLEY AND LYLE HEETER | *Robert Mapplethorpe, 1979*

'I see things like they've never been seen before.' –ROBERT MAPPLETHORPE

Mainstream American culture had little room for homosexuality in 1979, when Robert Mapplethorpe photographed Brian Ridley and Lyle Heeter in their full sadomasochistic regalia. At work, gay employees were largely closeted. In many states, expressing their love could be criminal. Mapplethorpe spent 10 years during this era documenting the underground gay S&M scene—a world even more deeply shielded from public view. His intimate, highly stylized portraits threw it into open relief, perhaps none more so than *Brian Ridley and Lyle Heeter*. Both men are clad in leather, with the submissive one bound by chains and the dominant partner holding his reins in one hand and a riding crop in the other. Yet the men are posed in an otherwise unremarkable living room, a juxtaposition that adds a layer of normality to a relationship far outside the bounds of what most Americans then considered acceptable. The picture and the series it was part of blew open the doors for a range of photographers and artists to frankly examine gay life and sexuality.

Nearly a decade later, Mapplethorpe's work continued to provoke. An exhibit featuring his pictures of gay S&M scenes led to a Cincinnati art museum and its director's getting charged with obscenity. (Mapplethorpe died of AIDS in 1989, one year before the trial began.) The museum and its director were eventually acquitted, bolstering Mapplethorpe's legacy as a bold pioneer whose work deserved public display.

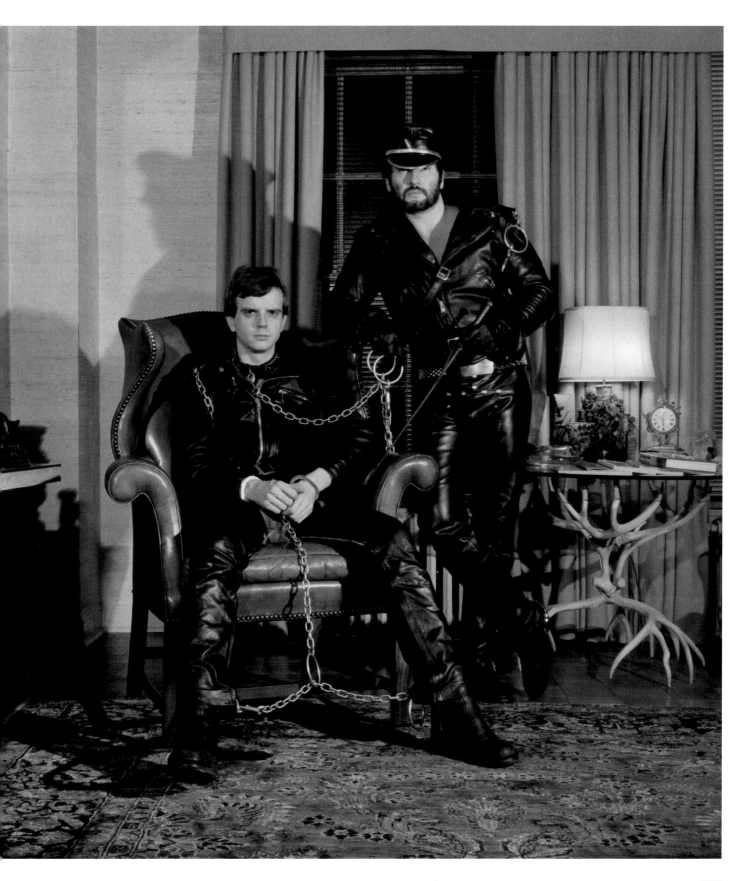

ANDROGYNY (6 MEN + 6 WOMEN) | *Nancy Burson, 1982*

'I really was, in a certain way, more interested in showing people what they could not see rather than what they could see.' –NANCY BURSON

Photography is a perfect medium for recording the past. But until Nancy Burson's *Androgyny*, it was useless for predicting the future. Two decades before the shape-shifting enabled by digital photography became ubiquitous, Burson worked with MIT scientists to develop technology that let her craft this composite image of the faces of six men and six women. The effect was revolutionary. Photographs could suddenly be used to project how someone would look, not just how they once did. Burson's composite work led her to develop pioneering software that could digitally age faces—the first time these images could be based on more than guesses. The Federal Bureau of Investigation acquired Burson's software to create present-day images of people who had gone missing years earlier, and it has been used to locate numerous missing persons.

IMMERSIONS (PISS CHRIST) | *Andres Serrano, 1987*

'Freedom of religion and freedom of expression have something in common:
they both have the power to polarize people.' –ANDRES SERRANO

Andres Serrano said he did not intend his 1987 photograph of a crucifix submerged in his own urine to offend; indeed, when it was first displayed in galleries, no one protested. But in 1989, after *Piss Christ* was exhibited in Virginia, it attracted the attention of an outspoken pastor and, soon after, of Congress. Angry that Serrano had received funding from the National Endowment for the Arts (NEA), Senators Al D'Amato and Jesse Helms helped pass a law requiring the NEA to consider "general standards of decency" in awarding grants. The uproar turned *Piss Christ* into one of the key fronts in the culture wars of the 1980s and 1990s, alongside the work of Serrano's fellow NEA recipient Robert Mapplethorpe, and divided a nation over the question of whether the government had the right to censor art.

The battle over *Piss Christ* has left a dual legacy. The campaign to place the picture outside the boundaries of acceptable art contributed to its fame, inspiring other artists to push limits even further. But those provocateurs are less likely to do so with help from the government: the decency-standards law passed because of *Piss Christ* was upheld by the Supreme Court in 1998.

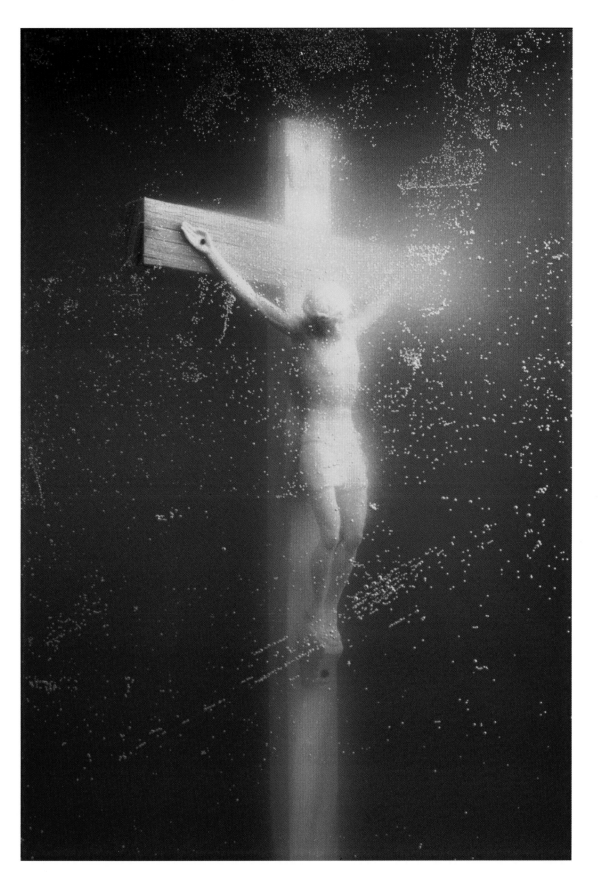

UNTITLED (COWBOY)
Richard Prince, 1989

'I was trying to avoid any reference to the fact that I was actually copying a page from a magazine, or the dot pattern, the printed quality. I was trying to make the photograph as much mine as possible.' –RICHARD PRINCE

The idea for the project that would challenge everything sacred about ownership in photography came to Richard Prince when he was working in the tearsheet department at Time Inc. While he deconstructed the pages of magazines for the archives, Prince's attention was drawn to the ads that appeared alongside articles. One ad in particular caught his eye: the macho image of the Marlboro Man riding a horse under blue skies. And so, in a process he came to call rephotography, Prince took pictures of the ads and cropped out the type, leaving only the iconic cowboy and his surroundings. That Prince didn't take the original picture meant little to collectors. In 2005 *Untitled (Cowboy)* sold for $1.2 million at auction, then the highest publicly recorded price for the sale of a contemporary photograph.

Others were less enthusiastic. Prince was sued by a photographer for using copyrighted images, but the courts ruled largely in Prince's favor. That wasn't his only victory. Prince's rephotography helped to create a new art form—photography of photography—that foreshadowed the era of digital sharing and upended our understanding of a photo's authenticity and ownership.

PILLARS OF CREATION | *NASA, 1995*

'As long as there have been people, we have been drawn by this question of what is our connection with the sky.' –DR. JEFF HESTER, HUBBLE ASTRONOMER

The Hubble Space Telescope almost didn't make it. Carried aloft in 1990 aboard the space shuttle *Atlantis*, it was over-budget, years behind schedule and, when it finally reached orbit, nearsighted, its 8-foot mirror distorted as a result of a manufacturing flaw. It would not be until 1993 that a repair mission would bring Hubble online. Finally, on April 1, 1995, the telescope delivered the goods, capturing an image of the universe so clear and deep that it has come to be known as *Pillars of Creation*. What Hubble photographed is the Eagle Nebula, a star-forming patch of space 6,500 light-years from Earth in the constellation Serpens Cauda. The great smokestacks are vast clouds of interstellar dust, shaped by the high-energy winds blowing out from nearby stars (the black portion in the top right is from the magnification of one of Hubble's four cameras). But the science of the pillars has been the lesser part of their significance. Both the oddness and the enormousness of the formation—the pillars are 5 light-years, or 30 trillion miles, long—awed, thrilled and humbled in equal measure. One image achieved what a thousand astronomy symposia never could.

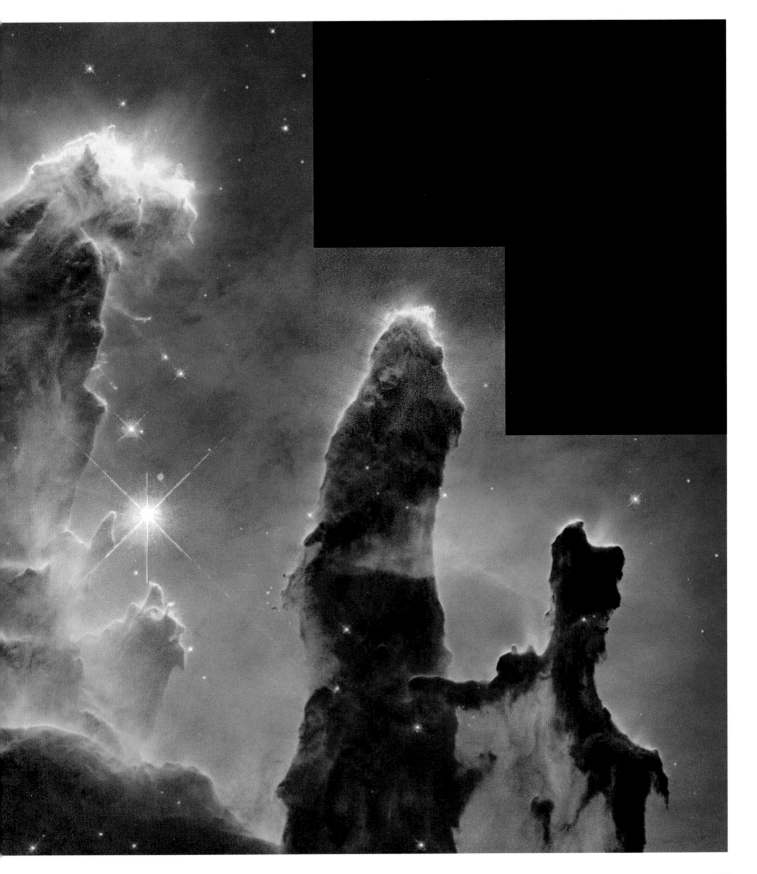

FIRST CELL-PHONE PICTURE | *Philippe Kahn, 1997*

'The camera phone was born in Santa Cruz on June 11, 1997, at the Sutter Maternity Clinic.' –PHILIPPE KAHN

Boredom can be a powerful incentive. In 1997, Philippe Kahn was stuck in a Northern California maternity ward with nothing to do. The software entrepreneur had been shooed away by his wife while she birthed their daughter, Sophie. So Kahn, who had been tinkering with technologies that share images instantly, jerry-built a device that could send a photo of his newborn to friends and family—in real time. Like any invention, the setup was crude: a digital camera connected to his flip-top cell phone, synched by a few lines of code he'd written on his laptop in the hospital. But the effect has transformed the world: Kahn's device captured his daughter's first moments and transmitted them instantly to more than 2,000 people.

Kahn soon refined his ad hoc prototype, and in 2000 Sharp used his technology to release the first commercially available integrated camera phone, in Japan. The phones were introduced to the U.S. market a few years later and soon became ubiquitous. Kahn's invention forever altered how we communicate, perceive and experience the world and laid the groundwork for smartphones and photo-sharing applications like Instagram and Snapchat. Phones are now used to send hundreds of millions of images around the world every day—including a fair number of baby pictures.

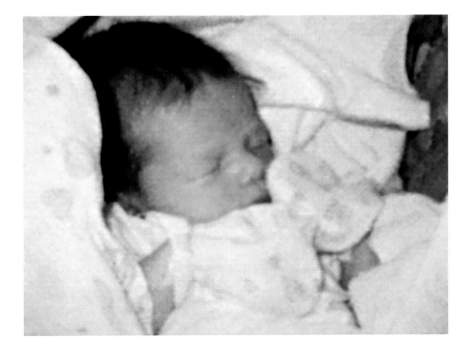

99 CENT | *Andreas Gursky, 1999*

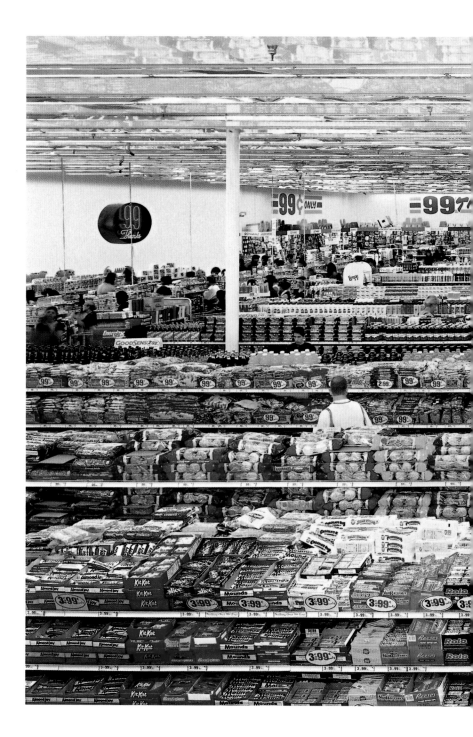

'The size of the work affects its reception, offering two different experiences: one immersive, one intimate.' –ANDREAS GURSKY

It may seem ironic that a photograph of cheap goods would set a record for the most expensive contemporary photograph ever sold, but Andreas Gursky's *99 Cent* is far more than a visual inventory. In a single large-scale image digitally stitched together from multiple images taken in a 99 Cents Only store in Los Angeles, the seemingly endless rows of stuff, with shoppers' heads floating anonymously above the merchandise, more closely resemble abstract or Impressionist painting than contemporary photography. Which was precisely Gursky's point. From the Tokyo stock exchange to a Mexico City landfill, the German architect and photographer uses digital manipulation and a distinct sense of composition to turn everyday experiences into art. As the curator Peter

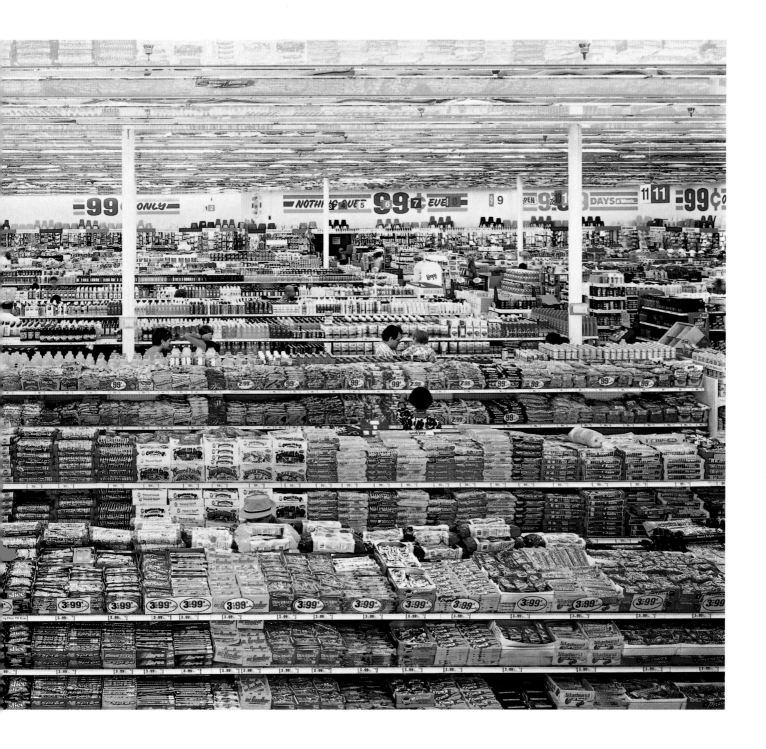

Galassi wrote in the catalog for a 2001 retrospective of Gursky's work at the Museum of Modern Art in New York City, "High art versus commerce, conceptual rigor versus spontaneous observation, photography versus painting … for Gursky they are all givens—not opponents but companions." That ability to render the man-made and mundane with fresh eyes has helped modern photography enter the art world's elite. In 2006, in the heady days before the Great Recession, *99 Cent* sold for $2.3 million at auction. The record for a contemporary photograph has since been surpassed, but the sale did more than any other to catapult modern photography into the pages of auction catalogs alongside the oil paintings and marble sculptures by old masters.

THE DEATH OF NEDA
Unknown, 2009

'It's heartbreaking, and I think that anybody who sees it knows that there's something fundamentally unjust.'
–U.S. PRESIDENT BARACK OBAMA

Neda Agha-Soltan was an unlikely viral icon. On June 20, 2009, the 26-year-old stepped out of her car on a Tehran street near where Iranians were massing in protest of what was seen as the farcical re-election of President Mahmoud Ahmadinejad. The Islamic Republic was experiencing its worst unrest since the 1979 revolution. The state made it illegal to join the demonstrations and barred most foreign media, which meant the burden of bearing witness was largely left to the citizens who waded in, cell phones in hand. It was around 6:30 p.m. when Agha-Soltan was struck in the chest by a single bullet, said to originate from a pro-government sniper, though no one was ever charged. Men struggled to save her as others focused their cameras on the unfolding tragedy. One frame from the footage freezes her final gaze as streaks of deep red formed a web on her face. The image, among the earliest and easily the most significant to ever go viral, commanded the world's attention. Within hours, footage uploaded anonymously to YouTube had been viewed by the President of the United States—proof that our new digital age could not only connect people; it could pry open even the staunchest of regimes.

NORTH KOREA | *David Guttenfelder, 2013*

'When they opened up the 3G network for foreigners, everything changed.' –DAVID GUTTENFELDER

David Guttenfelder was chief photographer in Asia for the Associated Press when it became the first international news organization to open a bureau in North Korea. He started making frequent trips to the country, which had been largely off-limits to foreign journalists and virtually hidden from public view for nearly 60 years. Guttenfelder dutifully chronicled the official events and stage-managed pageants in Pyongyang, but his eye kept wandering to the scenes of daily life just beyond the guided tours. In early 2013, North Korea made a 3G connection available to foreigners, and suddenly Guttenfelder had the ability to share those glimpses with the world in real time. On January 18, 2013, he used his iPhone to post one of the first images to Instagram from inside the notoriously secretive country. "The window [into] North Korea has opened another crack," he wrote on his widely followed account. "Meanwhile, for Koreans here who will not have access to the same service, the window remains shut." By using the emerging technology of the sharing age, Guttenfelder opened one of the world's most closed societies. He also inspired other visiting foreigners to do the same, creating a portrait of the monotony of everyday life not visible in mainstream coverage of the totalitarian state and bringing the outside world its clearest picture yet of North Korea.

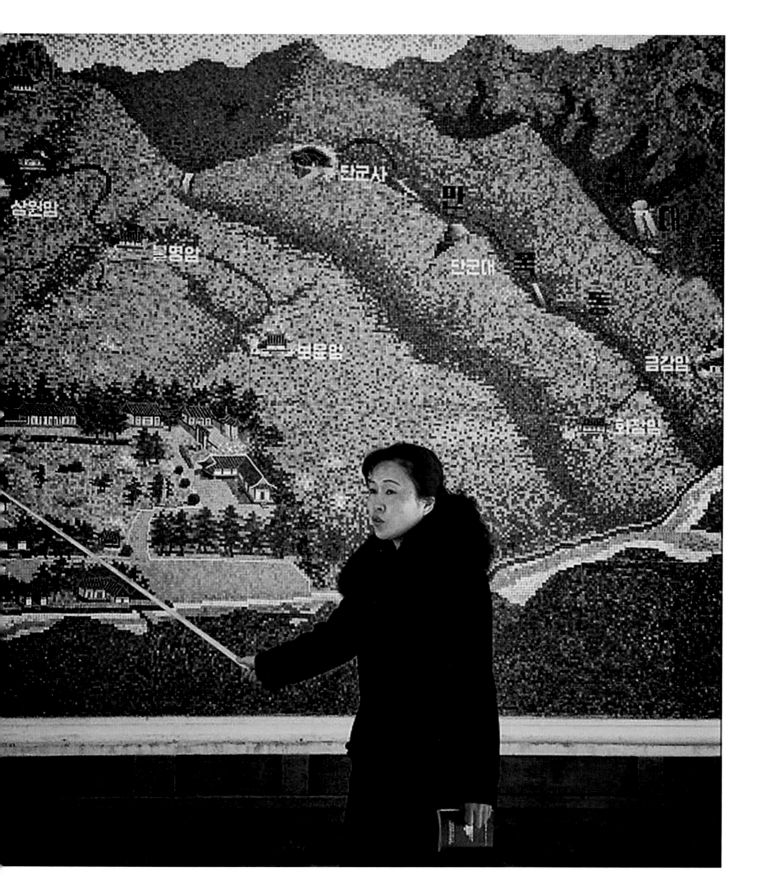

OSCARS SELFIE | *Bradley Cooper, 2014*

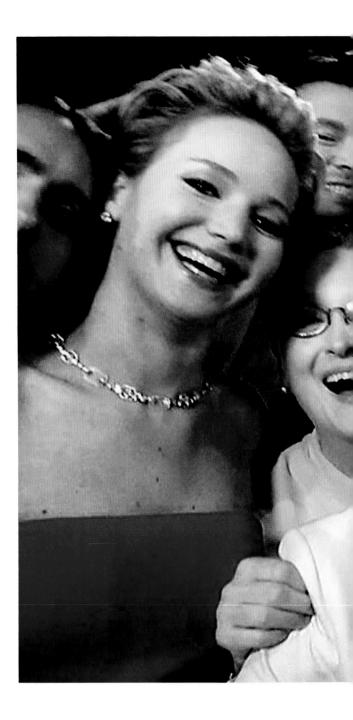

'It was this incredible moment of spontaneity that I will never forget. And thanks to the selfie, neither will anyone else.'
–ELLEN DEGENERES

It was a moment made for the celebrity-saturated Internet age. In the middle of the 2014 Oscars, host Ellen DeGeneres waded into the crowd and corralled some of the world's biggest stars to squeeze in for a selfie. As Bradley Cooper held the phone, Meryl Streep, Brad Pitt, Jennifer Lawrence and Kevin Spacey, among others, pressed their faces together and mugged. But it was what DeGeneres did next that turned a bit of Hollywood levity into a transformational image. After Cooper took the picture, De-Generes immediately posted it on Twitter, where it was retweet-ed over 3 million times, more than any other photo in history.

It was also an enviable advertising coup for Samsung. De-Generes used the company's phone for the stunt, and the brand was prominently displayed in the program's televised "selfie moment." Samsung has been coy about the extent of the planning, but its public relations firm acknowledged its value could be as high as $1 billion. That would never have been the case were it not for the incredible speed and ease with which images can now spread around the world.

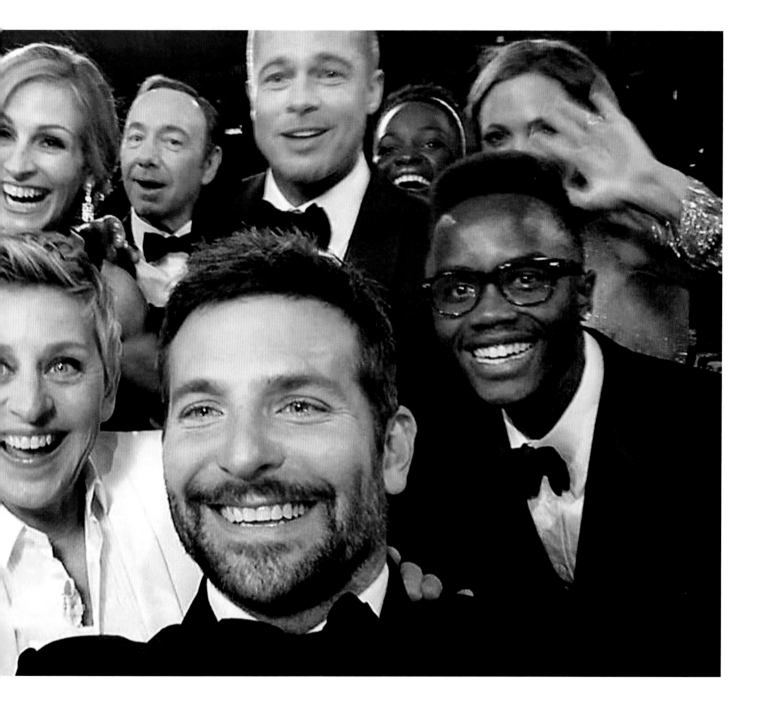

A PICTURE'S WORTH

David Von Drehle

hotography was scarcely 30 years old when Roger Fenton, a well-born Englishman, landed on the Crimean Peninsula with camera equipment and a wagonload of darkroom supplies. He spent most of the next four months documenting a dreadful war among European powers, the war that gave the world Florence Nightingale and the Charge of the Light Brigade.

One day in 1855, in a sloping declivity near Sebastopol known as the Valley of the Shadow of Death, among cannonballs scattered by the frequent Russian artillery barrages that gave the valley its nickname, Fenton spent the better part of two hours recording two pictures of the scene.

These stark and ominous images are widely regarded as the first important war photography. But in recent years they have been at the root of an intense controversy. After taking the first exposure, Fenton caused a number of cannonballs to be moved from the hillside and placed in the road. Why he did this is not clear.

The late critic Susan Sontag theorized that Fenton was sensationalizing the scene by making the road look more dangerous. Filmmaker Errol Morris, among others, has taken a more forgiving view. Perhaps Fenton was attempting to show the scene as it was immediately after a barrage, before the road was cleared.

What difference does it make? The controversy is a testament to the enduring power of a great photograph. One might imagine that a photograph would be the most ephemeral of documents. It is, after all, only the record of light reflected in a fleeting moment. But as this collection shows, the opposite is the case. An influential photograph retains its power long after eyewitnesses are gone and written accounts have been forgotten. Think of Joe Rosenthal's frame of servicemen raising the flag over Iwo Jima, Alfred Eisenstaedt's snap of a sailor smooching a nurse in Times Square, Nick Ut's photo of a naked child fleeing a napalm attack in Vietnam.

From its earliest days, photography has served to bring us in contact with unseen realities. As the New York *Times* editorialized after an exhibition of Alexander Gardner's unprecedented photographs of dead soldiers on the Antietam battlefield in 1862: "If he has not brought bodies and laid them in our dooryards and along the streets, he has done something very like it."

As a check on that power, we ask that the reality inside the frame be authentically real. It becomes a matter of great moment whether Robert Capa really caught a soldier in the moment of death, or Rosenthal's picture might have been a re-enactment, or Gardner's bodies were artfully arranged. We license the photographer to see the world with special acuity, to record it, to capture, in the words of Alfred Stieglitz, "a reality so subtle that it becomes more real than reality." But the germ must be real.

We live in a world transformed by photography, and the transformation continues at a blinding pace. Photography allows us to go anywhere, to see almost anyone, to witness life from womb to tomb, to peep inside palaces and hovels, to venture beyond the stars and beneath the seas, to be exalted by the beauty of a tender touch and revolted by the ugliness of an ISIS execution.

Now we've reached an age when everyone is a photographer and every scene a potential photograph. On social media, the photograph has become a kind of existential statement: I am here! Can you see me? Power has shifted from the photographer to the viewer, who has an almost infinite number of images to choose from.

Photography is a mode of communication, after all, which is to say a back and forth, give and take. The photographer frames a glimpse of the world; the viewer interprets and responds to it. There is potential for power and even revelation in both roles. We are, perhaps, moving ever closer to the ideal expressed by Edward Steichen: "When I first became interested in photography, I thought it was the whole cheese. My idea was to have it recognized as one of the fine arts. Today, I don't give a hoot in hell about that. The mission of photography is to explain man to man and each man to himself."

Von Drehle, a TIME *editor at large, is the author of* Rise to Greatness: Abraham Lincoln and America's Most Perilous Year.

CREDITS & ACKNOWLEDGMENTS

CONTRIBUTING CURATORS David Campbell; Charlotte Cotton; Philip Gefter; W.M. Hunt; Erik Kessels, KesselsKramer; Susan Kismaric; John Loengard; Santiago Lyon; The Associated Press; Azu Nwagbogu; African Artists' Foundation; Fred Ritchin; International Center of Photography; Carol Squiers; Aidan Sullivan, Getty Images; Anne Wilkes Tucker; Museum of Fine Arts, Houston

REPORTERS Melissa August; Erica Fahr Campbell; Richard Conway; Ben Cosgrove; Eric Dodds; Alex Fitzpatrick; Alice Gabriner; Krystal Grow; Bridget Harris; Olivier Laurent; Myles Little; Michelle Molloy; Noah Rayman; Maya Rhodan; Liz Ronk; Lily Rothman; Marisa Schwartz Taylor; Mia Tramz

WRITERS Sean Gregory; Andrew Katz; Jeffrey Kluger; Daniel S. Levy; Matt McAllester; Kate Pickert; Josh Sanburn; David Von Drehle (section introductions); Bryan Walsh

SPECIAL THANKS TO Dr. Shahidul Alam; Dora Apel; Bobbi Baker Burrows; Miles Barth; Irina Chmyreva, Ph.D.; Judith Cohen; Emmanuel de Merode; Yumi Goto; Bill Hooper; Roberto Koch; Silvia Mangialardi; Pablo Ortiz Monasterio; Kathy Moran; Andrei Polikanov; Manuel Rivera-Ortiz; Mark Sanders; Michael Sanders; Harsha Vadlamani; Paul Weinberg; Luis Weinstein; Ann Drury Wellford; Wim Wenders; Deborah Willis, Ph.D.

IMAGE CREDITS

TIME

EDITOR
Nancy Gibbs

CREATIVE DIRECTOR
D.W. Pine

DIRECTOR OF PHOTOGRAPHY
Kira Pollack

100 PHOTOGRAPHS

EDITOR
Ben Goldberger

DESIGNER
Janet Froelich

DEPUTY DIRECTOR OF PHOTOGRAPHY
Paul Moakley

SENIOR EDITOR
Roe D'Angelo

DEPUTY DESIGNER
Skye Gurney

PHOTO EDITOR
Marysa Greenawalt

ASSOCIATE PHOTO EDITOR
Tara Johnson

TIME INC. BOOKS

PUBLISHER
Margot Schupf

ASSOCIATE PUBLISHER
Allison Devlin

VICE PRESIDENT, FINANCE
Terri Lombardi

EXECUTIVE DIRECTOR, MARKETING SERVICES
Carol Pittard

EXECUTIVE DIRECTOR, BUSINESS DEVELOPMENT
Suzanne Albert

EXECUTIVE PUBLISHING DIRECTOR
Megan Pearlman

ASSOCIATE DIRECTOR OF PUBLICITY
Courtney Greenhalgh

ASSISTANT GENERAL COUNSEL
Andrew Goldberg

ASSISTANT DIRECTOR, SPECIAL SALES
Ilene Schreider

ASSISTANT DIRECTOR, FINANCE
Christine Font

ASSISTANT DIRECTOR, PRODUCTION
Susan Chodakiewicz

SENIOR MANAGER, SALES MARKETING
Danielle Costa

SENIOR MANAGER, CATEGORY MARKETING
Bryan Christian

ASSOCIATE PRODUCTION MANAGER
Kimberly Marshall

ASSOCIATE PREPRESS MANAGER
Alex Voznesenskiy

ASSISTANT PROJECT MANAGER
Hillary Leary

EDITORIAL DIRECTOR
Stephen Koepp

ART DIRECTOR
Gary Stewart

EDITORIAL OPERATIONS DIRECTOR
Jamie Roth Major

SENIOR EDITOR
Alyssa Smith

COPY CHIEF
Rina Bander

DESIGN MANAGER
Anne-Michelle Gallero

ASSISTANT MANAGING EDITOR
Gina Scauzillo

EDITORIAL ASSISTANT
Courtney Mifsud

SPECIAL THANKS TO:
Allyson Angle, Brad Beatson, Jeremy Biloon, Ian Chin, Rose Cirrincione, Pat Datta, Alison Foster, Erika Hawxhurst, Kristina Jutzi, David Kahn, Jean Kennedy, Amanda Lipnick, Amy Mangus, Melissa Presti, Kate Roncinske, Babette Ross, Dave Rozzelle, Divyam Shrivastava, Larry Wicker

Copyright © 2015
Time Inc. Books.
Published by Time Books, an imprint of Time Inc. Books, 1271 Avenue of the Americas, 6th floor, New York, NY 10020

ISBN 10: 1-61893-160-1
ISBN 13: 978-1-61893-160-3
Library of Congress Control Number: 2015935279

We welcome your comments and suggestions about Time Books. Please write to us at:
Time Books, Attention: Book Editors, P.O. Box 361095, Des Moines, IA 50336-1095

If you would like to order any of our hardcover Collector's Edition books, please call us at 800-327-6388, Monday through Friday, 7 a.m.–9 p.m. Central time.

100 PHOTOGRAPHS *the most influential images of all time*

This book is part of TIME's groundbreaking
exploration of the 100 photographs that shaped the human experience.

See the entire project at TIME.com/100photos.

Tour the virtual museum to watch compelling original documentaries,
hear the surprising and often never-before-told stories behind
the photographs, and read exclusive conversations with influential artists,
entertainers, innovators and world leaders.

ENDPAPERS: 12 of the 26 negatives from Philippe Halsman's 1948 *Dalí Atomicus* (front); a contact sheet of Donna Ferrato's images of domestic violence in 1982 (back)